THE BALANCING POLE

The Balancing Pole

A novel by
Ann L. McLaughlin

JOHN DANIEL & COMPANY
SANTA BARBARA
1991

Copyright ©1991 by Ann L. McLaughlin
All rights reserved
Printed in the United States of America

This novel is a work of fiction. Any resemblance between characters in this novel and real characters, living or dead, is purely coincidental.

Cover design by Francine Rudesill
Design and typography by Jim Cook/Santa Barbara

Published by John Daniel and Company, a division of Daniel & Daniel, Publishers, Inc., Post Office Box 21922, Santa Barbara, California 93121. Distributed by National Book Network, 4720 Boston Way, Lanham, Maryland 20706

LIBRARY OF CONGRESS CATALOGING-IN-PUBLICATION DATA

McLaughlin, Ann L., 1928-
 The balancing pole: a novel / by Ann L. McLaughlin
 p. cm.
 ISBN 0-936784-90-3: $9.95
 I. Title.
PS3563.C3836B3 1991 91-10307
813'.54—dc 20 CIP

for John and Ellen

THE BALANCING POLE

Chapter 1

MARGO

WHEN I try to remember how that whole dark journey began, I always think of a certain afternoon in the fall of 1959. We had moved to California just four weeks earlier and I was up in the attic room I called my studio, trying to work on a portrait of my mother. The woman I had painted held a flower pot in one hand, a trowel in the other; her long face had an expectant look. A month ago, when I had begun the portrait in Cambridge, I had been excited. "I think it's the best work I've ever done," I had told Terry, my husband, but here in my new Berkeley studio, I wasn't so sure.

"Look at this, Mummy." Laura was hunched over a coloring book on the floor, her padded blue bottom sticking up above the level of her blonde head.

"Just a minute, sweetie," I said without turning to her, and continued to stare at the expression in the woman's deep-set eyes. I stepped back to survey the whole. The easel looked lonely in the bare space with only the table of paints beside it and a solitary bucket of gesso on the floor. Beyond Laura's hunched form, a clutter of unpacked boxes was stacked against the eaved wall. I ought to have gotten this room settled before I started painting. In fact, I ought not be up here at all. I should take Laura downstairs and begin unpacking the books in the living room or. . . .

"Mummy." Mikey had gone to the kitchen for snacks and was climbing back up the attic stairs. It was chaotic working with both of them around me. Yet I needed to paint; I had to. I let my eyes settle on my mother's face again. How could I paint a woman I had not known since I was a child?

"You have to come down," Mikey announced. "I can't get the top off the apple juice. It's stuck." I sucked in my breath with a hissing sound, annoyed by the commanding voice my son had adopted since he'd turned five. These constant interruptions, these.... What time was it anyway? I peered at my watch. Three? Oh God. I had to stop. We'd be late for Dr. Ross.

Mikey went back to the waiting room to play with the train after his examination, and I settled in the chair opposite the doctor's desk. That neat, quiet office had become familiar since Mikey's hospital stay, almost a refuge, I thought, as I gazed at an even row of medical texts in the bookcase. Mikey was practically well after his severe asthma attack, Dr. Ross assured me. I nodded and focused on the line of pencils in the breast pocket of his white medical coat.

Behind his horn-rimmed glasses, the doctor's brown eyes looked kind. Mikey was well enough to start first grade next week, he announced. He smiled; I stared at his tanned, energetic face, then smiled back slowly.

"What about you?" he asked. "Mikey got sick just the day after you arrived, didn't he? How are you doing after this crisis?"

"I'm not doing very well," I answered. "I don't know why; I just can't seem to get organized. I...." I stopped. What was I saying? I couldn't spread out my personal feelings to Mikey's doctor.

"An event like this can be very debilitating," Dr. Ross said. "Your child was critically ill. It's normal to experience a let-down after a scare like that."

I looked down. My decisive energy the night of Mikey's attack seemed strangely remote. I had stood rigid in the hallway, listening to his choked gasping, then I had leapt up the stairs and snapped on the overhead light. "We've got to get him to a hospital," I told Terry. "He needs oxygen." Terry had carried Mikey

down to the car and I had followed close behind, clutching a tail of blanket. There had been tanks and tubes and nurses, and a tense conference with the intern on duty under the fluorescent lights in the tiled hall.

But all of that had happened over three weeks ago; Mikey's wheezing cough was gone. Fifteen minutes ago, when he was sitting on the high examination table, small and naked except for his underpants, Dr. Ross had pointed out that the angry red patches of eczema on his thighs had almost disappeared. He was practically well, but my throat was tight with tears. "I don't understand it," I went on. "I should be glad, relieved. But I keep thinking of my sister, of our old apartment, of.... It's so dumb." My voice shook. I reached up surreptitiously and smeared back some wetness from my cheek with the heel of one hand.

"People often feel homesick after a crisis," he said quietly.

"But I wanted so much to come to Berkeley," I rushed on. "It all seemed so perfect—the job, everything. Then the University went back on its promise," I explained, uncertain why I was telling him this. "They were going to give Terry a full-time teaching position, but they didn't have the students. He had to take an editorial job at an art magazine as well. He wasn't sure it was a good plan." I stopped; I was giving too much information, taking too much time. "But I urged it on him. I was set on this whole California adventure. And now...." I smeared back another tear. Dr. Ross reached a white-coated arm toward the plastic-covered Kleenex box on his desk and held it out to me. Good God. Why was I acting like this?

"I'm a portrait painter," I said and wiped my nose. "I do children mostly." I looked straight across at him, meaning to reassert my professional self. "I'm using this attic room in the house we've rented as my studio. I'm trying to finish a portrait of my mother." I should stop talking; I was just another garrulous mother, taking his time in the midst of a busy afternoon, but I went on. "It's a good painting and yet for some reason I can't seem to get it right." I twisted the Kleenex.

"Aren't you being a little unrealistic?" the doctor said. "A move takes time and you've had a very sick child."

"I know, but you see, I always seem to do the rest of my jobs better if I can make time every day for my painting." I paused.

"This painting I'm doing is hard. I mean, you see, my mother was killed in a car accident when I was thirteen and...." I glanced down at Bunchie, Mikey's teddy bear, which I was holding in the crook of my arm.

"A crisis like this often triggers old problems." Dr. Ross tipped back in his leather chair. "You know, you might consider a little psychiatry." He swiveled partway toward the window, then back again. "Nothing long-term. Just a couple of appointments, maybe. Someone who could listen professionally might be quite helpful to you right now."

"Psychiatry?" The queer medical name had a threatening sound. "Oh, I'm not sick." I clutched Bunchie's felt paw. "I'm just a little disorganized . . . a little. . . . " One of Bunchie's glass eyes was getting loose; I should sew it on tight before it got lost.

"Think about it," Dr Ross said. "Talk it over with your husband, why don't you? I can give you some names, if you decide to give it a try." He put both hands on the blotter and rose. "See you in three weeks. All right?"

"Fine." I tucked Bunchie under my arm. "Thank you."

"Just give me a call, if you want those names," Dr. Ross said and opened the office door.

Mikey ran down the asphalt path toward the swings in the little city park across from the medical building. These intervals in the park had become a ritual after each doctor's appointment—a reward for us both after the boredom of the waiting room, the tension of the examination, and the conference afterward—and I had indulged in them each time, even though they added an extra half hour to the babysitting for Laura.

Mikey grabbed the chains, bent his legs, then pointed his cowboy boots up, as the swing flew out. When it dropped back again, I was in my place behind him. I raised my hands to his striped jersey and pushed. "Harder, Mummy," he shouted. I pushed and watched him rise up again into the California sky. Its blueness was webbed with eucalyptus leaves, which Mikey seemed to touch with the toes of his boots as he swung high. Left behind, I turned to stare at the tall medical building beyond the row of shaggy palms. Why had I acted that way, I thought, visualizing myself in the doctor's quiet office. I had blabbered on to him

about my feelings, my painting, Terry's jobs. My God, I'd even told him about Mom's death, which was years ago, and I had cried. No wonder he'd recommended a psychiatrist. Oh, Lord. He'd thought I was crazy.

"Hey, Mummy," Mikey shouted, as he dropped back again. "You swing too." He pointed to the empty swing beside him.

"What?" I shook my head, as if to dislodge an insect, then glanced from the line of swings to the empty benches beside the walk. The park was ours alone on that quiet late afternoon.

I moved to the swing next to Mikey's and grasped the chains, which were rubbed bright along the length where other hands had clasped them. I pushed with my toe and rocked a little, thinking that I couldn't really swing in my good shoes and stockings. I pushed harder; the swing flew out and back. I pumped and rose again. Air sucked in around my ears; my long braid hit the middle of my back with a thump. "Wow." I laughed and tipped my head, feeling my braid drop down. "This is great," I shouted as I rose up once more.

I focused on my black leather toes pointing up, up into the leaves and glimpsed a red-tiled roof beyond. No, it was umber, I corrected myself, umber. Cars stood waiting in the parking lot, their smooth tops like beetles' bodies, gleaming in the sun. A television antenna glinted and I was riding out over a great aerial painting, swinging free. "Whee." I tossed my head. The heck with Dr. Ross and my embarrassment. We didn't have to see him again for three whole weeks anyway, and by then I would be fine.

I slowed myself so that I was even with Mikey, making up for the distance between my black shoes and the small blunt toes of his cowboy boots. We were in rhythm now—up, down, and up again. The asphalt walk looked far below us, the benches, and the sandbox with its dry mounds of gray-yellow sand.

"Look at me, Mom." Mikey stuck out his chin. "I'm an Air Force pilot. See?"

"I'm in the Air Force too," I called back, "if they take moms."

Mikey laughed; the sound caught and turned to a wheeze. I peered at him. "Let's slow down, honey." We dragged our feet and hung, staring down at the pounded dirt beneath the swings. Mikey's breathing evened, and he twisted so that his swing chains made a narrow triangle above his head, like a tall dunce cap. I

smiled. "You're getting to like California a little, aren't you?" I asked, then wished I hadn't.

Mikey dragged the heel of his boot across the dusty ground, making a thick line. "Can Fritzi come visit in the summer, Mummy? Please." He deepened the line in the dirt, but did not look up, as though he sensed the request was futile. Fritz, the little boy who had lived in the apartment below us last year in Cambridge, was now a continent away—a shy, white-faced child, doomed to drop into some dim space in Mikey's memory. Yet he and Mikey had loved each other; they had spent long afternoons together, hunched over their Tootsie Toys, making roads on the living room rug, building gas stations. But I had been impatient to leave that setting—the battered mailboxes in the front hall, the cockroaches in the kitchen sink—and now that apartment, Fritzi, Cambridge, that whole life was gone.

I thought of my sister in her maroon leotard doing her early morning headstand in the living room, her long legs shooting straight up, her hair crushed into an orange cushion on the rug. She had been with us all of July, acting with the Cambridge Shakespeare Festival. Now she was back in New York and we were in California.

"Homesickness is natural," Dr. Ross had said.

"He could sleep in my bed, Mummy," Mikey pleaded. "With me."

"We'll see, honey." I winced at the sound of my evasion. But what could I tell Mikey, really? Something was gone and something else was starting.

A bird's song rose from the slender leaves of a pepper tree, the clear sound spreading out in the quietness. Was it a mockingbird? Its song was supposed to be lovelier than the nightingale's, but was it really a mockingbird? I should know so I could tell my children. The sound enclosed us with soft rings that hung, trembling, before they dissolved.

"Listen to that," I whispered. The bird rose from the leaves in a flutter of gray and lighted on the top branch of the tree. He flicked his broad, upraised tail, flashing its white bars before us a moment; then he was gone. Had we frightened him?

I glanced around the empty park. We must leave in a minute; Nancy Benson, my neighbor, was babysitting for Laura, and I

had promised to be back by five. I could see Nancy in her kitchen, her Revere Ware pots, with their glowing copper bottoms, hanging in a graduated row, her PTA lists lined up beside the phone. If I were more like Nancy, I would have that portrait finished, the books all organized on the living room shelves and. . . .

"Listen, Mikey," I said, and rose. "I'm going to sit on the bench a minute. I've got to make a list." Mikey stood; he pushed his hands into the pockets of his overalls and turned away. "It's just for a second." I gazed at the empty swings, which were still rocking. I had broken something. "We'll swing again in a minute. Okay?" But Mikey stepped into the sandbox without looking back at me. He flopped down on his knees and began pulling the sand toward him with sweeping movements, creating a long barrier.

I sat down on the bench and pulled a pad and pencil from my pocketbook. "Painting of Mom," I wrote and made a Roman numeral one beside it. The answer was work. Last night in the kitchen, Terry had proposed that I abandon the painting for a while and begin on a commission I'd gotten for a portrait of a faculty member's grandson. "Listen," I said. "I scheduled that job for November on purpose. I'm not going to move to that project just because I'm temporarily stuck on this one."

"Okay." Terry shrugged his shoulders. "It was just a suggestion."

"Babysitting." I wrote the word in large letters and made a Roman numeral two beside it. I had been as surprised as Nancy at the matching genders and ages of our four children, but our babysitting exchanges were not going smoothly. Chuck had called Mikey a "sicky sap" and he had stolen two of Mikey's Tootsie Toys. I sighed. Four weeks ago I'd never heard of Nancy Benson; now her noodle casserole sat on the top shelf of my refrigerator, her list of repairmen fluttered from my bulletin board, and her son spent the late afternoons in our living room, squatting over Mikey's toys.

"Give me your pencil," Mikey ordered. "I need a flagpole." I stared at him a moment, then held out the pencil. We must go; we had to pick up Laura. I saw my daughter sitting with Dodie in front of the television. Her baby-like mouth would be wet when I

pulled out her thumb and yet I had come to depend on the sanity in those light blue eyes. Why, then, did I keep forgetting my second child?

"Come on, Mikey. We have to go." Laura and Dodie were friends, but Chuck was bad for Mikey right now. Tomorrow I'd tell Nancy that I couldn't babysit for him anymore. But what about my work? I couldn't paint with Mikey up in my studio all the time. "Hurry," I shouted. I reached to yank the strap of my pocketbook up on my shoulder, but shuddered instead. I glanced around me; something dark was moving in. I rose. "Come on," I called again.

"Wait," Mikey said. "I have to finish this wall." He pointed to the thick bank of sand in front of him, rounded on the sides. The yellow pencil protruded from a high mound at the end.

"No." My shout tore through the quiet air like a shot. I stood for an instant, listening, then bent and plucked the pencil out of the sand, and rammed it into my purse. I could feel Mikey watching me with wary eyes. "I'm sorry," I said. "But please. Come on."

At the edge of the parking lot, I paused and took his hand, unable to remember where I had left the car. When I caught sight of it, dusty and familiar at the end of a row, I felt relieved and efficient again and I strapped Mikey into his seat. But as I was digging in my pocketbook for the keys, he shouted, "Bunchie, Mummy. We forgot him." He leaned forward, trying to reach the lock button on the back door. "We forgot Bunchie."

"Now Mikey, he isn't lost," I began and wished I hadn't let him bring the teddy bear. "He's probably right there in the sandbox." Oh God, I remembered in a rush, Nancy had asked me to be sure to be home on time since she had to get ready for a meeting at her house that evening. I lifted Mikey out of the seat and slammed the car door behind him.

The sun had sunk below the line of eucalyptus and the tall, shaggy trees shadowed the sandbox area. I shivered and clutched my arms around me, as I stood peering at the spaces where we had been. The bear was not in the sandbox, nor beside it in the dry grass. I turned. The tall swing frame made a black silhouette against the pink and gray sky. But the bear was not among the tangled weeds at the bottom, or lying on his back beside the empty bench, gazing upward with his glassy stare.

"We probably left him in Dr. Ross's office," I said.

Across the street, beyond the dark line of palm trees, the tall medical office building showed squares of yellow light. I had held the bear in my lap during that stupid talk with the doctor, I remembered. Maybe I'd put him down in the waiting room, while I pulled on Mikey's boots. "I'll bet he's right there at the nurse's desk, honey, safe and sound." But the possibility didn't seem likely. I glanced around me, trying to think. Call Daddy, a voice suggested. My God, why? To ask him about a teddy bear? I didn't even know whether he was in New York now or Washington.

"Bunchie," Mikey whined. "What if he's here, Mummy? It'll get dark."

"He's not, Mikey," I said and paused, hearing the whine in my own voice. "You can see for yourself that he's not." I turned to glance around me one last time. "Come on."

"Don't leave him, Mummy." Mikey's cry twisted in me and I stooped down beside him on the gritty walk.

"We're not, honey." I put my arm around his shoulders and pressed his head against my blouse. "It's all right; we're not." I straightened, but Mikey looked vulnerable there below me, and the dim park seemed vaguely evil now. I stooped again and lifted him. Clutching his buttocks with one hand, his shoulders with the other, I began walking awkwardly toward the parking lot. Mikey curled his legs around my waist; his boots would dirty my skirt, but it didn't matter now. My pocketbook banged against my side, the strap threatening to slip down. "It's all right," I whispered again, as I made my way toward the rows of anonymous cars. "It's all right."

But what was it, I wondered, and what did all right mean? The metal side of a phone booth gleamed in the glow of a street light beyond. I put Mikey down, took his hand, and hurried toward it. My dime rattled in the box and I dialed.

"Dr. Ross's office. May I help you?" I breathed out, grateful for the secretary's familiar voice.

"Hi. It's Mrs. Sullivan," I explained. "Mikey's mother. Did we leave his teddy bear there this afternoon by any chance? We had a three-thirty appointment." I twisted the curling cord as I waited. "We did? Oh, good." My high laugh sounded incongruous, rising

beside the shadowy parking lot. "We'll be there in a few minutes." I'd explain to Nancy that we'd lost a toy, that I. . . .

Mikey ran ahead and stood at the curb, wrapping his forearms in the bottom of his striped jersey as he waited for me. I turned to gaze back at the park. The shadows were deeper now; the swing frame and the benches were black. I had found Bunchie, but I had lost something else, I thought; something within me had slipped down out of place and I was alone in the spreading dark.

Chapter 2

TERRY

I WAS so damn busy that first fall at Berkeley that I don't really remember when Margo's troubles started; the business in the attic took me by surprise. I was at the office one Saturday, trying to write a lecture on the ways in which the artist's vision of the American landscape changed in the nineteenth century. I had slides, of course, but I needed to back up what I was saying with quotes, and the job took the whole darn morning. It was noon when I got home. I expected the place to be empty because I thought Margo had said she was going to take the kids to the pool. But when I opened the back door I heard a heavy nasal voice talking in the living room in a tough Brooklyn accent. I stood holding the door handle a moment, confused, then realized it was the television, of course, some cartoon show probably. I stood my briefcase on the kitchen table and moved across the dining room. Had the kids been watching all morning?

After the bright California sun outside, the living room seemed dim and sour-smelling. Mikey sat cross-legged on the rug, frowning up at Bugs Bunny, who was lecturing Porky Pig in a loud voice. Laura was hunched over, her back to the set, as she struggled to stuff one of Bunchie's arms into a blue doll's coat. A cardboard packing box lay on its side just beyond her, its contents spread out. There was a not-quite-empty oatmeal box that had left a tan trail on the rug, a battered flour sifter, and some old *New Yorkers* stacked to form a table beside Bunchie.

I stood in the doorway a moment, watching as the bossy rabbit with his oversized front teeth threatened the pig with a mop. Although Porky looked vulnerable with his smooth round head, tiny ears, and short vested coat, he leapt out from under the mop with agility and rushed through the door, down the stairs, into the street, past a row of parking meters, and down an open manhole with Bugs Bunny in pursuit. I glanced at Mikey to see whether he was enjoying this chase, but his frowning stare indicated that Porky's flight was more of a worry to him than an amusement.

"Hi, gang," I said, moving over to them. I bent to tousle Mikey's hair. His chin was smudged and there were streaks of gray on Laura's overalls. What was going on?

"When can we go to the pool, Daddy?" Mikey demanded and pulled at my sweater. "When?"

Laura dropped the teddy bear and scrambled to her feet, tripping on the flour sifter. "Daddy," she said, catching my leg as she fell against me. "The pool. The pool."

"I thought Mummy was going to take you this morning," I said. "Where is she anyway?" I raised my voice to make the question audible over the loud sound of Bugs Bunny's teasing laugh as he clutched the end of Porky's vest.

"In the attic," Mikey shouted. "She said she'd be done by the end of *Merrie Melodies*, but it's already *Looney Tunes*. I helped. It got all dusty up there though; it made me cough."

"I helped too," Laura said and held up her dirty hands. "I helped, Daddy, and I came down all by myself."

"She's not supposed to," Mikey said. "Me or Mom's supposed to be there when she comes down the ladder. She was bad."

"I was not." Laura's tone was matter-of-fact; she had already returned to Bunchie and the coat.

I gazed up at the ceiling. What was Margo doing up there anyway? I glanced back at the screen. Porky had escaped again and Bugs had resumed his chase. Mikey pushed up one leg of his corduroy pants and began raking his fingernails back and forth across a red rash on his thigh in a mechanical movement as he sat staring at the screen. I bent and pulled the pant leg back into place. "Where's that ointment Dr. Ross gave you?" I asked. "Is it in your room?" Mikey nodded, but did not speak. I sighed.

Margo had been irritated when I had brought the television set home one afternoon; now I saw why.

I found the ointment on Mikey's bureau and paused at the window. Below me the red-tiled roofs jutted downward toward the bright expanse of the bay. This was the place we had wanted to be, but something felt wrong.

I thought of the afternoon last spring, when the University called to offer me a full-time assistantship. Margo had put together a surprise celebration in less than two hours: boeuf bourguignonne, meringue pie, and all our best friends. We had sat squeezed around the pull-out table in the living room, the windows open to the soft night, toasting each other's brilliant careers with cheap champagne. I sighed; that celebration seemed a long time ago.

Later, the Art History Department called to say the registration in their basic survey course had fallen and they could offer me only two courses, so I took an additional job as a writer-editor at *Portfolio*, a new art magazine in San Francisco. I didn't like the idea of dividing my energies that way, but, as Margo pointed out, my publications in the magazine might well help me land a permanent teaching position later on. Maybe they would, I thought, or maybe I would have done better to have stayed at Harvard another year. I picked up the ointment and went back to the living room.

"Listen," I said, as I smoothed the white goo on Mikey's leg. "Finish watching this, then get cleaned up. Okay? Both of you. We'll have lunch and then we'll go straight to the pool." We'd just skip naps, I decided.

The smell of dust assaulted me as I climbed the pull-down stairs to Margo's attic room; there were shoe prints in the gray film where the children had climbed up and down. I peered in. Margo stood on a stepladder, chipping at the wallpaper with a metal scraper. She was wearing an old blue shirt of mine, which hung out over her dungarees. Her braid swung down her back as usual, but the dark hair around her ears was gray with dust. Her easel lay on its side near a packing box, and a pile of spiral sketch pads and canvases had been pushed back under the eaves. There was a large brown area on the wall in front of her and a sort of dragon-like shape behind her, as though she had started scraping there, stopped, then moved and started again.

"What's happening?" I asked. Margo looked at me, then raised one arm to push back some hair.

"I'm scraping the paper off so I can paint," she said. "The Rowleys"—they were the owners—"said it was okay."

"I know, but...." I glanced back at the easel, the boxes.

"I want to lighten the room. See? Make it brighter so I can really work up here." She paused. The project was huge; she must have been at it an hour or more, and yet she'd barely begun. "Nancy showed me this trick." Margo picked up the large sponge and held it against the area above the brown patch. "It's a little slow right now, but it'll get faster."

I frowned, thinking of our bossy neighbor next door. The long sloping wall was covered with lines of lavender flowers, looped at intervals by greenish bows. Maybe it would be good to paint the room and yet the faded colors had a quaint look, I thought, and sensed Margo's silent agreement for a moment, as she followed my gaze.

"I haven't got time to help you," I said and dug my hands into the pockets of my khaki pants. "I mean with the proposals for the long papers due and that deadline at *Portfolio*."

"I know that," she answered. "I don't want you to. I . . . I . . ." The stepladder wobbled as she backed down. "This project is very important to me." She laid the scraper and the sponge on the nearest packing box and squeezed her hands together as she stood looking across at me. "You see, I need to do something hard, and if I can just repaper this room, I think I can turn this thing around."

"What thing?" The question sounded dumb; I knew she'd been feeling sort of low, but I was puzzled to hear her refer to her mood in that combative way.

"You know. This awful apathy that's been dragging me down."

"But why do this?" I glanced around the space again. "I mean there's so much else. Jeez, Marg. The kids, the place. If I weren't so damn busy right now. I mean...." I paused. "If you're going to be up here, why don't you get your own work started, finish that portrait of your mother instead of fussing with the wallpaper. You can always do that stuff later." The sun was streaming through the window at the back and two broad trapezoids of light lay on the dusty floor. I thought of Mikey in the dim living

room below and Laura surrounded by that mess of toys. "The kids are downstairs watching television."

"I know. The television was your idea. Remember?" She sighed. "They haven't been down there long." She turned to face me. "What I need is a challenge. See? Something hard to do."

"But you've got plenty of challenges," I protested. "There's all the unpacking, the settling, and your own painting. Wouldn't it make more sense to get to work on your new commission? I mean, think of Cambridge. You used to work three mornings a week, sometimes four, when Mrs. Browning came."

"I was making good money then—for a painter at least—and that was Mrs. Browning; she loved Mikey." Margo's voice rose in a whine and she stopped.

"We can afford a sitter once a week at least," I said. "There're students. Besides you're going to be making money soon with that commission you got, and others will follow."

"Those people canceled," Margo announced. "Didn't I tell you?"

"What?" I moved to the table and opened a brown portfolio lying on top. I drew out a series of black and white photographs of a little boy in gray shorts and white knee socks, playing near a fish pond. Margo always began her portraits by taking photographs, working from them initially, then moving back and forth between the live image in the sittings and the photographed one. Her camera work was sensitive and fine.

"These are good," I said, shuffling through the stack. But I'd seen them before; Margo had taken them at least two weeks ago.

"I know, but they decided against it. I guess I was too slow." She sighed, as I pushed the photographs back into the folder.

"Shit." I felt angry. Margo needed that first commission here. Why couldn't she have gotten going on it, made it work? Margo's best paintings have a kind of compassion, a sense of life. I know that because I thought about art school myself when I started college, but I ended up majoring in Art History instead. I've spent a lot of time in galleries though, and time with canvases of my own, and I know Margo's really good—or she can be. That's why that whole thing in the attic was so damn frustrating.

"I guess they decided I wasn't fast enough, didn't have enough of a reputation. They're probably right."

"What did they say," I demanded, "after they had you take all these pictures?"

"Oh, she gave the old excuse; they'd thought it over and decided they couldn't afford a portrait right now. They'll pay for the photographs."

"They damn well better."

"Well, they were probably right. I wouldn't have done a good job."

"Don't say that," I protested. "You've just got to figure out something else. It's only a matter of time before you're recognized here."

"I thought that too, a few weeks ago," Margo said. Her voice had a tired sound. "But now.... I've been feeling so heavy, so indecisive and.... You see, I've just got to swing around and confront it. I've got to...." She took a step forward and stood staring at me. "I've just got to do this job."

I studied her, then glanced away. My gaze rested on the portrait of Yolanda, Margo's mother. "Look." I paused, not sure what I was going to say. The canvas was leaning against the wall. "That's such a good piece of work. I wish you could see yourself as a real portrait painter, honey, not just some housewife-mother, torn between different tasks. I mean, we can pay to have this place papered later maybe, if that's what you want, or I could help you over Christmas or.... But only you could do that, Marg." I pointed to the painting. "Don't you see?" The long sensitive face gazed out at me with its deep-set eyes; it was virtually finished. What was the matter anyway?

Margo stared at the portrait. "It is good, isn't it? Something's wrong with the mouth though. If I could just fix that I think maybe it would be the best work I've ever done." She looked at me and twisted her hands. "I want to get back to the energy I had when I began it, that vision and confidence." She paused, then reached down into her bra. "Look at this, Terry." For just a moment, I thought she was going to open her shirt and pull me close. Margo is spontaneous sometimes; her breasts are warm and white with long blue veins. But she reached into her bra and pulled out a small notebook instead. "I wasn't going to tell you about this until it had begun to work," she announced. "But I'll show you now anyway." She opened the notebook to the first

page; I stared down at a series of vertical lines in a blur of disappointment. They had been drawn across the blue horizontal ones and the first column was crowded with writing. "See," Margo explained. "Last night I washed a pile of stockings. That was three points, and Thursday night I washed my hair. Two points. I got four points for starting a letter to Liz, but I haven't finished it. Today I'll write that I started this wallpaper job and, when I finish scraping, I'll have ten points—twenty when the whole thing's done." I stared at the notebook, feeling her eyes watching me.

"Marg," I said. "My God, Marg." I took a step back, hot with a flush of repulsion. This notebook thing was bizarre, it was . . . but Margo went on talking.

"It might work," she said. "It just might. I mean I don't know how else to attack it."

"But. . . ." I shifted. "If you'd just get going on that portrait of your mother." I turned to it again.

"That's what I want to do." Her voice trembled. "Don't you see? I just can't. I keep trying, but the mouth, the eyes are wrong, the whole feeling of the thing. There's something that comes close, and yet it's flat; it doesn't say what I want it to." She clutched her arms around her and drew in her breath. "I know I'm a good painter, Terry, and I know I can do more than just children, too. This picture is so . . . so important to me." She paused, then swept one hand out, indicating the scarred wall. "If I can just get this room right. Don't you see? If I can make the setting work, then. . . ."

The distant television voices below increased suddenly. I heard the familiar thumping tune that ended the Warner Brothers' cartoons, then a cereal commercial slammed toward us up the stairs.

"Don't, Laura," Mikey yelled. "You're not supposed to touch the knobs." Laura's whine rose.

We glanced at the stairs, then back at each other, aware that our minutes alone were almost over. "My plan could work, Terry. It could." There were fussy voices below, then a sound of scuffling feet. "Give me a chance, will you?" Margo pleaded. "Please."

"Okay. I'll make the kids' lunch." I heard the weariness in my voice. "I'll take them to the pool," I said. "That'll give you the afternoon. All right?"

There was an angry yell from Mikey down below, then Laura's screech. "Mummy, Mummy!" Laura started up the attic ladder in her four-footed crawl. "Mikey pushed me. I'm bleedy."

"Here, sweetie." Margo bent to help Laura up the last steps and gathered her close. "You're all right," she said as she examined the hand Laura held up. There was a red dot of blood oozing from a scrape on her palm. "That just needs a little Band-Aid. That's all." She took Laura down to the bathroom, fixed her hand, and made lunch. There was no more talk of the wallpapering project; we all went to the pool instead. Margo didn't go up to the attic the next day or the next week, as far as I could tell. When I asked about her project, she was evasive, and those brown scars on the wall were there for a long time.

I was more aware of Margo's moods after that Saturday, and yet it was all so vague; I kept hoping she'd just feel like herself again. She jumped up from the breakfast table one morning, horrified that she was going to be late for the car pool, and shouted to Mikey to get his jacket on. "Today is Wednesday, isn't it?" she demanded, turning back to me.

"That's right," I told her. "But take it easy. The world won't come to an end if you're a little late collecting Nancy's kids." I could see my words hadn't penetrated. Margo was stuffing Laura's arms into a red sweater, her face set and grim. I rose and gathered the cereal boxes and, when I glanced up, I saw her by the front door, with Laura close beside her as she fumbled in her pocketbook for her car keys. She was wearing the tweed jacket she had worn when we first met.

I thought of that meeting all at once. I was hurrying down the front steps of the library late one afternoon, when this girl behind me screamed. She was hunched down on the steps and I leapt back; I thought maybe she'd turned her ankle or something. But she'd dropped a shoebox file and a whole batch of three-by-five cards had cascaded down the leaf-strewn steps. She kept muttering, "Oh my God, oh my God," as she gathered the cards, barely glancing up at me. She had a paper due the next morning, she said, and it would take her half the night just to get the cards in order. When she told me she was writing about Georgia O'Keeffe, I invited her for a cup of coffee, since I was working on

O'Keeffe too. That was the beginning. We got the cards all resorted on the masonite tabletop, while we talked. I knew more, naturally, since I was doing a graduate dissertation, but her insights were lively and her visual sense.... Well, I still love that jacket; it's part of the magic of our early times.

"You guys look great," I said and they did—Margo holding Laura's hand, Mikey in his cowboy boots on the other side. I could have taken a snapshot of them.

"Don't say that, Terry. I look awful."

It was a nothing incident. I don't know why I remember it even, and yet it catches a feeling of that early fall—a mood I should have noticed more, maybe. But hell, I had two new jobs; I thought I was the one who deserved attention. Besides, it isn't easy living with someone who keeps telling you they're awful.

Margo's father turned up for dinner one night. It was an odd evening; it always is with Jack. He's a distinguished journalist. He's been all over the world doing stories for *The New York Times* and other papers, has won prizes and awards, and that fall he was doing a series on the future of the Democratic party. He called from his hotel late one afternoon. He'd been covering a speech Senator John Kennedy had made the night before in San Francisco. Margo invited her father for a simple supper, but as soon as she put the phone down she was in a panic, rushing off to market, ironing placemats, putting in new candles, as if Jack would notice any of that. We settled in the living room after dinner and I fixed him a scotch and soda—light on the soda, of course.

"So what do you think of Senator Kennedy's chances?" I asked him. "Isn't this Catholicism thing going be a pretty big hurdle, if he decides to try for it?" As a lapsed Catholic myself, I'd read about Kennedy with interest. I knew my family would be behind him, if he ran, probably all of Massachusetts too.

"Oh, he's got a chance all right," Jack said. "A damn good one, and it's almost a sure bet that he'll run. Humphrey can't get the nomination, and as for Johnson, he'll probably edge out Symington, but he can't win it either. Stevenson looks like a threat right now. Still, he's a two-time loser and the voters don't want that."

"So you think it'll be Kennedy," I said. Jack nodded. His high forehead was deeply creased, and there were lines of fatigue around his mouth. But his eyes shone with eagerness, as he looked up at me; this Kennedy story was clearly an exciting one.

"He's young, sure," Jack continued. "But he's charismatic. He could be just what the country needs after this old-man presidency, this Eisenhower status quo, this . . . this . . ." Jack stopped, halted by a racking cough.

"It was exciting about Khrushchev's visit," Margo put in. "I just wish they'd let him go to Disneyland. They should have figured it out somehow, since he wanted to."

Jack slapped his sides under his wrinkled jacket and stared down into his glass. "Kennedy's got some good men around him," he began again and looked back at me; Margo's comment did not deserve acknowledgement, apparently. "The guy has a talent for picking people. Not the old, known crowd, you know, but the bright new ones, the comers, and I tell you that's significant; the ability to pick good people is crucial for a president—absolutely crucial." He finished his drink and held out his glass.

I rose and took it. The forefinger of his right hand was stained an orange-yellow from his chain-smoking. "My bet is that he'll announce in January. He'll have a tough primary fight on his hands, of course, and yet, come summer, come the L.A. convention, I think he could take the nomination on the first ballot."

"The first ballot," I repeated. "That's amazing." I realized I was exaggerating my surprise, as I sloshed in more scotch and left to get the ice. The party conventions next summer, politics in general, in fact, seemed rather remote to me. My own ambitions were in another world—to teach, to write about contemporary American art, Georgia O'Keeffe in particular, and the art of transcendence, what it meant, where it was going. Jack's passions were different, and he was about as different from my father as a man could be. My dad was a Yard cop at Harvard before he retired. Dennis Sullivan. I used to think he'd make a good cop in a musical comedy—red-faced, smiley. He always kept a metal whistle in his jacket pocket and a big black flashlight that he could have used as a truncheon if he'd had to, though he never did.

"God, I'm shot," Jack said as I gave him his drink. "Had to file that reaction story an hour ago, and I've got to take the red-eye

special back; I don't get into New York until five in the morning."

"Sounds tough," I said, but I was convinced that Jack was enjoying this assignment. He had always pushed himself hard, and after his wife died, he had thrown himself into his work, according to Margo, making infrequent visits to his little girls at their aunt's house, which seemed queer to me. I mean, my dad would have wanted to be with his children then. But, as I say, Jack is different.

"What about this journal you're writing for?" he demanded. "You like it?" He held me in his searchlight stare and I realized the interrogation period for the son-in-law had begun.

"Pretty well," I said. "I'm doing some teaching in the Art History Department too, you know. Great students. Some of them better than Harvard."

"Oh," he said and frowned down into his glass. "How's your father?" he asked and looked up again.

"He's fine," I said. "Sends his regards." Dad had walked right up to Jack at our wedding and started talking politics, aware of who Jack was, of course, but convinced that Denny Sullivan had insights he should hear on Cambridge politics, the police department, and baseball. My relationship with Jack was more complicated, of course. I had felt a certain awe when I first visited Margo's aunt's house in Cambridge. I remember sneaking looks at the photographs in the hallway of Jack with FDR, Jack shaking hands with Konrad Adenauer, and Jack holding his honorary degree outside the Harvard chapel. To an Irish Catholic kid from East Cambridge, it all looked pretty impressive.

"Like to see him again sometime."

"He'd like that too," I said, and thought of my father in his Barcalounger, a beer beside him, *The Cambridge Chronicle* spread out on his knees. I was the youngest of seven, and my parents were tired by the time they got to me. My three brothers had to go to a Catholic college, but when I got a scholarship to Harvard, my father didn't fuss. I knew my mother was secretly pleased; art was her love—paintings, museums—though she rarely saw it. When I announced later that I was going to do graduate work in Art History, my father rolled his eyes at the ceiling, but my mother flushed with excitement.

"I've got a lecture to finish," I said, and rose. "Class tomorrow

morning. I'll be back in a while. Okay?" I felt a little rude, but my exit was planned. Margo had asked me before Jack's arrival whether she should talk to her father about her depression. The question seemed sad to me. If I wanted to talk to my dad about something, I'd just go ahead and do it. I mean, I don't talk Art History with him, or... and yet Dad's my good friend. But Jack.... Still, maybe he could help her, I thought, as I settled down at my desk.

My study was a narrow glassed-in porch that adjoined the living room. I'd warned Margo that they wouldn't be really private since the door didn't close completely.

"I don't care," Margo had said. "There's nothing I'm going to tell him that I haven't told you at least eighteen times."

I pulled out the folder with my notes for the next day's lecture and began going through them. I was absorbed in the job when I heard Jack ask, "Things are okay with you, are they?" I raised my head, wondering what Margo would answer.

"Well, not quite," she began. "I'm having kind of a struggle. I don't know why."

"What do you mean, struggle?" Jack asked.

"I don't know. I can't seem to get myself organized. I got one good commission, then they canceled. But I think I can get others. It's just...."

I heard Jack's cough and I looked back at my notes, but listened again when I heard his voice. "I don't see your problem. Seems to me you've got a good situation here. The place, the kids, Terry." There was a pause. "Is it something between the two of you?"

I listened, feeling my fingers tighten on the pencil I was holding.

"Oh no. It's nothing like that. It's... it's...."

"Well, if you think you can get some more commissions," Jack said, "then you've got your work started. Right?"

"Sort of," Margo said. "I mean, I think I've got some possibilities and.... I've got a room up in the attic that makes a good studio, but...." I rolled a sheet of paper into the typewriter and banged out the title of the lecture. I knew I shouldn't be listening, but I kept hearing Margo's phrases. "Overwhelmed somehow. ...Dragged down.... Stupid. I hate myself for it. We're here in beautiful California, where I wanted to be, and yet...."

28

I heard Jack cough again. "I know something about depression myself," he said. "It's a bitch. Never really solved it either. Try one thing, try another. Sometimes the best tactic is just to turn on it and give it some fight."

"Fight." I heard Margo repeat the word in a breathy voice, as if her father had just tossed her some magical pill. "You're right, Daddy. Fight. That's what I've got to do." I looked back at my notes, uneasy once again about my eavesdropping. The voices murmured on, then I heard Margo say, "Dr. Ross, Mikey's pediatrician, thinks maybe I should see a psychiatrist. He says it needn't be anything long term, you know. Just one or two talks maybe. But I don't know. Do you think seeing a doctor makes any sense?"

"A psychiatrist?" Jack asked. I imagined him staring down into his drink. "Well, yes. Maybe. I went to see one myself years ago."

"You did?" Margo said. "You saw a psychiatrist?"

"Yes. It was a bad time—the year your mother died. I was broken up, of course, but there was more.... There was...." He stopped. "The guy was pretty bright, though I didn't think so at first. I thought he was a phony; I hated going." There was a pause. I heard Jack rise and cross the room again. He had probably splashed some more scotch into his glass. "It was peculiar," Jack continued. "Something happened, something began to work. I can't tell you what it was or how. I'm not even sure the doctor had much to do with it. But I felt better; I began to let go of some of the old guilts that were paralyzing me." I looked back at my typewriter and began on the study questions. A few minutes later Jack's voice took on a concerned tone and I listened again.

"Maybe you oughta give this psychiatry some thought, Marg," he said. "I'm sure there're plenty of charlatans in the profession, but that's true anywhere you turn, God knows. If you trust this fellow, this Dr. Ross, why don't you see what he can come up with in the way of some referrals."

"It's expensive," Margo said. "Thirty dollars an hour and I'd probably have to pay a babysitter too. If I could do the whole thing in two appointments, maybe, but...."

"You can't. I'll guarantee you that. You've gotta give it a month or two anyway."

"I just hate to start in on more medical bills after Mikey,"

Margo went on. "You see I've got a lot of the living expenses figured out. I mean, the rent's really low here. The owners are in Europe and they didn't want to do repairs. The house is kind of a mess in spots, but... and I've got a neighbor I exchange baby sitting with and.... Well, actually that's not perfect, but if I could begin selling portraits again and...."

"Suppose I were to pay for this," Jack said. "How about that? You send the bills to me. Or would Terry object?"

I waited, listening with a hot concentration now. "Oh, he'd object," Margo said. "I'm sure he would. He feels taking money from my family is weak, almost corrupt." Is that what I'd said, I wondered?

"Well, if he won't, he won't," Jack mumbled. I frowned at the typewriter. "Hey, puss. Come here," I heard him call out. Our elderly gray cat must have entered the living room, I thought, and was probably staring up at him, aloof and delicate on her white paws. Margo had told me how her father used to relate to the various cats and dogs of her childhood far more easily than to his human family. He would come home from a long day and stand in the front hall, whistling first for the dogs. He would stoop and scratch their stomachs, pull their ears, and talk to them awhile, then straighten finally to greet his wife, his children. "California agreeing with you, Mabel?" he asked. He remembered the cat's name, I noted, but had hesitated earlier with Laura, uncertain whether his granddaughter was Laura or Lisa.

"What's the deal with this *Portfolio*?" he asked. "Is the editor a guy named Kurt Wolfe, by any chance, who ran some kind of arty mag in the Village a few years back?"

"I think so," Margo said. "I've only met him once. Terry thinks he's brilliant, but kind of erratic and...." I frowned and looked back at the lecture notes. Kurt was plenty erratic, but I was lucky to have found that job. I began typing again, ignoring the voices beyond me.

"Depression isn't like you, Marg." Jack's voice was louder and I suspected he'd crossed the room again. "Now if it were your sister or.... But you've always been a damned hard worker. You've got some discipline. You've kept your painting going despite those kids. Listen, how's Liz anyway? I never hear from her back in New York; we live in different worlds. She's a good

actress, though. I saw her in a play last summer, some Arthur Miller thing. I forget what it's called. Salem witch trials, the whole McCarthy business." He paused, then asked, "What age is your sister now, anyway?"

"Well, I'm twenty-eight, so she's twenty-six," I heard Margo tell him. I sighed and began typing again. I didn't look up until I heard Jack exclaim, "Hey, my God, it's almost ten. I've got to make that New York flight." I heard his cough again and then his footsteps as he crossed the room. "Where the hell's that damn taxi anyway?"

I'd offered to drive Jack to the airport, but he had insisted on ordering a taxi and I was grateful. I still had a lot of work to do before class the next day. I rose and went back into the living room. "I'll call again," I said, but the beep of a car horn rose from the street below. I went to the window and peered down. "There it is," I told him. "Right on time."

Jack slapped his hat on his head and took his briefcase from the chair. He turned and swept the room with a long glance. "Take care of yourself, puss." He nodded at Mabel, who had folded herself together on the back of the couch. "Thanks for supper. Good to see you again." He pushed his large hand out to me, as though I were some reporter he'd known years ago and not too well either. He slapped Margo's shoulder. "Call me if you want anything. Hear?" The offer seemed awkward; after all, he had been out of touch for months, but I saw tears in Margo's eyes.

"Sure, Daddy." Her voice shook. "Come back soon." We stood in the doorway together, watching as Jack leaned forward a moment in the lighted cab to give directions. He tossed a cigarette from the open window; it fell through the darkness like a tiny red flare. Then the overhead light went out, the tail lights gleamed, and the cab disappeared down the street. Margo got busy on the dishes and I went back to the study. When I went into the kitchen later, the sharp smell of bleach rushed toward me; Margo was scrubbing the sink.

"You're doing a major job," I said. "The porcelain, all the counters."

She looked up at me and sucked in her breath with an audible sound. "I thought you were Daddy," she said. "I thought he was

in that doorway, watching me." I felt a chill run down my back, but it was natural she'd be thinking of her father, I told myself. "He said I should put some fight in it." She looked around the kitchen and back at me. "He's probably on the plane right now, working on his article about Senator Kennedy's speech."

"Honey, he had to file that this afternoon before he came over here. He told us he had. Remember?"

"Oh," Margo said. "Well, he's probably working on something else then. Reading up on campaign politics or...." She looked down at the gritty white surface below her. "But I'm only cleaning the sink." She straightened all at once, threw back her braid, and fixed me with a fierce gaze. "But don't worry. The mess in the house isn't the only thing I'm going to fight. I'm going to plunge into my work and fight hard on that too. I'm going to finish that portrait of Mom and it's going to be good. Very good, see?" I nodded and dug my hands into my pockets. "Daddy saw a psychiatrist once," she told me. "He offered to pay, if I wanted to see one." She paused and twisted the towel. "But I don't," she said. "I'm going to do this myself."

She pushed the towel over the rung and moved close to me. "I am," she whispered. "I'm going to fight with everything I have." She lowered her head against my chest.

"Good." I said and put my arms around her. "You're going to be fine." But was she, I wondered, as I felt her tears dampen my shirt. I thought of that point system in the notebook, of her tension, and her gloomy assessment of her situation to her father. Maybe she did need help. Maybe I should let Jack pay. Or could she fight this thing alone?

Chapter 3

MARGO

TWO more weeks slid by. I hadn't called Dr. Ross, but I hadn't gotten myself organized either. I was late picking up Terry one afternoon at the Art building; I could see him waiting by the curb, holding his bulging briefcase, its torn zipper hanging down. "I'm sorry," I called out. "Mikey had his check-up with Dr. Ross and...."

"S'okay." He shoved the briefcase in back and tickled Laura in her car seat. "Did the doctor say you were okay, Mister Man?" He tousled Mikey's hair. "Did he say your rash is better?"

"He's fine," I answered for Mikey and slid over so that Terry could get in behind the wheel. "We don't have to go back until January."

"What's for supper?" Terry asked as he shifted into drive. "I had a committee meeting right after my second class, and I didn't have time for lunch."

"I'm not quite sure," I started and looked down at my shoes in the dimness. "I mean, I didn't go to market. I sort of thought I'd use that left-over chicken and...." I let my voice trail.

"Want to go out then?"

"We just did Tuesday."

"Well, let's go to Brock's. It's on the way home."

"I don't want to go to Brock's," Mikey whined from the back seat. "Go home, Daddy. Please. I want to see *Leave It To*

33

Beaver." I winced; Mikey's growing dependence on television was clearly my fault.

"It's expensive to keep eating out," I began.

"We can have hot dogs, Mummy."

"No, we can't," I snapped. "We haven't got any more."

"Let's go to Brock's then." Terry's voice was cheerful, but I knew that disciplined sound. He had been up until two, working on an article for *Portfolio* and then he'd had this meeting today and he had more class preparation tonight.

A sprinkler rocked back and forth on a green slope beyond us, shooting its long curving rays across the shadowy grass. A bicyclist with a bookbag on his back swerved to avoid the spray. I looked down the avenue of academic buildings; their gray stone sides were washed with pink in the soft evening light. Near the campus gates, some dark palm fronds jutted up against the red-streaked sky. This was California, our great adventure, but when would I see it? When would I lift out of my grayness and respond? We moved into the traffic and down the cluttered highway with its car dealers, rug stores, and furniture marts. The restaurant sign rose on our right, the large red letters blinking in the evening light: Brock's. Eat. E-A-T.

"I'm going to feed the pigeons," Mikey announced shortly after our orders came; he lifted his half-eaten hamburger from the plate.

"But you haven't finished," I protested. "You have to eat more than that." Mikey looked at me for a long minute, wiped some catsup from his mouth with the back of his hand and slid down from the plastic-covered bench.

"I want to go too," Laura whined and raised her arms to be lifted out of the restaurant highchair at the end of the table.

I glanced from one to the other. "Just for a minute," I said and made my voice stern to mask my lack of control. I peered beyond Mikey to the bird-spattered patio outside, where they had fed the pigeons before. I could keep them in view, I thought, as I lifted Laura down. "Stay together now." I handed Laura a piece of bread from the wicker basket and watched as she followed her brother between the tables to the half-open doors.

I looked across at Terry in our sudden aloneness and sighed. "Dr. Ross talked to me again this afternoon about seeing a psychiatrist," I began.

"Oh?" Terry pulled the catsup toward him. "What do you think of the idea now?" I sat silent feeling the seconds pass, as he picked at the rubbery rim around the top of the bottle.

"I don't know," I said. "I don't know."

"If your father paid," Terry began, "we could treat it as a long-term loan or...."

I stared at the gray half-circles beneath his eyes, the long creases that sloped downward on either side of his mouth. Were we so old already at twenty-eight and twenty-nine? "A psychiatrist can't market for me, can't make supper, can't tell me when to paint. I've got to do this stuff myself. Don't you see?" I scratched at a scab of food on the table top. A tear started down my cheek; I snuffled and pulled a Kleenex from my pocketbook.

"Will that be all, sir?" The waitress stood next to the highchair. I felt her eyes sweep over me as she pulled a pad out of the pocket of her short white apron.

"Yes, thanks," Terry answered. "We just need the check." He waited until the girl had retreated, then said, "I talked to Kurt about you yesterday." He paused. "I thought it might be helpful to...."

"Kurt?" My voice rose. "But I barely know Kurt. We've only met a few times and...."

"I know, but he's very knowledgeable about psychiatry. He studied in Austria before he went into publishing, you know. I told him you'd been depressed this fall, that you felt behind with your work and kind of exhausted. He thinks some psychiatry could be helpful—nothing long and drawn-out." Terry waited for me to respond, but I waited too. "I needed to talk to someone, Marg," Terry said finally. His brown eyes looked serious, pleading. "Can't you understand that? Kurt knows a lot and...."

"But I don't know him," I whined, then stopped. My husband was scared, I realized all at once, scared and lonely. Of course, he had to talk. And Kurt was his friend here, the person he knew best in our new California world. I wiped my nose and looked back at Terry. He was peering down at the bill the waitress had brought.

"Do you have any quarters?" he asked.

I pulled my change purse from my pocketbook. What if I took out a gun instead and aimed it at my temple? "That woman shot

herself," someone would scream. "Call an ambulance. Quick." The noise of the siren would tear through the soft darkness outside, while the red lights continued to blink—Brock's. Eat. E-A-T. I put the change on the table and raised both hands to my face to push back the fantasy. "She's bleeding," the voice yelled. "The bullet went right into her head." Stop, I told myself. Stop.

I saw Laura making her way toward us between the tables and for an instant I thought, Laura will help me, Laura will smooth it away. But her face was tense with some urgency. "Mikey's gone," she wailed. "He got mad waiting."

"What?" Terry pushed the bills and change into a mound on the table. "Which way did he go?" He picked up Laura and hurried toward the door. I stuffed my arms into my coat, grabbed my pocketbook, and followed.

It was cold outside, and suddenly dark. I rushed to the parking lot after Terry and paused a moment to survey the rows of cars. Just as we stood there trying to decide which direction to take, a young woman rose and waved from the curb. "Hey, Terry," she called out. "There's somebody over here you know." Terry ran toward her, Laura jouncing in his arms. I caught up with him and stood staring at a tall girl standing beside a large black motorcycle. Mikey was stooped down, peering at the front wheel.

"Susan," Terry panted. "Mikey. My God." He looked from one to the other. "How did you know . . . ?" Terry stared at the girl, then moved over to put his hand on Mikey's shoulder.

"Mikey," I began. "Mikey. You mustn't . . . you. . . . "

"How did you know he was ours?" Terry demanded.

"He looks exactly like you for starters. Two handsome Irishmen," the girl said with a teasing smile. "Besides he told me his name was Sullivan."

"This is Susan Burrows," Terry explained, introducing me. "The copy editor and general administrator at *Portfolio*."

"Oh," I said. "Wonderful. Thank you for finding Mikey and. . . ."

"He found me," Susan explained. "He wanted a ride on my motorcycle."

"Can I, Dad? Please. She said I could."

"We'll see. Not now," Terry told him.

"You did a serious thing, Mikey," I started. "You can't just run off like that and. . . . "

"Is this yours?" Terry pointed to the motorcycle. I felt threats and punishments churning within me as I glanced from my husband to my son. The girl was wearing tight dark pants pushed down into high boots and her blonde hair was wrapped in a bright blue scarf. I wished all at once that I had put on some lipstick in the restaurant and that I wasn't wearing my old gray coat.

"It's all mine, except for the payments," Susan said with a laugh. "I told you I was going to do this. Don't you remember?" She gave Terry another teasing look.

"I didn't believe you, but it's terrific," Terry said. He put Laura down and moved close to the motorcycle. "I see why you wanted to go for a ride, Mikey." He leaned over and ran one hand along the gleaming handlebars.

"Mikey, I told you specifically to stay on that patio." My voice rose in a whine; I was alone on the sidewalk.

"It's brand new," Susan said. "I just bought it Monday. What do you think of these saddlebags and how about this leather seat?"

"Wonderful," Terry said. "What kind of acceleration do you get?" He enclosed the black grips at either end of the handlebars in his hands.

"Oh, the acceleration's great," the girl said. I watched her point to a dial in front. Mikey shouldn't leave like that, I fumed; it was dangerous. He should be reprimanded now. But I was studying Susan's buttocks in her pants, her short black jacket and the silk scarf. What was her full name? Susan . . . Susan Barrows or . . . ? Could she tell that I hadn't fixed dinner for my family? Could she tell that I was a mess? She threw one leg over the wide leather seat, settled her feet on the foot holders, and tipped back her head.

"God, that looks like fun," Terry said. "Will you take me for a ride someday?"

"Sure." Susan laughed. "You and Mikey too, if you want. I've got a date now. But how about next week sometime?" Terry smiled and agreed. Laura reached for my hand as the roar of the motorcycle filled the parking lot. "Bye," Susan yelled. "See you." The single headlight gleamed in the darkness, then swung away from us and out into the traffic.

37

I strapped Laura into her babyseat in back, and Mikey climbed into his. "You mustn't wander off that way, Mikey," I started.

"I wasn't," he said. "I was leaving."

I twisted to look back at him from the front seat. "Leaving?" I repeated. "Mikey said he was leaving," I told Terry as he turned out onto the highway.

Terry gave a short sigh and glanced back at Mikey. "We all want to leave sometimes, Mister Man," he said. "But we can't, you know. We have to stay. You tell me next time you think about leaving. All right?"

"All right," Mikey mumbled and turned to the window. He wanted to leave because of me, I thought, and stared at the glowing dials on the dashboard. We were a family closed into this intimate space of the car, two children and a husband and I was failing them all.

"Susan's a very pretty girl," I said. "She has a lot of style. It's sort of unusual for a girl to buy herself a motorcycle, don't you think?"

"I guess." Terry slowed for a traffic light.

"You must feel sick of me and all my mess when you see someone bright and lively like that." I waited, but Terry did not comment. "I suppose you think of divorce. I would."

"Oh, Christ, Margo. Cut it out, will you?" The sound of his anger vibrated in the car. I should turn and reassure the children, I thought. Scary things were pressing in around us—Mikey's attempt to escape, Terry's anger, my selfishness—but I continued to stare out at the highway instead. Carpet Land rose up on our right and beyond it a store called Ken's, which was having a tire sale. Another car dealer's passed; its fluorescent lights lit an empty office with a lonely blue.

"I'm going to see a psychiatrist," I announced, and clutched my arms around me. "I'll call Dr. Ross tomorrow morning and get those names. We'll just let Daddy pay. All right?" Terry turned his face toward me in the dimness and I saw him nod. "I've got to do something," I whispered. "I'm not getting anywhere now."

The naugahyde cushion on the waiting room couch sighed beneath me as I settled on it and crossed my legs. *Life*, *Look*, and *Time* were arranged in the same overlapping rows on the low

table in front of me, although other hands must have fingered them since I had been here a week ago. Three sessions. Thirty times three plus bus fare, and it wasn't helping. This process was doing nothing at all. I stared down at the rug. That spread of vacuumed gray-green nap with its slight medicinal smell was a sign to entering patients, I thought; pain must be packaged here. No torrential tears were permitted, no loud complaints.

I sighed. Three weeks ago I had half-believed that Dr. Bauder might touch my life in some magic way, lighting it all at once, dissolving the fog. I didn't believe that now; I was only marking time here until the grayness lifted at last and I was myself again. But when would that happen? When? I was wading deeper and deeper into humiliation, falsity, mess, abandoning all dignity and self.

The door opened. "Mrs. Sullivan." The doctor's voice was cool. Her usual manner, I wondered, or did she feel a particular disgust for me today? "Come in, please."

I settled into the chair beside her desk and ran my fingers over the row of brass bumps along the arm. Three times thirty, plus.... If she were a he, a doctor more like Dr. Ross, or.... But there were many women psychiatrists now. I gazed around the familiar office. Oh God, this wasn't helping. I must end it, and soon.

"How are things today?" The doctor asked and placed her elbows on the blotter. I glanced down, irritated by the condescending lilt of her voice. Maybe her coolness was a defense against inexperience. Dr. Ross had explained that Dr. Bauder had not been practicing long.

"About the same, I guess." I reviewed my mental list of complaints in silence: Mikey's rash, Terry's fatigue, my painting, my painting. Why couldn't I paint? Was Dr. Bauder as bored with my case as I was? "My sister's coming to San Francisco in December," I announced and swallowed. Why start there? That was almost a month away.

"And how do you feel about her arrival?" Dr. Bauder leaned forward slightly.

"My sister?" The subject of Liz opened before me like a bright nest of light among dark branches. I thought of us sitting on the couch in our nightgowns last summer, talking together in the

early morning, of Liz laughing, as she leaned close to the bathroom mirror, to poke the wire of a dangling earring into her pierced lobe. Liz must not see me like this; I had to get back my energy, my sense of self before she arrived. "I'm glad she's coming," I said. "It's great for her. The Actors' Workshop here is doing *The Crucible*. Liz has one of the leads. She did it in New Haven last summer and...." Dr. Bauder sat forward; I could feel her watching eyes. "You see, we're quite different really. Liz is an actress, and a costume designer too. I got married and she hasn't yet. I mean...."

"Do you get along well?" The doctor tipped her linked hands, displaying her bright fingernails. This new subject was clearly more interesting to her than my usual list of complaints.

"Yes. We've always been close," I told her. "Of course, I was the older sister, the bossy one. I tried to be responsible and.... I don't know. Sometimes I feel sort of threatened by Liz's way of life."

"Threatened?" The doctor's voice rose slightly. "How?" I glanced at the clock on the bookshelf with its spindly ornamental legs. At some point during each session, I mentally snipped off those legs and set the clock down firmly on the white-painted shelf. I snipped and looked at the clock face. Almost ten minutes were gone.

"I don't really mean threatened," I said. "Being the only children, we were together a lot." I paused. How could I circle back to my present life—the guilt, the mess, the feeling of waste? "Liz's always been the bright, funny one. I guess I've been jealous of her in ways."

"What ways?" Dr. Bauder asked and touched the pearl circlet at her throat with a long forefinger. She had trapped me into this, damn her. She was leading me into an area she wanted to hear about, but it was not one of the problems I needed to solve.

"Sisters frequently feel a natural rivalry, you know," Dr. Bauder announced.

"I suppose you're referring to our Oedipal situation." I drew in my breath, startled at my sudden boldness. "You're assuming that we were both in love with my father." I waited, feeling my face grow hot, but the doctor waited too. I sighed finally and looked down at my hands. "I'm sure my relationship with my sister is important," I said. "She and I went to live with my aunt and

uncle after Mom died. We were together a lot, although we liked our cousins. Liz could be wild at times, but I could always depend on her when things got tough." I glanced back at the clock with its claws. What could I tell this woman about my sister, the person with whom I had shared most of my life?

"We used to pick blueberries together in the summer," I began. I saw the long driveway in Essex, the shaggy meadow on the left, edged with wild cherry and old apple trees. The blueberry bushes that grew among the scrub juniper were tangled with cat's paw vine, which tore at our jeans and left red scratches on our arms. "My aunt and uncle had a place north of Boston where we spent summers—I must have mentioned it. Liz always picked faster than I did. She'd fill her pan first, but she'd always mix in green berries and leaves that we had to sort out later."

"You resented your sister's sloppiness then?"

"Not really," I said. I felt the warm sun on our shoulders and heard the heavy hum of a greenfly in the weeds nearby, then the pinging noise as the first berries hit the bottom of the pan. Later we would lean against the soapstone sink in the kitchen and gasp as cold Coca-Cola exploded in our mouths and dots of light swam before our eyes. We would press the damp green bottles to the wet valleys between our breasts, then lift them and peer in at our sweaty bras—secret badges of our new womanhood.

"But you feel you were the one who took responsibility, who carried through. Isn't that right? Your sister tends toward carelessness, perhaps."

"No. No, I didn't mean that. Liz is very loyal, very understanding. We've been through so much together...." I thought of Liz and me swinging slowly in the hammock on summer evenings as the fireflies made dots of orange above the peony bed. I could hear the groan of the rope creaking in the metal ring on the wall; I could see the vague sheen of Liz's forehead opposite, coated with Pond's face cream. I could smell our magnolia blossom perfume, wrapping us in its heavy sweetness, while we talked of boys and teachers, of Van Johnson and Gregory Peck, and the bright red formal with its wide shoulder straps that we would take turns wearing to dances in the fall. Beyond us the darkness deepened over the rose garden, and the mourning dove ceased her comfortable complaining in the willow tree.

"The older sibling often feels threatened by the bright, younger one," the doctor said.

"Threatened? Was that my word?" I paused. "I've needed my sister. I need her now and yet.... I don't want her to see me this way. I have to...."

"Sibling rivalry can go very deep," the doctor said.

"But so does sibling love." I heard my voice shake.

"We need to examine this relationship further." The doctor placed her hands, palms down on the blotter. The signal startled me and I glanced back at the clock. But she was right; the fifty minute hour was over and I had wasted it with talk of Liz, dreaming of Essex summers, evading the mess of my present life. I had not gotten the help I needed; I had not even mentioned my intention to end this expensive, ambiguous process.

"I've exaggerated my uneasiness about my sister," I started. "I'm really delighted she's coming." I pulled the twisted strap of my pocketbook over my shoulder and struggled up from the chair. "I didn't mean to imply...." But my time was over; the doctor was standing. Why had I spread out those intimate sun-warmed memories in this impersonal place? Why hadn't I told her that this treatment was not working, that I would not be back again?

MIKEY

I don't like California; it's boring. If Fritzi were here.... If he could visit.... If I could go home to Cambridge and see him.... I could hitchhike, the way Dad used to do or.... I wish I were grown up. I wish I didn't have to stay here all the time.

NANCY

I was annoyed yesterday when Margo was late picking up Mikey and Laura. She'd told me that she had to return some curtains at the Emporium. "That department store must be jammed this afternoon," I said, "if it takes you three hours to return a pair of curtains."

Margo glanced up at the Revere Ware pots and squeezed her hands together, then she looked across at me. "The curtains were

a lie," she said. "I've been seeing a psychiatrist. Today was my third time." I stared. I've never known anyone who went to a psychiatrist, at least nobody I knew well. "I thought it would help," she added and sighed. "But it hasn't."

I crossed my arms over my chest and drew in my breath. It was perfectly obvious to me that if Margo would just do some of the jobs she kept complaining about, she'd feel better. She still hadn't unpacked completely, and that garage was a mess with all those boxes and crumpled newspapers—a fire hazard really—and. . . .

"You know sometimes if you just buckle down and get a few things done, it makes you feel better." I waited, but Margo didn't reply. "Haven't you ever heard of will power?" I asked. "It can be a lot more effective than some fancy doctor, and a lot cheaper too." I waited once more, but Margo just stood there squeezing one hand with the other. A fancy psychiatrist, I thought. That was plain self-indulgence. "It's just a matter of will power," I said again.

Margo gave a queer, high laugh and gazed up at the ceiling. "Oh God, Nancy," she said. "That's what I've been telling myself for weeks, but I can't find that thing you call will power. I don't seem to have any left."

TERRY

Kurt and I were eating our lunch at the layout table in the *Portfolio* office one noon, when a question that had been burning inside me spurted from my mouth. "How long does the treatment for an ordinary neurosis take?" I studied the remaining crust of my bologna sandwich lying on its wax paper wrapping, then added, "I mean, how long until the patient gets some relief?" I hadn't mentioned Margo's problems to Kurt since our talk six weeks ago about whether she should see a psychiatrist, but all at once my questions felt urgent. Margo had announced last night that she wanted to end her treatment, although she had only been seeing the doctor a month. I felt uneasy talking about her to Kurt again, but I needed to air stuff, dammit; I needed advice. Margo wasn't the only problem, either. I'd been naive about the possibility of an appointment at the University soon, or ever maybe, since the candidates they

were considering sounded a lot more qualified. I liked Kurt, admired him in a lot of ways. He was brilliant, but he was exploitative too; he had a habit of snatching up ideas, mine and other people's, and shaping them for his own use. And Berkeley? The dry fall days without rain went on and on, and the wail of fire engines in the hills above us had become a familiar sound at night. Our California adventure was not turning out the way we had envisioned.

"Treatment time?" Kurt said, and drained his coffee mug. "Depends on which of the neuroses you're talking about." He paused. "I'd hardly call Margo's situation ordinary myself. She has a rather remarkable talent. I was fascinated by that portrait of her mother. Has she finished it yet?" I shook my head. Kurt had an instinct for the heart of the problem. He had come to lunch Sunday and had insisted on going upstairs to visit Margo's studio. I had thought for weeks that if Margo could only get going on her painting again, she would feel better, and might not need psychiatry at all. "She ought to get that picture done and shown," Kurt said. "There are several galleries in San Francisco that put on regular portrait shows. Besides, Margo is a beautiful woman, you know." He smoothed his beard, then pulled at it slowly. I stared at Kurt. What the hell did Margo's looks have to do with it? "Do you have a diagnosis yet?" he asked.

"Depression," I said, and crumpled the wax paper from my sandwich into a ball. "I mean, the doctor's spoken of manic-depressive patterns, apparently, but so far it's just depression, as far as I can tell."

"Hey, Kurt." Susan hurried into the room, clutching a stack of papers. "The printer just delivered these." She moved Kurt's coffee mug to one side and spread the proof sheets on the table. "What do you think?" She pulled herself up on the high stool next to me. "Do you like these section divisions?" Her perfume rose up around me as she reached over to point at the swirls in the middle of the page. "What about those double lines?" She leaned forward and I realized that, in the darkness under the table, her knee was pressing against my thigh. I glanced across at Kurt, but did not pull back. Was the movement intentional or accidental? I couldn't tell. The warm steady pressure continued; I didn't move. I thought of Susan's blue scarf, her motorcycle.

"It's the same format as last month. It's what I told him to do."

Kurt turned back to me. "Manic-depression is common among women in their late twenties and thirties," he went on. I glanced at Susan. Did she know we were talking about my wife? Her blonde hair swung down over the page proofs. She pushed it back behind her ear and turned one sheet face down, then another. My leg had begun to tremble, but I held still, hot, guilty, yet determined not to draw back as long as her knee was there.

Kurt glanced up at her. "Get going on these right away," he said. "We've only got until Friday." Susan stood; the sudden absence of her knee saddened me. "Let's see if you can do some real copy editing this time for a change."

I glanced from Kurt to Susan and back to Kurt again. What was going on? I thought they were living together. Had Kurt grown tired of her? Was she making a play for me in revenge? She stood clutching the sheaf of papers to her breasts.

"Okay," she said and turned, then turned back again. "Hey. The Actors' Workshop's doing *The Crucible*, that Arthur Miller play. I just saw a poster. It opens in January."

"My sister-in-law's got the lead," I announced, important all at once.

"She has? Would she get us free tickets, do you think?"

Kurt gave Susan a stern look, then turned back to me. "That's Margo's sister Elizabeth, isn't it?" I nodded, surprised that he had gathered that information. "Hmmm," Kurt said. "So she's going to be Elizabeth in *The Crucible* is she? Very fitting, it would seem. When does she get here?"

"A couple of weeks, I think." I hesitated, feeling Susan's eyes. She was definitely avoiding Kurt's, I decided, as I watched her leave the room.

"It's really impossible to predict the length of treatment," Kurt went on, as though there had been no interruption in our talk. "I'd give her six or seven months anyway."

Six or seven months. I stared down at the paper ball in my fist. That was a damn long time. Kurt brought out his tobacco pouch and began tamping the brown, sharp-smelling shreds down into the bowl of his pipe. I watched. He was unreadable, not really a friend. So he was through with Susan, was he? But how did Susan feel about him, and how did she feel about me, I thought, me, a married man working two part-time jobs with a wife

locked into a long psychiatric treatment? And how did I feel, I asked myself? Mad, I realized. Mad and frustrated. Then I thought of Margo, of her gloom, her sadness, and guilt poured in. Oh God. I squeezed the paper ball and threw it at the trash can; it missed and fell on the floor.

Chapter 4

MARGO

I WOKE to the unfamiliar sound of rain in the night—a wet rushing in the drainpipe outside the bedroom window. The long dry season is over at last, I thought, and curled back into sleep.

As I hurried down the sidewalk the next morning to catch the bus for my appointment with Dr. Bauder, I noticed that the earth was dark and muddy at the edges of the parking strip. Tiny droplets clung to the flat, pink flowers on the oleander bushes, and the dusty yellow fog, which had hung over the hills since late September, was gone. I tipped back my head; the sky was a new, washed blue. Beyond me, the tiled roof of a Spanish stucco house gleamed with a vivid umber color in the new wetness. I had heard that the hills around Berkeley turned green almost overnight when the rains started. Maybe I would drive the children up to Tilden Park in the afternoon and take my watercolors along. I stopped and looked around me, startled; that was the first time in weeks that I'd thought spontaneously of painting.

I waited beside the bus stop sign near a large eucalyptus tree. Curling strips of bark swung down from its shaggy trunk. A breeze made the gray leaves tremble, sprinkling drops on my hair. Smells were all around me, I realized, eucalyptus, rosemary, and a hint of breakfast sausage from a house nearby. The bus roared up; its door slammed open. I climbed the steps, settled myself on the side bench behind the driver, and looked around. The faces of the other passengers seemed to reflect the relief of the night rains too, I

thought. An Oriental woman in a brown coat met my eyes for a moment and smiled. We rattled along, stopping, then starting up again. When we reached the bridge, I gazed out toward the city. The glass side of a skyscraper was shining, and beyond it the metal frame of a half-finished building glinted in the sun. I twisted to watch a gull dip down over the crinkled water. How beautiful it was. I swallowed. My mouth felt dry and a pulse had begun to throb in my temple. I turned and stared back at Berkeley. The terraced houses with their red-tiled roofs were bright against the hills and below them, I could see the Campanile spire. Up at the right was the Claremont Hotel and somewhere below it was our house, I thought. I swallowed again; my jaws ached. It was beautiful, and I was seeing it at last.

I turned back to the Oriental woman. "It's there," I wanted to tell her. "It didn't stop in the long weeks of my grayness—it's still there." A man sat forward, his face hidden by the tented newspaper he held in front of him. BAKER PREDICTS GIANTS COMEBACK, announced a sports headline. That was it, I thought. My own giant comeback was beginning. Somewhere I had known it would happen, and it had. I had not slammed a bullet through my head or jumped from a car. I was alive; the rains had swept away my grayness, and I was back in life again.

I swallowed and put my hand to my jaw. I must find something to drink in the bus terminal before I started up the street to Dr. Bauder's office. "I've got wonderful news," I imagined announcing to Terry from a pay phone. "I'm better. I'm well at last." The bus entered the underpass before the terminal. No. I would not call yet. It might not continue. But if it does, I thought, I'll be well for Christmas. I'll start shopping today, planning, filling the house with Christmas excitement and my own enormous relief that my depression is finally over.

Plans spilled through me as I waited to follow the others down the steps of the bus. I would go straight to the Emporium department store after Dr. Bauder. But I must call Nancy. She wouldn't mind keeping Mikey and Laura an extra hour. Once I had the big presents for the children, I must find a present for Liz—a sweater maybe. No. Some long dangling earrings. Then I would find a thank-you present for Nancy, a little gift to show my appreciation.

There was no drinking fountain in the bus station and a Coke would have taken too long. I stopped beside a souvenir stand and pulled off my jacket, surprised at how hot I felt. I folded it neatly, pulled my suit skirt straight, and bent to catch my reflection in the glass door ahead. My face looked oddly flushed and I could feel my pulse beating. It's excitement, I told myself, as I hurried toward the collection of pedestrians, waiting at the light to cross. Excitement.

The city spun and swirled around me. Taxi cabs rushed down Sutter Street, their yellow sides gleaming, and above me the multi-windowed buildings seemed to throb with life. I crossed to Union Square, where a cluster of pigeons was busy pecking at seeds in the damp grass. I gazed down at their feathered backs. Each was different. On some the designs of gray and black faded into lavender toward the tail, on others there were speckles that merged with white. A bell chimed from a nearby church. Life, I thought, so infinite, so various. I wanted to kneel or cross myself, but I hurried on.

I remembered my thirst as I sat down on the waiting room couch, but the ladies' room was on the lobby level and I had only two minutes before my appointment. I would get a drink of water when the hour was over, I told myself, and pressed my hands to my hot face. When I lifted them, the room seemed brighter than usual, welcoming in fact. A bar of sun lay on the rug, warming the green, so that it harmonized with the darker green of the plastic philodendron plant in the corner. I shook my head; how could this space that had once seemed gray and antiseptic, feel so serene and comfortable now?

"Margo?" Dr. Bauder stood in the doorway, slim and professional-looking in her black suit and pale blouse. I stared. She had said Margo, hadn't she, not Mrs. Sullivan; this was the first time. I rose, smiling. She had already detected the fact that I had changed even before we had talked. I followed her into the carpeted office, settled into the green leather chair beside her desk, and ran my fingers over the row of upholstery buttons.

"How are things today?" the doctor asked.

"Wonderful," I said. "Just wonderful." I sat forward and locked my hands around one knee. "I felt a little different when I started out this morning. I mean the rain, you know, and the

washed look of everything. Then something started to happen in the bus." I glanced around the office; it too seemed cleansed and filled with light. "It's lasted. I mean I'm all right. I'm well. I can start on Christmas. I've been making mental lists and. . . . You see I want to show the children right away that it's all right, that I'm back. I'll have to rush, of course. Liz's coming next weekend and. . . . Oh, we'll have a wonderful Christmas. Liz will be with us and. . . . It's so strange," I said, interrupting myself. "So sudden. It just happened in the bus really—without any warning or reason."

"Just happened?" Dr. Bauder repeated. She touched the pearl circlet at the neck of her blouse with one manicured finger.

"That's the way it feels," I said. "I mean, when I made breakfast, it seemed like any other morning: the old guilt, the usual gray routine. I didn't think I had anything particular to tell you."

"But you did, didn't you?" Dr. Bauder put both hands on the polished desk and leaned forward.

"You know, I think I'll invite Kurt, Terry's boss at *Portfolio*, for Christmas dinner. Terry's been feeling a little down about him, but Kurt's getting a divorce and he's lonely, I think. Of course, it's a lot to do fast, all the shopping, the decorating, the Christmas cards, and the cooking. But I can. I know I can. I've even got some ideas about my painting. I'm going to try some watercolors this afternoon in the park and. . . . " I paused. I must slow down; my rapid talk might alarm the doctor.

"Have you been having difficulty sleeping?" Dr. Bauder asked. "How did you sleep last night?"

"Fine. I mean, I woke before dawn this morning when I heard the rain. It was so strange—that sound and . . . but then I went right back to sleep." I smiled. Surely she was pleased that my depression had gone. I watched her gaze slide down to a stack of manila folders at the side of her desk. Maybe she felt a little confused by my brilliant upswing; most of her patients probably recovered more slowly. I might well be her first experience of such a rapid return.

She pulled out a folder and opened it.

"You're not taking any sleeping medication now." She turned over a page in the folder and looked back at me. "I think it would be wise to. . . . " She put down the folder, opened the center drawer of her desk, and drew out a prescription pad. "Sleep is crucial," she

said, as she wrote some words on the pad in a small, quick hand. "I'm prescribing a mild sleeping medication for you," she explained. "I want you to take one pill tonight before bed."

I stared. Could she steal this sudden energy from me with some kind of medicine? "But I really don't have trouble sleeping," I objected and paused. I took the prescription and folded the paper over. If I spoke more quietly, I could disguise the pounding within.

"We have achieved a change," Dr. Bauder began. I put one hand to my chin. We, I thought. "We have made some real gains," she continued. "But we have a great deal of work to do now before we understand what it is that has really happened, you see." I nodded. She wanted some credit for her treatment, her psychiatry. I smiled. Let her take it; I could afford to be generous now. I assumed an alert look as Dr. Bauder talked on, but I was rushing down my list. First I would find a red racer wagon for Mikey, then a stuffed animal for Laura, maybe. Goose would be festive for Christmas dinner, but it was greasy. I would make a plum pudding, I decided, and kept my eyebrows slightly raised, so that the doctor would think I was concentrating on what she was saying.

"As I explained last time, I'm not going to be able to see you next week," Dr. Bauder announced. "A professional conference, a paper I'm delivering." She looked down at the folders again. "I think it would be wise for you to see my colleague, Dr. Gray. He's here in this building on the fifth floor." She turned the prescription pad and I watched her write a name, then a number. She paused, crossed out the number and wrote another below. She was nervous, I thought, worried about her paper. "If you call Dr. Gray this afternoon, you can set up an appointment with him for next week."

"Do I really need to see him?" I began. "I mean I'd be glad to call him if something comes up or.... But you see, I feel so well now."

"I'm quite sure he can see you Tuesday," Dr. Bauder said. "I'll tell him to expect a call from you this afternoon." She touched her pearl circlet again. "Once you understand what has caused this depression, you can guard against a repetition."

"A repetition!" I sat forward with a jerk. "But it couldn't repeat itself. I wouldn't let it. I'd fight it off. I'd see it coming. I'd...."

"But if you don't understand why it happened," Dr. Bauder interrupted, "it *could* happen again."

"No. I couldn't go through this another time," I said and raised

my hands to my hot cheeks. "I couldn't do this to Terry, to the children. I couldn't live through this again. Really. I couldn't."

"Then, we must work to understand what creates these sudden swings within you, mustn't we, Margaret?" Margaret? I stared. She was nervous, I reminded myself again, as I watched her pat the folders into a neat rectangle. The paper, the conference—she had a lot on her mind. And yet maybe she was right. Maybe this clumsy process of psychiatry really had produced this change; maybe it was not as sudden and mysterious as it seemed. I stared down at the bamboo wastebasket. Perhaps these awkward sessions had achieved something after all. If so, I could not take the chance of abandoning them; I must work hard at this and keep on.

"There's so much happening now," I said. "My sister's coming, and I want to help her get settled in her new life here, meet people and. . . . Liz might enjoy Kurt, you know. I mean he's very interested in the theater." I glanced at the ornamental clock on top of the bookshelf, snipped off the legs, and set it firmly on the bookcase. "You see I feel I can get my life organized now. I have the energy, the will." I squeezed my hands together. "But I need your help. I mean, I see that now. I need it badly."

"You're right," Dr. Bauder said. "It's very important that you should continue your treatment."

"But. . . . " I stared at her and raked one stockinged knee with my fingers. "Is it really the psychiatry?" I paused, then raked the knee again. "I mean, what happened this morning seems bigger than psychiatry, somehow. It just doesn't seem like something rational. My whole body feels different in the last two hours—warm, lithe, pulsing. I don't mean to be disrespectful or. . . . " I clawed at my knee. "But this change just doesn't seem related to analysis."

"What else could produce it but psychiatry?" Dr. Bauder asked.

"I don't know." I ran my tongue over my lips, surprised at their dryness. "I don't know. It just seems so sudden, so amazing."

"Psychiatry is amazing at times." Dr. Bauder smiled and glanced at the clock. "You will experience other remarkable things before we're through."

I stared. Maybe she was right. "If psychiatry is what it takes to control this thing," I began, "I promise you, I'll work as hard at this as I've ever worked at anything in my life." I thought of art school and of my long nights in the studio before the opening of

my Cambridge show. "Harder," I added and heard my voice shake. "Much harder."

The doctor spread her hands palms down on the maroon blotter, the signal again. "I want you to call Dr. Gray tomorrow and set up that appointment for next week."

"All right," I said. "It seems sort of unnecessary, but...."

"I'll see you the following Tuesday as usual. Get that prescription filled at your drugstore and take one pill tonight before you go to bed."

I nodded obediently. "Fine," I said. "Fine."

The red wagon with its sturdy rubber wheels and shiny sides was exactly right for Mikey, I told myself, as I stood tapping my charga-plate on the counter. White letters spelled out "Radio" on one side and below it, "Flyer" in flowing script. I could see Mikey pulling toys across the living room or down the sidewalk to the Bensons'.

"They'll deliver it on Monday," the salesgirl said and smiled. "You have a Merry Christmas, now. You hear?"

"Oh, thank you. You too," I told her. "That wagon is going to make ours really merry. I know." My stretched smile trembled and my face felt hot.

> O little town of Bethlehem,
> How still we see thee lie.

The carol oozed through the store, spilling over the lines of shiny bicycles and scooters as I moved past.

> Above thy deep and dreamless sleep,
> The silent stars go by.

The electric organ music enveloped me, and I whispered the words of the next verse to myself as the melody began again.

> How silently, how silently,
> The wondrous gift is given....

That's what it was, a wondrous gift of life given back again—a miracle, like Christmas itself. A large brown bear blurred on the counter in front of me, and I raised one hand to wipe my eyes.

Would Laura like a bear? Perhaps. She did play with Bunchie, after all.

I turned from the row of animals to the dolls. They stood lined together within a glass case behind a counter, red-lipped and smiling, with staring eyes. Some had long hair and grown-up clothes, coats and dresses and tiny black shoes. Others were curly-haired babies in pink or blue sleepers with eyes that opened and shut. I bent to peer at a blonde doll in a blue embroidered dress; it was Joan, my own doll from years ago. She had the same small mouth, the same hinged eyelids and tiny, painted brows.

"May I help you?" a gray-haired saleswoman asked.

"Yes. I'd like to look at that curly-haired doll there." I pointed. "She looks so much like one I used to have."

"Oh, that's a classic," the woman said. She pushed back the sliding glass door and lifted the doll out of the case. "Excellent workmanship. You might well have had the same kind. This company's been making them for years." I held the doll in the crook of my arm and smoothed her dress.

"It's amazing," I said. "She really is exactly like a doll I had twenty years ago."

"She probably is," the woman said. "These cost a little more, of course. But they are such good toys when you compare them with all those cheap ones with things inside to make them talk or wet; those break so quickly."

I thought of Joan and Lucy in their matching beds—my doll and Liz's. They had been integral to our childhood, Margo and Liz, Joan and Lucy, the four of us together in the back seat of the car on trips, the four of us in the big canopied bed at night. Their dresses had faded, their baby faces had grown brittle and cracked, as they sat on bureaus or shelves, watching us turn into adolescents. Where were they now? I didn't know. Liz would be amazed to see this doll when she arrived.

"Nineteen-fifty, with the dress," the saleslady said. "And there's a darling little crocheted jacket and matching bonnet. They're extra, naturally." Twenty dollars for a doll? I frowned. But she was unique, full of my own past. The saleslady held out a little blue jacket, then fitted it on.

I moved toward the escalator, carrying the package. Laura loved to dress and undress her stuffed animals. Would she play with a

doll? It was so expensive, and I had bought the cap and jacket too. I imagined slitting open the Emporium bill, balance due, one hundred and twenty-five. One hundred and seventy-five? But it had been months since I had gotten any surprises for the children, and this was a Christmas we would all remember. Now Liz's present, I thought, as I stepped onto the escalator and gazed down at the shoppers below. How beautifully everything was working—first the wagon, then Joan. After I had found the right earrings for Liz, I would get Terry the recording he wanted of the Bach B Minor, and a bright Christmas tie. I paused beside a plaster model of a thin young woman, her head wrapped in a bright silk scarf. Susan? No wonder Terry thought her attractive. "How much are these?" I asked and pulled a blue scarf toward me. If Susan could look pretty, so could I.

MIKEY

A lot of mornings I wake up when it's still dark. There're animals out there in the yard—raccoons, possums sometimes. I know. Dad saw a deer up on Davenport Street beside a trash can. I wish a deer would come to our trash can some night. I'd watch at the window and see.

It's going to be Christmas soon, and what I know is, there's a lot of Santas, not just one. Me and Dad saw a Santa Claus walking down Sacramento Street; he went right into the drug store; he was thin with black hair. But the Santa at the Emporium was really fat and his beard was all curly. There's lots of different Santas; that's the thing.

I went downstairs early because I heard somebody in the living room. If it was a robber, I'd call my Dad, but it was just Mom. The sleeves of her bathrobe were rolled up and she had all these books stacked around her. The room looked funny with just the ceiling light on, because it was still black outside.

There was a pile of empty boxes by the couch. She'd unpacked that whole line of them that's been over by the wall ever since we moved here. I was quiet; I just stood watching. I didn't know if she would get mad and make me go back upstairs, but she turned

to me and said, "Oh, Mikey, you're up. Wonderful. We can watch the sunrise together."

She made us cocoa, and we watched the water get all bright and the city show up far off. Mom told me not to tell Daddy that we'd been up so early together, which was sort of funny. But I can keep a secret all right. I liked it, just me and Mom, talking and stuff. I got up in her lap and we snuggled, like I like to do sometimes. If we could just stay that way.... But she had to finish those books, so I sat at the window to watch for animals. I knew they wouldn't come though, not with that light on and Mom talking. They like it quiet and dark.

MARGO

One morning, very early, just three days after my change, I noticed a picture of the new chancellor of the University and his family on the front page of *The Daily Californian*. They ought to have their children's portraits painted, I thought. They're good looking kids and the paintings would warm up the rooms in that big chancellor's residence. What if I were to go and introduce myself and get a commission? The job would be wonderful publicity for me. I peered at the newspaper photograph again; the wife looked friendly. Why not try?

I made the appointment without trouble and it was only when I was climbing the stone steps to the large elegant house that I had a moment of terror, wondering what I had done. But Mrs. Crawford was gracious and interested. She wasn't much older than I was and I felt we were friends at once.

"How do you work?" she asked. "I mean, how do you get the children to cooperate when they're sitting?" She'd been flipping through the photographs I had brought of my other portraits, and she looked up at me with a smile. I described the way I let kids play with certain brushes and paints, let them talk and do their own paintings too. She seemed genuinely interested; she's a good mother, I decided. Then she asked about costs. I hesitated.

"Five hundred a portrait," I said and waited. That was two hundred more than I'd ever asked, but I thought she could afford it. She agreed, assuming the portraits were satisfactory. I was sure

they would be; I felt so happy and full of life. I knew the paintings I did for her would be worth that price. I hummed to myself as I drove down the driveway. Terry would be so surprised. I'd overspent on Christmas presents—the wagon, the doll for Laura, a beautiful cashmere sweater for him. But now I could cover all that and more with the one thousand extra I had just earned. I'd buy myself a new suit, I decided—a new suit, a pretty blouse. The heck with Susan. I was a mature woman with plenty of sexy charm.

"You went to the chancellor's house yourself?" Terry asked, staring in at me from the kitchen doorway. "You just went in and talked to Mrs. Crawford?"

"Sure," I said. "I'm an accomplished portrait painter of children, and she recognized that fact." I smiled at him and shook a head of lettuce over the sink. "She's lucky I'm available for the job."

"When does she want you to begin?" Terry asked. "I mean, Liz arrives next weekend, and then there's Christmas after all."

"No problem," I told him. "We agreed that I'd start right after New Year's. It's all going to work out beautifully," I said. "You'll see."

Chapter 5

LIZ

I WAS so excited; I didn't sleep more than an hour during the whole flight from New York. I saw Margo and Terry and the kids waving at me from the window in the waiting room, and I stopped halfway down the plane steps and waved back. I was so relieved to get that part in *The Crucible* with the Actors' Workshop. I mean, my God, what a break for me, and a break too to have Margo and Terry already there, settled in Berkeley. I was wearing a Mexican serape—I like bright clothes—and these red boots I'd bought in the Village. Mikey pointed at my feet and asked why I was wearing them. I nodded at his cowboy boots and said I'd bought mine so that I could help him herd cattle. "Isn't that what you do out here in the West?" I asked. Mikey gave me a puzzled look, glanced up at his mother; then, he finally smiled.

I was talking away in the front seat beside Terry; Margo and the kids were in back. The freeway stretched out—the traffic, the city skyline, and then that great bridge. I'd seen pictures of it, of course, but there it was. I stopped to stare, then went on chattering about the theatre, the director, this lucky thing of his seeing me in *The Crucible* last summer in New Haven. I was going a mile a minute, when all at once I realized that something had shifted. I wasn't getting the attention I was used to. Margo kept interrupting. There was a lot to catch up on, of course, and yet talking's always been my department. Margo's the one who usually listens, then gives advice. But she was talking away, too—her Christmas plans, a

portrait commission she'd gotten for the chancellor's kids or somebody, the plum pudding she was making for Christmas dinner. She showed me around the house, telling me about all the things she was going to paint and fix. She even insisted that I climb up these pull-down stairs to see her studio in the attic. When I finally sat down at the round table in the kitchen, I remembered all at once that I'd been up most of the night.

"You look great, even if you haven't had any sleep," Margo said.

"My hair's awful," I told her. "I had to dye it red in October for *All's Well That Ends Well*, and now the brown roots are showing through."

"Not much. Don't dye it again though," Margo said. "If you don't have to, that is." I leaned back. I would do what I damn well pleased about my hair, I thought. I didn't need to follow my big sister's taste. I shook my head to push back my irritation, and felt my long enameled earrings swing. When the kettle began to scream, Margo snatched it from the burner. I stared at her as she turned, realizing all at once that she looked great herself, vivid and beautiful, with her long black braid hanging down her back and her high-colored cheeks. I used to try to persuade Margo to wear make-up and not be so puritanical, but right then it didn't seem to matter. "You look good too," I said.

"I feel wonderful." She poured some hot water into a brown clay teapot, swished it around, put in the strainer compartment, and dumped in some tea. "I'm so happy, Liz," she announced. She put a pitcher of milk on the table, took two mugs from the cabinet, then sat down opposite me. "It just happened," she said. "Just ten days ago. I've been in a dark tunnel for weeks and weeks, but now I've come out into the light." She smiled across at me and poured the tea.

"What do you mean?" I peered at her. My sensible older sister sounded strangely like me.

"I've been really low." She cupped her hands around her mug and stared down into the tea a moment. "I mean, I've been very depressed. I've...." She hesitated a moment, then looked straight across at me. "I'm seeing a psychiatrist in San Francisco, Liz; she's a woman."

"Oh?" I said, and nodded.

"It's kind of funny seeing a woman doctor, but...." I nodded again; this was an important revelation.

"Is she helping?" I asked.

"I didn't think so at first. I mean, I was in an awful slump. I thought it was a terrible waste of money. But just last week, Tuesday, in fact, it began to work. I mean, it's working or something is. I feel wonderful. Better than I ever have, almost." I studied Margo as I sipped my tea. I go up and down a lot myself and I thought of reminding her that the up times are usually followed by downs—at least they are for me. But then nobody is really like anybody else, and if she was feeling happy, I didn't want to spoil it.

"Daddy was here," Margo announced. "I wrote you that, didn't I? He told me he'd seen a psychiatrist after Mom died. I didn't realize he'd done that, did you?" I shook my head. "He's paying for my treatment, Liz," Margo went on. "Isn't that something?"

"Well, maybe he ought to," I said.

"Oh Liz, not ought," Margo corrected. "It's very generous of him. I feel closer to Daddy than I have in years."

"Good for you." I picked up a spoon and stirred my tea. Sometimes it feels as if Margo gets everything; she's got Terry and two cute kids and all the stability of being a wife and mother, and now she had Daddy's attention too. I was jealous, of course, but she makes me tired at times. She's so naive. I gazed around the kitchen at the highchair and the crayoned pictures fastened to the refrigerator door. Maybe it wasn't going to be so great living with my sister after all.

NANCY

Just about two weeks before Christmas, Margo changed. I knew it was due to that little talking-to I'd given her about will power. All of a sudden she was getting things done, checked off, just the way I'd suggested. She tackled the mess in the garage and unpacked the book cartons upstairs. One afternoon she brought me this pretty little cologne and bath powder set and insisted it was a thank-you present. Well, of course, I had done a lot of extra things for her and, as I said, my advice had obviously proved crucial. She talked an awful lot, but then, after her sister arrived, I saw less of her. Liz

seemed a little tacky to me with her dyed hair and her earrings and all, even though she was an actress. She babysat some, which meant Margo and I weren't exchanging sitting as much, but I knew she wanted to get a place of her own in San Francisco, and I hoped she'd find one soon.

TERRY

I was going through some receipts at my desk one night and I came upon a group from the Emporium that totaled a hundred and eighty-nine dollars and ninety-three cents. "What the hell is this?" I said, waving the batch at Margo from the kitchen door. "What could you have bought that cost this much?"

"Oh, don't panic," Margo said with a laugh. "It's Christmas, and Christmas gets a little expensive with a family."

"I'm not panicking," I told her, "but my God, Marg...."

"Well, there was the wagon, the doll for Laura, and presents for you and Liz. You don't want me to spoil your surprise, do you?" She laughed again. "And then there's your parents and your sisters and...."

"Margo, we've always just exchanged Christmas letters with all of them. I have three sisters, remember, and three brothers."

"I know that's what we said. But I saw this darling locket that looked just perfect for Marie, and if I was going to send it to Marie then, of course, I had to send something to Teresa, you know."

"You sent presents to all my family?"

"Just about. But remember, I'm going to be bringing in an extra thousand in January."

"I know. But, Marg...." I turned away, feeling frustration roaring within me like an engine.

Ten days earlier I'd been relieved by Margo's change, the return of her energy and cheer after her weeks of gloom. We'd made love in ways we had not known since Cambridge. But now that first joy was gone; Margo had grown preoccupied. She indulged my needs, then rolled over into sleep, leaving me tense with disappointment. Recently she had begun getting up in the night to paint or write in her journal. She was evasive when I questioned her. Yes, she admitted, she had been up a little while the night before, but she'd

slept hard when she came back to bed. The little while had stretched from three in the morning to close to five by my calculations. Dr. Bauder prescribed a stronger barbiturate. I stood in the bathroom doorway watching as she swallowed the blue and yellow capsule; I wanted her to sleep, wanted her to even out, and I wanted sex again too. But the pills didn't seem to do much. The ease did not return to our love-making, and Margo continued to get up in the night. The journal writing went on, the painting projects, and the endless-seeming talk. She talked of the children and their problems, and, if Liz wasn't home, she talked about her. She talked about the primaries, the Middle East, the nuclear tests that were poisoning the world's atmosphere and what she could do to help. Her talk was sometimes exaggerated, sometimes brilliant, often exhausting and my frustration mounted. Why couldn't she just be well, I felt myself muttering. Why did she have to indulge in all these projects, this talk? Why couldn't she just. . . . That was the point, of course; she was sick, she couldn't help it. With that realization, my guilt always rushed in once more.

I remember thinking of home and of a punching bag my dad bought Kevin, one of my older brothers, who was always getting into fights. When he got mad, Kevin was to go down in the basement and punch the bag, Dad said, instead of his brothers. It worked, sort of, or it did for me a few years later. I thought of the dusty furnace room with the tire chains hanging on the wall, the naked light bulb, and me punching that bag, punching out a mean sixth grade teacher or a dumb girl who'd called my art interests sissy, punching just to get good. I actually thought of getting a bag to hang in our Berkeley basement. Would Mikey use it later? Would I?

One morning, when Margo was out, I decided to call Dr. Bauder. "I just wanted to go over my wife's case and ask your advice," I said. "I mean, she seems kind of high and excited to me, and I know she's not sleeping well."

"I'm sorry, Mr. Sullivan," the voice on the other end said. "I never discuss a patient's symptoms with members of the family. It can destroy the doctor-patient relationship."

"Oh?" I frowned. "But wait a minute. We're paying a lot for this and . . . I mean, I'm her husband. I'm *living* with this problem. Can't you give me any information at all?"

"I'm well aware that it's difficult for you," the doctor said. "But that's my policy. I'm sure you understand." The phone clicked. I ground my teeth as I walked to the window. The doctor-patient relationship. Jesus. Maybe I would buy that punching bag after all.

LIZ

I was really busy with rehearsals those first two weeks. They were going into techs right after Christmas, and I had a lot to learn. The commute from Berkeley was a pain, and I wanted to find some kind of sublet in the city. Still, it was fun being with Margo for the holidays. She had put up the tree and had hidden the kids' presents in my room. It got a little crowded when the wagon arrived, but they didn't seem to suspect.

It's funny about Margo and me. She sort of mothered me after Mom died, and broke paths for us too. She left college, despite a lot of protest from my aunt and uncle, and went to art school. Two years later I copied her; I left college to study acting in New York. Then Margo announced she was going to marry this Irish Catholic guy from East Cambridge, which really startled Aunt Libby and Uncle George, though Daddy didn't seem upset. Now I could probably marry pretty much anybody I wanted to, if I wanted to marry, that is. In fact, Aunt Libby would be relieved; I know she suspects I've had some affairs.

I had a day off one Saturday and went into the kitchen late to warm up some coffee. The kids were leaning over the table, making Christmas pictures with red crayons on green construction paper. I was admiring this big Christmas tree Mikey was drawing, when Margo appeared from the back hall.

"Oh, Liz, you're up. Great," she said. "Would you mind hanging around here a few minutes, while I clean up some stuff in my studio?"

"Sure." I dropped a slice of bread into the toaster.

"I just want to get some things organized up there. I want to be ready for the Crawford portraits when I start in January and...."

"Okay," I said. "I'll keep an eye on these wild creatures."

I settled down beside the kids with my coffee mug and the paper. I could hear scraping sounds above, as Margo dragged a

bookcase or some packing boxes. She hurried into the kitchen, filled a bucket with soapy water, and gathered some rags from under the sink.

"You seem to be doing a big job up there," I said, but she only smiled and hurried off. I rinsed out my mug and began adding some extra decorations to Mikey's tree, although I should have been going over my script. In a few minutes I heard the roar of the vacuum cleaner and some more scraping noises. Maybe Margo was scared about painting the chancellor's children, I thought, despite all her triumphant talk. Maybe getting the studio ready would make her feel more prepared. There was a muffled thud from the hall and then a crash, as the metal braces on the back of the pull-down stairs vibrated with weight. What was she heaving up there, I wondered. There was another thud, followed by a shuddering sound.

"Dammit," I heard Margo mutter. I rose and hurried partway up the stairs.

"Are you okay?" I called up.

Margo stood halfway up the steps, clutching a large overstuffed rocking chair that had been on the porch. She bent and heaved it to the next rung, then paused again. "Do you want some help?" I called, but Margo hadn't heard me. She grabbed the green plush arms of the chair once again. Her face was flushed and damp and, although I was only halfway up the stairs below her, I could see a vein standing out in her neck as she gripped the arms. If I got around behind it, I thought, and took part of the weight from the top. . . . But something stopped me from calling out again. I knew my sister; I knew she was absorbed in an intensely personal task that she wanted to do alone. I watched her heave it up to the next step, pulling it high enough so that the long wooden rockers didn't catch in the black springs on either side of the ladder-like stairs. I was poised to run up if Margo faltered, but she held the back of the chair with one arm, crawled around it, and pulled it up onto the attic floor with a final yank. I listened to the dragging noise, then turned back to the kitchen.

The kids went outside to play and after a while Margo called down to me. "Hey, Liz. Come up and see what I've done." I climbed the stairs to her studio. The smells of wet wood and turpentine rushed at me. On the easel was a brand new canvas; the

easel itself looked damp from scouring, and the tubes of paint were arranged in neat rows on a low bureau beside it. There were buckets of gesso on the floor and beyond them was a bookcase where Margo had arranged a collection of her books. I recognized *To The Lighthouse* and the gray back of her journal. Beside the bookcase stood the heavy overstuffed rocking chair, comfortable-looking now, with a band of sun falling across its green plush seat. There was even a rag rug on the floor and striped curtains hanging from the rod in the window. I glanced down at the row of paintings that stood leaning against the low eaved wall.

"Marg." I pointed to a portrait at the end. "That's Mom. That's the herb garden, the lilac bush by the kitchen fence and oh, my God...." I covered my mouth with one hand and felt my jaws tremble.

"That's right." Margo moved close. "Do you like it?"

I drew back. Tears had jumped to my eyes and I reached into my pocket for a Kleenex. "It's...." I swallowed and wiped at my face. "It's...."

"You're moved," Margo said and put her hand on my shoulder. "Oh, Liz, I'm so glad. I loved working on it last summer. It came fast and.... But then, when we got here, I don't know. It got hard somehow. I want to finish it now, but the eyes, the expression.... I don't know."

"What's the matter with it?" I asked. "It looks finished to me."

"It is almost, but not quite. There's something wrong with her face. Something's missing." I stared. I couldn't see what my sister meant. The painting was clearly Mom, but it was Margo's vision of her, not mine.

"What the heck happened to that jacket?" I said, and stuffed the Kleenex back in my skirt. "I could use a denim jacket like that right now."

Margo laughed. "Maybe Santa Claus'll bring you one." She looked around her and smiled. "You see, I've got the place ready now. I've finally got it ready so I can really begin to paint, begin to live. You know?" I nodded, but I was still thinking of Mom, of me, of how far back her death was and yet how close. "It's strange, Liz. It's almost as though I'd forgotten this whole vital part of my life. I've barely been up here all fall since we moved in, except to start that other portrait, and then they canceled." We stood together

beside the easel. Through the long window beyond it we could see the tiled roofs below and the bright bay. "Painting's close to the center for me. I don't know whether I've got any real talent, finally. But I love it; it's the happiest thing in my life, almost. I want to paint all kinds of people and get beyond this literal portrait stuff with children. I want to show relationships, moments between people. You know? I feel as though I have to stay well, not just for the family and everything, but to work."

TERRY

When I look back on that period before Christmas, it seems to me I should have been more patient with Margo, more sensitive to all the stuff she was going through. But I had so much work at the end of the term—papers, student conferences—and, I suppose, the truth is I was mad and frightened. I didn't know how to help or what to do. I should have made time to talk, to smooth out misunderstandings, ease frustrations. Some of it was little stuff really. I'm fond of Liz, but it was a strain having her living with us. Margo and I had less time alone, and sometimes, when she and Liz got going on past boyfriends and teachers, I felt like the butler or the yard boy.

I stayed on at *Portfolio* one afternoon to help Susan finish the layout. I actually like that kind of work; I find the fitting and shaping relaxing after all the reading and junk I usually do. I didn't realize it had gotten so late, and when she suggested that she go get us some hamburgers so that we could continue, I agreed and called Margo.

"Well, thanks for thinking of me," Margo said, when I'd explained. "I'd begun to wonder. It's seven-thirty, you know."

"You knew I was at *Portfolio*. You could have called if you were worried." I was guilty, so I wasn't going to apologize. It served her right if I'd made her jealous of Susan; I had a few complaints myself after all.

"I knew you had a twenty-minute drive home on the freeway," she said. "But, of course, if anything had happened, the police would have come to the house with the report."

"I'll be home by ten," I said. I didn't like her sarcasm.

Ann L. McLaughlin

LIZ

We were all up late Christmas Eve, stuffing the stockings, wrapping last-minute presents. Terry had to screw the wheels onto that darn wagon. My room, which had been a maid's room in some earlier era, was just off the kitchen, and when I raised my head before dawn the next morning, I heard Margo singing "O, Little Town of Bethlehem" as she stuffed this enormous turkey—at least that's what I assumed she must be doing at 5 A.M. Why twenty pounds, I'd asked her the night before. Kurt, Terry's boss at *Portfolio*, was the only guest. But Margo had a list of reasons: cheaper by the pound, more tender, good leftovers, nutritional for the children. I listened to her singing, then rolled over and slept some more.

The kids really liked their presents—the wagon, even that doll Margo thought looked so much like the ones we used to have. Afterwards, Margo and I got going on the dinner, and Margo began talking about Kurt. "He's a very attractive guy," she said, as she unpeeled a stick of butter and put it in the frying pan. I nodded. I had an ominous suspicion that she was trying to fix me up with this man.

"I was a little dubious about him at first, actually. I mean, you know, two divorces and then this affair with Susan, the motorcycling copy editor you met at the office. But Susan seems to be irresistible to all males."

I glanced up from the celery I was chopping. Did Margo think Terry was attracted to her? The girl seemed sexy certainly, but Terry? I arranged the celery and the carrots in a glass dish and began unscrewing the olive jar.

"Kurt's about ten years older than we are, fifteen maybe, bearded. He's really brilliant. He studied in Austria after the war and he's very interested in the theatre."

"Watch out," I shouted. The pool of yellow butter in the pan had turned a dark brown.

Margo snatched the pan from the burner. "Never mind," she said and went on talking as she poured in the turkey drippings. But I did mind. My sister's support was one thing; her managing my personal life was another.

I settled on the couch, half resolved to dislike our Christmas

dinner guest. But Kurt was definitely attractive, charismatic even, in his brown tweed jacket and white turtleneck. He seemed at ease in the living room, admiring the tree, knocking the ashes out of his pipe and relighting it again. "That ought to carry at least twenty pounds," he told Mikey, who was pulling his wagon around the couch. "You could take all your cars in it." Mikey nodded seriously, pleased to be the focus of Kurt's attention. It turned out Kurt knew Tom Euland, the director at Actors' Workshop, and so we chatted about the cast, the productions of *Encore* and *The Zoo Story* earlier. I told him I hoped to get a part in *A Doll's House* in the spring. I pushed my hair back, displaying my dangling gold earrings, and hoped I looked dramatic in my red silk blouse. If this was Margo's plan for me, I would play along with it a while.

After the turkey and the fixings, Margo brought in the plum pudding, which flamed for a minute, and we all clapped. Kurt peeled back the foil from a bottle of French champagne he'd brought and pushed the cork up with a professional pop. We sat talking over the remains of the pudding, as the afternoon darkened outside. The children went upstairs for their naps, then came down again. "Kurt, tell Liz about your meeting with Picasso in Paris after the war," Margo urged.

Kurt gave a self-denigrating smile. "Oh, that was years ago," he said. "I was a brash G.I. with a vulgar appetite for famous people." He laughed and twisted his champagne glass. "It all seems very remote now."

I glanced across at Margo and realized, as I watched her smile at Kurt, that we were both attracted to this man. I studied my sister's white long-sleeved blouse, the lace border beneath her chin, and her black braid hanging over her shoulder, then looked down at my silky low-necked top which revealed the shadowy separation at the top of my breasts. I looked back at Kurt and saw him smile at me. I could have this man if I wanted him, I thought; Margo wasn't even in the running.

"I've been thinking about Picasso a lot lately," she began. "I was going through that book you lent me on his early work. I'd forgotten how radical that whole movement was in its early stages. Looking at those reproductions yesterday before dawn, I really felt inspired. I thought that I could. . . ."

"Before dawn?" Kurt broke in. "Do you usually wake that

early?" Margo smiled and started to continue, but Kurt demanded, "So you're in the manic phase now, are you, the upswing?"

There was a pause. "What?" Margo glanced from Kurt to Terry and back to Kurt again.

Terry leaned forward. "We don't see it as manic, Kurt," he said sternly. "Margo has come through a bad patch; it's behind her now." I stared at Terry; I knew he didn't see the situation that simply at all.

"Of course," Kurt said and turned back to Margo. "You've made such rapid progress. Extraordinary, really. Terry's told me a little bit about your problems and I've been really interested. I mean I've done some reading and studying in the field, you know, and...."

Margo frowned. I saw Terry draw a series of parallel lines on the tablecloth with an unused fork and I remember wondering if they would come out in the wash or if he was damaging the fabric. "The manic period is often a very creative time," Kurt continued. "After all, when one looks back at Van Gogh or Nietzsche—their great periods came during their high times. I mean, think of "L'Arlesienne" or "The Sunflowers" or, as far as that goes, *Thus Spake Zarathustra*." He paused to drain his champagne glass, then leaned forward to continue, but Terry reached across him and stacked the dessert dishes together.

"Let's drop it now, Kurt. Okay? Comparisons really aren't very useful in this kind of thing."

Margo rose at the other end of the table and stood looking down. Her face was flushed, and she tossed her head so that her braid swung back over her shoulder as she lifted her chin. "My depression had no resemblance to Van Gogh's or to Nietzsche's," she announced. "Although I barely know who Nietzsche is. Besides it's over now, and it's not coming back." She paused and I squeezed my hands together under the table. "I mean, I'm not going to let it," she added. "What I'm in now is my ordinary, normal state, *not* a manic phase." She lifted the plum pudding dish, but the silver serving spoon dropped off the side and fell to the floor with a noisy clatter.

"Of course, of course," Kurt said again, as he bent to retrieve it. "I spoke out of turn. I'm sorry." He smiled, surveying the half-cleared table. "This has been a magnificent meal. Magnificent."

Margo gave me a warning look. She had revised her feelings about Kurt, I realized, and was signaling me to do the same. But I wasn't going to follow my sister's directions.

"Good heavens, it's almost six," she exclaimed and turned to the children, who were doing a puzzle on the rug. "Do you want cold turkey for supper, monkeys, or would you rather have hamburgers?"

I traced the rim of my champagne glass with my forefinger and waited. Clearly Kurt had been intrusive, but clearly too, he had reminded Margo of something terrifying that she wanted to evade.

"I'm meeting Tom at the theatre for a drink later," Kurt said, turning back to me. I felt his eyes rest a moment on my medallion hanging on its gold chain, then slide on down my breasts. In all probability, we would make love that night. "Can I give you a ride?" he asked.

"Great. That would be a help." I knew what I was doing; it was my life.

Chapter 6

MARGO

I STOOD in the living room doorway, staring at the corner where the Christmas tree had been; I was panting because I had just dragged it down the stone steps outside to the parking strip. The space looked shockingly naked; broken needles and bits of branches made a trail across the rug to the top of the stairs. The crèche on the mantel was framed with dried clusters of pine branches and two red, half-melted candles stood on either side, their wicks black.

Laura reached for a gold ball amidst the clutter of ornaments on the coffee table. "Don't touch that," I snapped. "You'll break it, and we won't have any for next Christmas." I frowned at the blackened fireplace; Laura had only meant to help. Next Christmas, I thought wearily. How would I be then? Beyond the empty metal stand with its rumpled sheet was a red Tootsie Toy truck I had bought for Mikey, its back wheel already broken. Everything breaks or spills or slips away, I thought: Christmas, happiness, and control.

I glanced up at a withered clump of mistletoe taped above the kitchen door, dragged a chair over, and mounted. "Don't take that down, Mummy," Laura shouted. "Please." Ignoring her, I reached for the clump and jerked the tape back; a scale of white paint shattered on the floor.

"Dammit," I muttered and felt tears spring to my eyes. Laura whimpered and I stooped down beside her. "Don't cry," I whis-

pered and pulled her against me. But she was right; I should have left it. I twisted to stare again at the corner where the tree had been. What if I just put things back? I could bring the tree in and put on the ornaments. I could buy new candles and cut some fresh pine. If we had Christmas around us once more, my happy energy might return. But no, of course not. Christmas was over. I was only tired; everybody was tired after Christmas. I would be fine again once this job was done.

I yanked the vacuum cleaner across the rug. Its roar enclosed me, and I pushed the wand over the scattered needles, knowing they could damage the machine. I heaved the couch forward with a hard push. Once I got this place cleaned up, I thought, I'd take Laura with me up to the studio. I had stretched both canvases for the Crawford portraits and gessoed one; I must be ready for that job.

The phone rang. "I had a three o'clock appointment with Dr. Sullivan," a student's voice said. "But he's not here."

"I'll call *Portfolio*," I promised.

"Hello, Margo," Kurt said. "No, Terry's not back yet. He went to lunch with Susan." Fine, I thought, fine. I stuffed the vacuum cleaner under the low shelf in the back hall. Why shouldn't he have lunch with Susan? She was his colleague, after all.

MIKEY

I got a red truck for Christmas, but the back wheel's all broken. Mom said she'd take it to the store where Santa got it, and they'd fix it right away. But she didn't take it, and she's probably not going to either. I don't like first grade. Mrs. Watson smells funny.

MARGO

I snatched the car keys from the nail by the back door, then turned. I had time to exchange Terry's sweater at the Emporium, or I could take it later and gesso the second canvas. I glanced out the window toward Nancy's kitchen. She had said the kids could

stay until four, so there was time. The gessoing came first, didn't it? Or should I exchange the sweater?

I turned my head with a jerk. That other me was standing there in the doorway. She was back; she was watching. I crossed my arms and grabbed the upper parts as I felt my jaws tremble. Stop, I told myself. Stop. This is just a moment of panic on an ordinary afternoon. I'm a little tired; that's all. But I could feel her eyes boring into me, pressing the shape of my decision into grayness. Should I do this? Should I do that? Where was I going? What did I want?

I put my hands to my face and stood peering between my fingers at the wide stretch of sky beyond the Bensons' roof. Smoky layers of fog were rising, and above them stretched a gray-white space, without path or direction.

I slammed down the keys and grabbed the edge of the counter. The decision didn't matter. The point was to do, do now, and not think. I turned to the back hall and jerked a smock from the clutter of dirty clothes spilling from the plastic basket on the floor. As I stood buttoning it over my blouse, I noticed a potted geranium I had bought a month ago, sitting dry and forgotten on the dusty window sill. I snatched it up, moved back to the kitchen, and stood clutching it against me. Overlapping notices were attached to the refrigerator door: a PTA party, January 10th. Bring salad. "It's starting," I said out loud. "It's starting again. What can I do?" The me did not answer. "I've got to do something fast." I turned to the sink, then back to the refrigerator again. "Help me," I said, and heard my voice in the empty silence. "Help." I had come out of my depression on the bus to the city on December fourth, six weeks ago. It couldn't come back so soon, this indecision, this panic. I hadn't even had two months of energy. It couldn't come back; but it had.

I moved to the wall phone and dialed part of a number, paused, then hung up the receiver. "You're paying her to help you, dammit," I told myself and dialed again. "Dr. Bauder," I said, startled to get her voice instead of the medical answering service. "I need help. The depression . . . it's starting up again. I can feel it. It's all around me. It's just begun. Just now. It's. . . . "

"We'll talk about it Tuesday," the doctor said. "At the usual time."

"But it's here now," I gasped. "It's just beginning. If I could push it back now, if you could help me. I realize your schedule's crowded, but...."

"Margo, I think you're quite competent to deal with this yourself for the present. I'll see you Tuesday and we'll talk about it then," the doctor repeated. "At eleven." The phone clicked and I replaced the receiver slowly. Tuesday was three days off. I stared out at the sky again. By Tuesday I might be mired so deep in shame and despair that I wouldn't even be able to describe my situation. "She won't help," I said out loud, and looked back at the kitchen. All that talk and time with her, and in the end I have only myself.

I grabbed a memo pad and sat down at the table. I had an hour and twenty minutes before the kids got home. I would gesso the second canvas, then put the laundry in and do a quick vacuuming before Liz came home. It was all right, all right. I could do it. I could hold back that tide of indecision, that gray swirling fog. I had my weapons, my lists, my energy. I could do it; I had to. I glanced back at the phone. Dr. Bauder thought my mood was part of some objective therapeutic process, but I knew better. This darkness rising in me was beyond reason and talk. I was alone now, but I was a fighter. I would beat it back, dammit. I would.

I started toward the studio, but, as I turned back to glance at the kitchen clock, I caught sight of the geranium in its pot on the drain board. Its withered stem protruded from the caked earth. I had killed it with my negligence. What else would I harm or kill? Shut up, I told myself, and jammed my fists into the pockets of the smock. Just keep going, I whispered. Just keep on.

LAURA

Mom likes Mr. Green Jeans; she thinks he's funny and I like to sit in her lap when *Captain Kangaroo* comes on. It's warm and she blows on the top of my head and then she kisses me. But today when Mikey shouted, "Green Jeans, Mom. Hurry," she yelled back.

"Be quiet. Can't you see I'm busy?" All she was doing was making Wheatena. I hate that kind anyway—brown with speckly things in it.

TERRY

I was locked in with work that January. I had two long articles for *Portfolio*, plus my preparation for the new classes. Margo began her portraits of the Crawford children right after New Year's. She hired a student, a nice girl, to babysit two afternoons, but she took to working at night as well. She'd tell me she was going to get to bed by one, but she worked straight through until dawn three nights at least. I had thought she'd enjoy painting the chancellor's kids. She'd been so triumphant about getting that commission, but she seemed driven and beleaguered. The sittings went well, I think. She scheduled three of them for each portrait. Then she settled into the work of shaping, filling in, finishing. In a way it was a relief to have her working steadily at her painting again, and yet I knew she was working too hard.

"Why don't you take a few days off?" I asked her one night, when she was sitting slumped at the table, after the kids had gone to bed. "Mrs. Crawford doesn't have any particular time schedule, does she?"

"No, but I do," Margo said and looked across at me with eyes that seemed to burn in her tired face. "I have to keep going. I have to get this job done."

"But, sweetheart...." She stretched one paint-stained hand out flat on the table and I clutched it in both of mine. "You look so tired. The bills can wait. You...." Margo pulled her hand away from mine. She rose and and stood clutching her arms around her. "I'm going back upstairs."

"If you get sick, Marg...a cold, I mean, or...." If I could just hold her in the kitchen a little longer, I thought, persuade her to go to bed. "The kids, me. We all depend on you, you know."

"I'm not stinting on the kids, Terry. You know I never do. I'm strong. I'll be okay."

"I know," I said. "It's just this driven way you're working right now.... I mean, if you could give yourself a little break—just a day or two, even." She stood there, clutching her arms around her, her eyes staring. "We're both shot," I continued. "Let's knock off tonight and go to bed."

Lovemaking used to be a dependable resource for Margo and

me. When other stuff was going badly, we had that comfort. But things had changed in California. When Margo was depressed in the fall, she evaded me or acted so submissive it felt all wrong. Then, before Christmas when she'd felt energetic again, she was either exhausted from rushing around or so peculiarly aggressive about our lovemaking that once again it felt wrong. That night though, it seemed to me that sex was what we both needed, that it would help. "Come on," I said. "I'll turn the blanket on. The bed'll be nice and cozy."

"I can't. I have to keep at it." She looked back at me as though she wanted to say something more, explain or.... I waited, disappointed, tense, anticipating my familiar swing from irritation into guilty concern once again. "I have to go on with this job, Terry. Don't you see?"

I turned the hot water on full force so that it rushed into the dish pan and began scrubbing a crusted casserole dish with a queer fury. I saw, but I didn't want to.

One Friday night toward the end of January, Margo called me up to the studio. I felt uneasy as I climbed the pull-down stairs, knowing I would have to make a judgment. I stood surveying first one portrait, the blond little boy in lederhosen, and then the other, a delicate girl with long dark hair falling to her shoulders. "They're beautiful," I said. "Wonderful. Both of them."

Margo turned back to me, her face thin and fierce. "They're not wonderful at all," she muttered. "They're mechanical and dead and you damn well know it." I stared, startled at her anger. Her words echoed around us a moment and then, in the quiet, I heard her swallow. "I'm sorry," she said. "I'm just tired, I guess."

"I know," I told her, somehow relieved to realize how much anger she had pressing up inside. I moved to put my arm around her shoulders. "You've done a good job. You've almost finished. The Crawfords are going to be pleased."

"They've got a lousy aesthetic sense if they're pleased with these things," she said and gave the easel holding the girl's picture a push with her toe.

"Marg, you can't love every portrait you paint," I began. "These are good competent paintings. They...."

"They stink," she said. "I'm going to hate myself for delivering

them." She covered her face with her hands. "I wanted to do well—to do something beautiful and living, but . . . but. . . . "

"Stop torturing yourself," I said, and heard my voice loud and shaky, like a shout. "You've finished a big job. Now you can get a little rest."

"I don't want to rest," she answered. "I have to keep on."

Why, I thought, and looked around me. Wasn't there any end to this, any way out? I noticed three curious facial studies tacked to the wall. The sketches were unfinished and the work looked hurried. "What are these?" I asked.

"Self-portraits," Margo said. "Studies. I don't know what they are." I could feel her watching me look at them. The faces were queerly contorted, the planes at opposing angles in an abstract mode. Margo's features were distinguishable in each, however, her eyes, her long forehead, the black braid. "Are they studies for something bigger?" I asked.

"I don't know what they are," she repeated. "Nothing, probably."

When Margo delivered the portraits later that week, Mrs. Crawford was so pleased that she wanted her to begin painting a friend's child. But Margo turned the job down. She took out books on abstract art from the library instead and talked about doing a self-portrait. I still hoped she'd take the job Mrs. Crawford's friend had offered, but I knew better than to try to persuade her. Yet I couldn't see that she went up to the studio much at all.

Liz found a sublet apartment in San Francisco at the end of the month—at least that was what she told us—and she moved out. *The Crucible* had opened and the reviews were good, but Liz was no longer part of our daily lives. Her multicolored serape did not drip from the hook by the front door, and her mascara brushes no longer cluttered the shelf above the bathroom sink. We all felt her absence; Margo seemed dazed. Liz said several times that she was going to invite us all in to see the apartment, but the date got put off. Sometime late in January, I realized that Kurt was seeing a lot of Liz. He mentioned taking her to one party or another, and once he said something about going out for breakfast with her. Margo and I speculated about their relationship; I thought

they might be living together, but Margo was sure Liz would have told her that. In some ways Margo was on a friendlier basis with Kurt than I was; he lent her some books on psychiatry and philosophy and they had several long talks about them on the phone. But in early February I discovered something about Kurt that made us both feel differently, and I brought the evidence straight home.

I had been researching an article on Frank Lloyd Wright, which was to be a companion piece to a long article Kurt had done on Wright's early work in a preceding issue. I was checking references in the library one Saturday morning, when I came upon an essay in a small midwestern review that seemed eerily familiar. The initial paragraph and the conclusion were different, but the body of the article was almost word for word what Kurt had said in his piece on Wright two months ago. I copied out long sections and spread them out on the kitchen table beside Kurt's *Portfolio* piece for Margo to look at that night, after the kids had gone to bed.

"What do you think?" I asked as I watched her peer at one paragraph, then another.

Margo looked across at me and sighed. "It doesn't look good. What do *you* think?"

"That he's plagiarized it, and that I should resign." I rose and moved to the window, then turned back to her. "That sounds fine. But how can I do it? How? We've got the rent. I've got to get the brakes on the damn car fixed. We've still got payments on Mikey's hospital bills and... and...." I jammed my fists into my pockets. "The thing is, I believed in *Portfolio*, dammit. We need that kind of art criticism. Why the hell did Kurt do this? That's what I don't understand. He didn't have to."

Margo sat looking up at me. "It's strange," she said. "He's such a brilliant guy. I learned more about Freud in a couple of conversations with him than I did from that whole biography."

"He *is* brilliant," I said. "Brilliant enough to know the chances are he won't get caught. That little midwestern journal has never heard of *Portfolio* probably, and even if it has, how would they have the money to sue? Oh Christ. I don't know. Kurt's under a lot of financial pressure right now with this thing. I mean, those New York backers of his will only dole the money out issue by

issue, so that he's always under the gun to make the new issue better, flashier than the one before, and, of course, he's understaffed. Just me, part-time, and Susan and. . . . "

"But he's committed plagiarism," Margo broke in.

"I know. I'm not trying to excuse him, just understand the thing a little. He's scared, I think. His Village magazine went broke, you know, and now he feels he's got to make it with this one."

I sank down at the table again and sat, looking across at Margo. "The funny thing is that six months ago I felt lucky that Kurt wanted me. I thought he had an exciting vision for *Portfolio* and . . . but now. . . . " I glanced back at the dark window, then at Margo again. "Do you think we made a mistake coming all the way out here?" I asked. "I mean, I could have stayed at Harvard another year, you know."

"I know you could, but. . . . " Margo joined me at the window and put her arm around my waist. "We can't get into the what-ifs now, honey. It's going to be all right. It's going to work out. You can tell Kurt what you know and that you're going to leave just as soon as you can find something else." I gripped her hand against my ribs.

"That's just what I was planning," I told her. "I thought I'd show Kurt the article Monday and tell him I'm going to look for something else, another editorial job, more teaching, and tell him I'll be leaving *Portfolio* soon." I paused and we sat down at the table again. "The thing is," I said. "I can't get another teaching job in the middle of the term. I can't even get an editorial job now probably." I sighed and let my head sink into my hands. "Maybe I could go back to cab driving for a while." I had driven a cab in Boston during graduate school. The money was pretty good, but it meant late nights, more time away from home.

"You don't know the city," Margo objected. "And those San Francisco hills must take special experience. Besides you'd have to rent a cab and that would just be more expense."

"You're right." I paused. "Okay. I guess we'll have to do what I said; I'll go on at *Portfolio* until the term's over and meantime, I'll work my ass off sending out applications. I mean, Jim Walker at San Francisco State told me he'd definitely take me on for the summer if he has any openings. The summer school faculty's a lot looser than the regular one, you know."

Margo nodded. "That makes sense, honey. Sure." She let out a long sigh. "It's lousy luck, but we're going to be all right. I think I can still get that portrait commission from Mrs. Crawford's friend; that would help." She glanced at the dark window again and frowned. "You know it's funny, but in a way I'm more worried about Liz than about you or us."

"I know," I said. "I've been thinking about that whole business too. I guess all we can do there is wait and see." I gripped her hands and smiled at her as we sat opposite each other there at the kitchen table. It was curious, but I felt more married, more part of a working partnership that night than I had for a long time.

LIZ

It never should have happened the way it did. I intended to tell Margo soon, but I kept procrastinating. She seemed tense and, well, even though Margo and I are close, love, sex, relations with men, all that stuff—they're hard subjects for us to talk about. We're just too different. But the way she learned about it was bad. She stopped by Kurt's apartment to drop off this biography of Freud he'd loaned her. Kurt had a fascination for Margo; she liked discussing books and ideas with him even though he'd clearly annoyed her at Christmas. It was almost as though she felt he had some special knowledge that she needed.

I was alone that morning. Kurt had left for the office, but I'd had a matinee the afternoon before, plus the regular evening show, so I was sitting at the kitchen counter in my negligee, drinking coffee when the buzzer rang. I opened the door and there was Margo.

She stood in the apartment hallway a minute, staring at me, then she held out the book. "I brought this; it's Kurt's."

"Come in," I said and stepped back. She moved inside and looked around her at the book-lined walls, the etching of Freud, the framed reproductions of Modigliani, and the stack of journals on the teak coffee table.

"Sit down." I pushed back a newspaper on the couch.

"How long have you been living here?" she asked as she settled herself on the white cushions.

"Three weeks," I said. "I was planning to tell you soon, Marg,

but I didn't want to talk about it on the phone. I wanted to come out and explain, and. . . . "

Margo crossed her legs and drew in her breath. "Are you happy?" she asked.

"Yes," I said. "Of course."

"Are you in love?" Her voice was tight.

I pulled my negligee together at the throat and frowned, aware all at once of my bare thighs and the dark slippery material with its lace swirls clinging to my breasts. I'd bought that negligee a month earlier when the affair was just beginning; it was the kind of thing Margo wouldn't wear in a million years.

"Yes, I'm in love," I said. I pulled a mohair blanket from the back of the couch and wrapped it around my shoulders. "Sure, I'm happy," I continued, feeling more respectable with my neck covered. "But I don't really like living with a man I'm not married to." I had done that before, as Margo knew, but this time it felt different, and I wanted to explain that difference to my sister. "The thing is . . . " I began.

"Are you planning to marry him?" Margo broke in.

I sighed. Goddammit. Why couldn't she listen for half a minute? Why did she have to be such a prude? "I don't know about marriage," I said wearily. "Kurt talks about it from time to time, but I'm not sure."

"You've only known him two months," Margo said. "His second divorce hasn't even come through."

"So?" I was mad—sick of always being typed as the bad little sister. "You're full of facts, Marg, but you can't be bothered to listen to my feelings about it." Margo waited and I extended the wait; I reached for my cigarettes, lit one, and exhaled slowly. If Margo could only be more tolerant, more sophisticated, I thought, I wouldn't have to be so darn rebellious.

"You don't need to judge me, Margo," I said slowly. "And you don't need to interfere. I'm a big girl too, you know."

I watched her press the couch pillow between us with her long chapped-looking forefinger and for a moment I thought of covering her hand with mine. But I was angry. What right did she have to make me feel ashamed? I shrugged off the mohair blanket and walked to the window.

"I don't expect you to feel overjoyed about this relationship. I

know what Terry said to Kurt about that article business, and so I can imagine what you think of this." I glanced across at the creased white spines of the books in the shelf—French paperbacks of Sartre and Camus. "I'm doing things my way, Margo, not yours," I said and looked back at my sister. "I'm sorry if it makes you mad, but I really can run my life without your advice. See?"

TERRY

I'm not a kid. I knew perfectly well what was in Susan's mind late that afternoon when she suggested that we go over the proof sheets at her place rather than at the office. I followed her in. The apartment was small and had a sort of cheesy smell. A Van Gogh print of Arles hung crookedly on the opposite wall and below it a philodendron plant with yellowing leaves sat on top of a low bookcase. A pair of high heeled slippers lay abandoned on the rug. Susan made no pretense. She closed the door behind me and put her arms around my neck. We kissed, then I drew back. I held her at arm's length and sighed.

"I can't," I told her. "I shouldn't have come. It's not you or . . . I'm sorry, I just can't." I looked down at the floor, avoiding her eyes.

"Oh, boy," she said and put her hands on her hips. "I guess the little woman and the kiddies win."

"That's right," I said and stooped to pick up my briefcase. "I'm sorry." I said a few more things, but I could feel her eyes burn my back as I turned and made my way down the dingy hall and out into the parking lot. My hands shook as I reached for the keys and, when I stopped at the light on Euclid, I gripped the steering wheel. What the hell was the matter with me? How had I gotten myself into that mess? Loneliness, worry about Margo, and. . . . "Oh, cut the goddamn excuses," I muttered. My harsh whisper filled the car, as if another man had spoken. I was failing. California had been the wrong choice; I was making a mess of everything.

My head ached as I started up the stone stairs to the house. I was more than an hour late and the kids were already in bed. I had told Margo that I had an exam committee meeting and, fortunately, she didn't ask me about it. She simply dished up a

bowl of stew, served me some salad, and sat down opposite me at the kitchen table. I felt hot with relief as I sat staring across at her—my wife, my home, my life. In a minute I would grab her hand, I thought, and tell her about Susan, tell her that I had abandoned my sanity momentarily, and that I was sorry. She would forgive me; she would understand, even; we were old friends. We would sit talking about my problems and hers, and about why this time in California was proving so hard.

"I went to Kurt's apartment this morning," Margo began. Her eyes were bright and I realized all at once that she had been waiting impatiently to make this report.

"Oh?" I picked up my fork. The moment for my confession had passed.

I listened to Margo's account of the visit, what Liz had said, what Margo had answered. I still wanted to break in with my confession, but Margo was absorbed by her discovery and needed my reactions. I heard myself offering to go meet Liz after her show some night soon and talk. The plan seemed awkward, a kind of guilty attempt at restitution, but, as I was developing what I might say, Margo covered her face with her hands. "I wish I hadn't taken those portraits to Mrs. Crawford," she said. "They were so dead, so bad."

"I thought we were talking about Liz," I said and frowned. This would be a bad time to begin explaining the mistake I'd almost made with Susan.

"We were. I'm sorry. I'm listening." I continued to talk about Liz and what I might say about Kurt and their relationship.

"It might work," she started. "I mean, she respects you and she won't listen to me, at least not now." Margo pushed back her chair and rose. "I feel so tense about Kurt, your work with him and.... I hate you being so subservient and...."

"But it was your plan too, Marg. You thought it was a good way to...."

"Oh, I know." She gathered my bowl and glass, the remains of the salad, then turned back from the sink. "Did you have lunch with Susan today?"

"What?" I stared as Susan's living room opened before me again, the Van Gogh print on the wall, her slippers on the rug, my awkwardness, the drab hall. "Why?"

"I don't know why," Margo said. "I've been thinking about her. That's all."

I rose and took the dish towel from the rack. "Things aren't so bad," I began as I polished the glass slowly. "I've been honest with Kurt and he knows what I think. I've mailed off four applications now, and I'm almost sure I can get something at San Francisco State this summer. Besides, it's possible that something permanent's going to open up in the department here later on. See?" Margo nodded, but I knew she was no more reassured by my Pollyanna talk than I was. The tides of uncertainty, sloshing around my life, looked littered with refuse. "Let's go out on the porch." I watched Margo pour out the dishwater and stuff the pan in the cupboard under the sink, then I took her hand.

We were sitting close together in the dusty glider, my arm around her shoulders, when the phone rang in the kitchen. Margo leapt up to get it. I groaned, angry at the interruption. I'd resolved that in another fifteen minutes, I would tell her about Susan, about my disappointment here, my confusion, and we would talk, and after a while it would be all right.

Margo reappeared in the lighted doorway, clutching her arms around her. "It was that Miss Johnson, the secretary in the Art History Department. She said there's an exam committee meeting tomorrow at five. When I laughed and said the exam committee seemed to be meeting all the time, she said no, this was only the second meeting of the term." Margo stared across at me. "You're having an affair with Susan, aren't you?" she said slowly. "My God, how stupid I've been. It never even occurred to me that you'd do that."

"I haven't. I'm not." I started toward her, knocking my knee against the edge of the metal coffee table. "I mean, I went to her place this afternoon, but there's no affair, and there's not going to be."

"How stupid I've been," Margo repeated. "How stupid and self-absorbed. I should have known. I should have seen that coming. But I didn't."

"Marg, listen to me." I grasped her shoulders and felt my blood pound. "I went to Susan's apartment this afternoon at six-thirty. She wanted me to stay; that's true. But I was . . . I was disgusted and guilty. I left. It was six-thirty, seven maybe. I shouldn't

have gone, but I didn't stay." I dropped my hands and stared at her. "That's what happened." I stared. Surely she would understand this clumsy incident; surely she would see it as just a dumb mistake amidst the pressures and confusions of this bad time. "I felt lousy about it," I went on. "Stupid. I was going to tell you at supper and then ... " I let my voice trail. "I'm sorry. I don't know how I got myself into that situation."

"You were with that girl tonight before you came home?"

"I just told you. Yes. I'm sorry. I'm really sorry. It just happened. I didn't mean it to, and I stopped before...."

"But you lied to me. You told me you were at an exam committee meeting. You were with *her*."

"Marg. I told you. I made a mistake, a stupid mistake. I'm not in love with that girl. I don't even like her. I'm not going to see her outside of work again or...." But Margo had turned. She stood with both hands pressed to her mouth, staring out. "She invited me over and I should have known. I did know, but...." I rushed on, trying to outtalk a rising sense of dread that I had hurt my wife in some deep way, that was out of all proportion to the situation—a hurt that might make her really sick. And yet I had done nothing; I was telling the truth, and.... All at once I felt like a caged animal, thrashing in my own guilt. "Dammit, Marg," I began. "Don't exaggerate this. It's an incident. It doesn't mean anything. We'd both do better to forget it." But Margo did not turn back to me. She continued to stand with her hands pressed to her mouth, looking out at the dark bay.

"I should have known," she whispered. "I should have known about Liz too."

MARGO

Two days passed. I thought about Terry and Susan and Liz and Kurt over and over, but mostly I thought about myself. I was procrastinating. Thursday night, though, when Terry was out at class, I switched on the light in the back hall and went down the stairs to the garage. I stood in front of the tool bench, scanning the uneven line of paint cans, varnish, car wax, the Three-in-One oil, all crowded together on the shelf in front of me. The garage

was dim and chilly. I pulled up the collar of my chenille bathrobe and reached for a brown bottle. The heavy black letters on the label read: ORTHO, and below it in smaller letters, MALATHION INSECT SPRAY. A black beetle was silhouetted against a red background and below that in small writing, "Kills insects: aphids, red spider mites, flies, mealybugs and scale." I turned the bottle. There were two columns of directions in small print. "Cover both upper and lower leaf surfaces thoroughly and other infested plant parts...." This would do it, I thought, and unscrewed the top. A harsh, chemical smell rose up around me, reeking of tar and turpentine. I held it out, frowning, then turned; Mikey was calling me. I put down the bottle and hurried to the stairs.

MIKEY

My legs were all itchy and I wanted Mom. She'd come up and put that goo on, then sometimes she'd sit on my bed and talk to me in the dark. But that night Mom found the goo on the bureau by the light from the hall and pulled back my blanket. "What's that stinky smell?" I asked, as she bent over me.

"Nothing, honey." She smeared the goo on my leg; she didn't look at me. "It's just some turpentine I'm using." I stared. It didn't smell like turpentine to me. She screwed the cap back on the goo and stood beside the bed a minute, looking down.

"Bunchie needs a hug," I said. That's the way I get her to sit down. She sits on the bed to hug Bunchie, then she hugs me too. But she didn't sit down or pick up Bunchie even, she just stood there, smelling funny.

"Mikey," she said. "I love you. Do you know that?" She was all serious, and I was mad. I knew she wasn't going to sit down and talk, so I just flumped over on my side and pretended I was asleep. I heard her open Laura's door to look at her. She came to my door again, but I went on pretending. Then I heard her footsteps going down the steps.

MARGO

I made my way back down the stairs to the garage. My death would be a shock for them all, of course. But soon, remarkably soon, things would be much better. Terry would remarry, and the new mother would be bright and organized and.... I raised the bottle. Would he marry Susan? Would Mikey like her? Would Laura? Would they really be better off? "Kills insects: aphids, red spider mites...." I brought the bottle to my lips. The smell poured over me. Do it, I ordered myself, just do it. I opened my mouth. The liquid was fire, burning my tongue, my gums. I clutched the edge of the bench with my other hand, and stood a moment with my cheeks puffed out, uncertain whether to spit or swallow. I couldn't hold the heat in my mouth any longer; I swallowed. The poison moved into my throat, then down into my chest, burning a path within me, like a long blue flame. My breath rushed out in a noisy gasp, breaking the damp quiet of the garage.

After a moment, I put the bottle down and clutched the tool bench with both hands. Had I taken two mouthfuls? Three? I was gasping loudly. I turned and stared around me. Oh my God. What had I done? I lurched toward a dark shape in the corner— a stack of tires—and fell against it. Terry would be home soon. He had to be. An oily clump of rope on the opposite wall rocked toward me, then back again. Beyond it, Mikey's red wagon blurred. My throat was on fire. I moaned and let my head roll back. Terry must get here soon.

TERRY

I was worn out as I drove home from class that night. I'd been unprepared for the stuff on English Romanticism, and that smart-ass grad student, who wasn't even taking the course, had asked a question I could barely answer. I saw the light in the window of the garage door as I turned into the driveway, and was blaming myself for leaving it on, when the door on the right side opened and Margo appeared in the headlights. Her bathrobe was tied

loosely and her braid hung forward over her shoulder as she moved toward the rolled-down window on my side.

"I drank some poison," she said in a hoarse voice, as though she was pressing the words out with pain. "You'd better get me to a hospital fast."

"You what?" I stared at her as I felt the burning guilt inside me flare and explode. It was my fault, of course, in some major way it was all my fault—the thing with Susan, my worries about my job, my damn compulsive ways. Margo moved through the beam of the headlights and got in on the other side, invading the car with a harsh chemical smell. "What'd you take?" My voice sounded low and strangely controlled. "They'll need the label."

"Insect spray." She fumbled at the door handle, meaning to retrieve the bottle.

"Stay there," I ordered. I swung my door open and leapt across the grease stains on the concrete floor and grabbed the brown bottle from the tool bench. "There's no traffic," I told her, as I shifted into reverse. "We can get there fast." Margo hunched over, clutching her stomach. Then she straightened a moment and looked at me.

"The kids are both asleep," she said in that low, hoarse voice. "Mikey woke earlier and I put some ointment on his legs. Liz'll come over, if you call her from the hospital. *The Crucible* closed Sunday, you know." I squinted; the details of our domesticity seemed remote, almost grotesque. As we swung out onto the avenue with its line of arching yellow street lights, I heard Margo draw in her breath with a long shaking sigh. "I can't even kill myself right," she said. "I'm not even good enough to do that."

Chapter 7

TERRY

THAT nightmare night kept coming back to me. I saw Margo stretched out on a gurney in the Emergency Room, limp and gray, a black tube running from her mouth down to the bucket below. I heard the intermittent roaring of the pump and saw the purplish liquid gushing, trickling, then gushing again into the bucket, while that reeking chemical smell wrapped around my nose and mouth, muffling everything. I was in shock, I guess. I wasn't even sure I was allowed in the room, but the two interns who were working over her seemed too busy to notice me. I held her hand a while, but her head was turned and I don't think she knew I was there, though she was conscious, they said. The tall intern, the one I talked with later, said he was astonished that she'd ingested so much. The question was whether she'd damaged her kidneys or maybe her brain.

I remember sitting in a small windowless office off the Emergency Room later, as that tall intern told me that her vital signs were good—pulse, blood pressure, respiration. He said the timing was crucial; she'd taken a lot, but it couldn't have been in her more than forty-five minutes, an hour at the most, and he was sure they'd gotten it all. They would keep her under observation, of course, but the prognosis was good, he insisted, good. I nodded my thanks and covered my mouth with my hand to hide my shaking jaws.

"Thank God," Liz said, when I called to tell her the news. "Oh, thank God."

They took Margo upstairs. She was sleeping, they said, but I stayed on, so I could be there when she woke. I canceled my first class and called Dr. Bauder at nine in the morning to tell her what had happened. I needed to find out which psychiatric hospital she would recommend, since it was obvious that Margo would have to be hospitalized for a while.

"It's Terry Sullivan," I said, when she answered. "My wife attempted suicide last night." I heard the sharp intake of her breath and wished that I hadn't announced the fact so abruptly.

"What happened?" she asked. "What did she do?" I described the Ortho spray, the pumping, the diagnosis.

"I'm sorry," she said in a low voice. "I really couldn't predict . . . I mean it's impossible to foresee these actions, these. . . . "

"I realize that," I said, breaking in. "I have to decide on a hospital now and. . . . " I felt embarrassed by her distress, her defensiveness.

"Yes, of course." Her voice grew brisk. "Remington is the hospital the Berkeley General usually recommends for psychiatric patients. It has an excellent reputation. Ordinarily the recommending psychiatrist makes an initial visit. Then, of course, you and your wife will have to decide. Your wife could continue with me on an out-patient basis later or she may prefer to. . . . "

I felt her horror and guilt vibrating behind that screen of professional talk, and I was sorry for her, but angry too. "I suspect they'll transfer her as soon as possible. I'll go out to see her Wednesday afternoon," she said and paused, as if consulting her calendar. "I'll check with the attending doctor first, of course. But I think they'll probably decide to transfer her Monday. Tuesday, in any case." Her mask of cool professionalism infuriated me and it was a relief to feel angry again after the turmoil of guilt I'd been in for hours. I bit my back teeth together as she continued to talk, feeling my rage mount. "You may want to find out more about Remington first. I can give you some names or. . . . " I stared at the smudged numbers penciled on the wall beside the phone. I had spent the night in the waiting room down the hall, flipping through wrinkled magazines, going back to wait outside the doctor's office, then back to the magazines again. My wife had

almost died ingesting inspect spray and this doctor was talking calmly about names. All at once I heard myself shouting.

"It's not the hospital I'm worried about, Dr. Bauder. It's the treatment. I don't think yours has proved all that damn good. You've been seeing Margo five months now, and this is the result. It seems to me you've been on the wrong track," I continued. "She never did respond to your kind of analytic approach, but you wouldn't try anything else. Maybe you didn't know anything else." I heard my own heavy breathing, but I kept on. "You insisted on analysis and...." I paused, astonished at myself. "We're going to find another kind of treatment, another doctor," I added more quietly. "I just wish to God I'd decided that three months ago."

"Very well, Mr. Sullivan," Dr. Bauder said, "if that's what you want. It's your decision, of course. Yours and Margo's. I hope you'll talk it over with her at least." I hung up the receiver and slumped back against the tiled wall. Just at that moment, the tall intern came down the corridor and stopped beside me. The black loops of a stethoscope poked up from the pocket of his wrinkled jacket, and there were yellow stains on the side of his white duck pants. I told him everything I'd just said to Bauder and everything else—how Margo had started with Bauder, how her father had paid, how Bauder had refused to see her once right after Christmas, how rigid she'd been with me. God help me, I even told him about Susan and her near seduction. Christ. The intern twisted the cowlick at the back of his head.

"This whole thing could have a positive side, you know," he said slowly. "It could lift you out of a treatment that's obviously not working and into something that will." I stared. He told me that Remington was known for its experimental approach. He said some other things—I'm not sure what, but they were reassuring. The guy's kindness was crucial to me then. I just hope I thanked him; I wish I remembered his name.

MARGO

I waited beside the door of the low cement block building while the gray-haired nurse put down my plaid suitcase and took a ring of keys from her uniform pocket. "You'll like Remington," she said, unlocking the door. "There're a lot of nice girls here."

After my days in the Berkeley hospital, I felt numb to the look of nurses, their caps and white stockings, their cheery maternal manners. I followed this one down a tiled corridor. I was in this hospital because I had failed; I had botched the job of ending my life. What did it matter what happened to me now?

"You're going to be right in here," the nurse said, leading the way into a long, rectangular room with two beds on either side, covered in identical green striped spreads. "The others are over at OT right now. That's Occupational Therapy. They'll be back soon. This is your bed," she said, pointing to one that was precisely made and had an empty night table beside it. A yellow sweater dangled from the metal footboard of the opposite bed. Its striped spread was rumpled and a movie magazine lay face down near the pillow.

"I'll be back in a minute, dear," the nurse said. "I have to get your towels." I sat on the edge of the bed and studied the cluttered objects on the next table—a plastic container labeled "hand lotion," a school snapshot of two children in a cardboard frame, and a bunch of pink hair curlers in a blue box. I turned and noticed that the nurse had put the clipboard chart she was holding down on the bottom of my bed. I glanced at the door, then turned it toward me with a jerk. "MARGO D. SULLIVAN," read the printed name at the top. "Dr. Murray." Below my name, I read, "Female. 28. Depressed. S." The rest of the page was blank. I pushed the chart back into place. Who was Dr. Murray? What did "S" mean? I looked around me again. "Suicidal," I thought, and sighed. So this was what I had made of my life. After college and art school, after Terry and Mikey and Laura, after all that I had been given, I was a suicidal patient in a psychiatric hospital.

Supper was served in the lounge at the end of the corridor, then there was television to watch. At nine, the patients went back to their rooms to get ready for bed. I undressed slowly, shy amidst these strangers, although I knew two of their names. Peggy, the heavy one in the black kimono, stood at the bureau rolling her dyed orange hair in curlers. Claire, who had smiled and handed me a tray, when we stood in line for supper, sat on her bed, filing her nails. There was a third roommate, lying on the bed in the corner, whom Peggy and Claire seemed to ignore. She had not gone to supper, but had stayed stretched out on her bed, staring at the ceiling, the toe of one soft boot hooked underneath the bar of the footboard. I buttoned my nightgown and stood a moment, wondering whether I should get in bed now or wait.

"What kind of treatment did they tell you you'd get?" Peggy demanded, turning to me. "Shock? Drugs?"

"Shock?" I repeated and stared.

"Aw come on, Peg," Claire said, rising. "She doesn't know about her treatment yet. She just got here this afternoon." She pulled back her bedspread, then looked at me again. "They do electroshock on some people," she explained. "EST, they call it. Drugs on others, or just plain talk therapy. Talk—that's a lot of it really."

"Don't let them do shock," Peggy warned. "It's the worst. Takes away your memory for weeks. Sometimes you never get it back."

"Really?" I looked from Peggy back to Claire. "What is it? I mean, how does it work?"

"Oh, it's not so bad," Claire said. "You get this sodium pentothal to knock you out and. . . . But they won't do anything fast. I mean, they'll explain. Shock's kind of the last resort here. They don't do it that often."

"Often enough." Peggy jammed in a final hair pin and covered her head with a net. She looked at me, then jerked her head toward the silent young woman, lying on the bed, still staring at the ceiling.

I glanced over. Was that what they would do to me?

LIZ

I hadn't been able to get in touch with Kurt all day and I was swallowing an aspirin at the kitchen sink when Mikey asked if they could have hot dogs for supper.

"Not tonight," I said and pressed my fingers to my temples. "Go wash your hands and call Laura. Your Daddy has to leave for the hospital right after we eat. Hurry."

Mikey let out an old man sigh. He turned to the door and pushed his fists down into his pockets. Terry had told him that Margo had had to go to the hospital because she had been very sad. Sadness was a sickness sometimes, he explained. It was called depression and when it got very bad, you went to a hospital and doctors helped you to get well again. One way or another, Mikey had a pretty full picture—everything, that is, except the poison— and, knowing Mikey, he might well have figured that out too.

"Mikey," I said. He looked back without raising his eyes to my face. "Mikey, I know you miss your Mom." He looked at me then, his brown eyes probing and serious. "I miss her too." I stooped all at once and knelt beside him on the floor. "I know you're feeling awful, Mikey," I went on, "because I am too." I pulled him to me and rocked him in my arms. "It's going to get better, Mister Man. It really is. She's going to get well and come home. We just have to wait a while and be patient. But she's going to get well, Mikey. She is."

MARGO

"Do you think you really meant to kill yourself?" the doctor asked. He was sitting opposite me in the windowless consultation room where I had been before. He wore a long white medical coat and his legs were crossed, revealing brown slacks where the coat parted. A line of sharpened pencils protruded from his breast pocket and, behind them, I could make out the rectangular shape of an intercom receiver.

The doctor repeated his question. I looked down. "I don't know," I said. He was different from Dr. Bauder, more relaxed,

more accessible maybe. But it was all a waste, this private hospital, this expensive treatment; none of it could help me now.

"It's often an ambivalent gesture," the man said. His name was Dr. Murray, I remembered, and his dark blue eyes had a quiet intelligent look.

"I've been a mess since we moved to California," I began. "I mean, part of the time I've been sluggish and awful and part of the time I've been exuberant, almost brilliant, really. I was full of energy at Christmas and then I went down again and . . . and I couldn't stand it. There were other things, too. My husband. . . . There's this editor at the journal where he works and. . . . But it's not that. It's. . . . " I raised both hands to my mouth, then dropped them to my lap again.

"Sometimes I feel as if I'm on a kind of a roller coaster, going up, down, up, down. I can't get off. You see?" The doctor nodded and I stared, startled that I had told him that. "Now I've committed what must be a criminal act." I looked down at the rug and waited. "I don't understand it. I love my children, my husband. I have work I really want to do. I suppose that's hard for you to believe," I said, and looked up at the doctor again. He uncrossed his legs and leaned toward me so that his eyes were gazing directly into mine.

"No, not really. You're ill, Margo. You have a sickness we call manic-depressive psychosis. Dr. Bauder must have used that term. It's a sickness marked by a pattern of up and down moods." He sat back again, keeping his eyes on me. "Imagine a sheet of graph paper," he said, "with a line going up, then down, and then up again."

I imposed a pattern of pale blue boxes on the tan surface of the rug and saw a jagged black line going down, then up. Could this thing really be objectified that way, I wondered, and frowned as I looked back at him. Could it really be something apart—something for which I was not completely responsible? "You mean it's a sickness . . . a. . . . " I stared at the rug again. I thought of Liz and of Terry and that Susan person. "Even if it is a sickness, I've messed things up so terribly." I stopped; I had caused that stupid affair as clearly as if I had written the script for it myself. A better, brighter wife would have yelled at Terry, thrown a pot at his head. But I had gone down into the garage and drunk insect spray, an act I would live with the rest of my life.

I stared down at the imaginary graph I had made. If it were true... if.... That graph could free me of so much guilt, but maybe he was just being kind.

"You're not condemned to ride this roller coaster forever," the doctor said. "There are ways out of this thing, you know."

"What ways?" I kept my head down, lest the doctor detect the flush of hope which had made my face grow hot. He did not know all the help I had pushed away: Terry, Liz, even Nancy. He could not envision the destruction I had caused my children; especially Mikey, I thought, and twisted one hand within the other again. Oh, my bright little son.

"I need to get to know your case first," the doctor said, "before I can decide what treatment is appropriate. But there are things we can do." He lifted his clipboard chart from the desk beside him as if to indicate the interview was ending. "Believe me," he said, rising. "This thing is treatable. You're going to feel better soon." I glanced up at his tall shape in the white medical coat. "Tomorrow at three, in this prison cell again. Okay?"

I rose and for a moment I could feel a smile starting, but I remembered the green-painted hall outside, the steam table smell, my bed with its striped spread, and the clicking noise of the locked door as a nurse let herself in. "Okay," I said and sighed.

TERRY

Visiting hours were rough. It took me thirty-five minutes to drive out to the hospital, and I was doing well if I got home by eight-thirty and then I had to work until midnight or later. Margo was so silent during my visits that first week that my efforts didn't seem to make much difference anyway. "How's the new doctor?" I asked.

"He's okay," she said. I waited, but she didn't elaborate. "What have you told Nancy about me?" she demanded. I told her I hadn't said much, but when I added that Nancy was going to take the whole crew—her kids and ours—into the city Saturday to the Fleishhacker Zoo, Margo squeezed her hands together. "Oh God," she groaned, "now I'll be in debt to her for months."

MARGO

The occupational therapist put a box of small square tiles on the table in front of me. "Why don't you look through these," she said, "and see if you can come up with a design." I scooped up a handful of the hard, bright squares and spread them on the table. "With your experience—I mean you said you'd done some painting—you could make a box like the one over there quite easily." She pointed at a display of objects on the bookshelf under the window: brown leather moccasins, a change purse, two clay ashtrays, and the box, its top decorated with tiles. "Or you could make a trivet," she added. "I think we've got one more trivet kit left."

I nodded again and swallowed. The young woman was obviously anxious to get me started on a suitable project. Heads around the table had turned to stare. I looked down at the tiles, longing to sink back into anonymity. "Thank you," I mumbled. "I'll just think about it a minute."

"Okay," the therapist said. "Let me know when you decide."

I stared at the brown tiles I had pulled out, then sighed and glanced around the table. Other patients sat sewing leather boots or belts from kits as they talked. Claire was knitting something blue on circular needles as she chatted with a gray-haired woman from the room across from ours. A pimply girl sat opposite me, her chin resting on an unopened boot-making kit. I saw the therapist glance at her. She was a problem. Would I be another? "Let me know when you decide," the therapist had said. But if I had been able to decide, I wouldn't be here; I would have finished off that bottle of Ortho spray. I glanced back at the box decorated with orange tiles. If I made a box like that, what would I put in it? Stamps, paper clips? The therapist didn't understand; if I had been able to organize my desk, my studio, my life, I would not be in this place.

I lined four blue tiles together. Blue was for my profession, my happy painting talent. I saw myself in a gallery, mingling with friends, smiling at compliments, embracing newcomers. It was a small unpretentious show, but the critics had been kind. I put a black square flecked with gold at the end of the line and imagined

myself in a low-necked blouse, leaning toward a guest at a candlelit dinner table, graceful and amusing. I fished out another tile. That deep green was Mikey's color—the color of his giggling and rolling on the grass, and that yellow was for Laura with her pale, silky hair, and this light blue was for a third baby, who would never hear his mother yell at him, nor remember a certain strong smell in the night.

"How's that design coming?" the therapist asked, and bent over me to peer at the tiles.

"Oh," I said and covered them with my hands. "I . . . I haven't got a design really. I mean. . . . " I pulled the squares together in a jumble and half-rose from the table. "I don't think I really want to. . . . " I glanced down the table again. The pimply girl had started sewing some turquoise boots. I nodded at them. "If you don't mind, I'll just begin on some of those instead."

TERRY

"I'm completely bushed," I told Susan one afternoon at *Portfolio*. "These classes, the preparations, now this damn article Kurt wants, and commuting out to that hospital night after night. I mean, I'm just done in."

"You've got reason to be," Susan said. "How're the kids doing? How's Mikey?"

"Not great. He doesn't say much. He's just sort of sullen and apart."

"He was great on the motorcycle, though. Remember?" I nodded and felt her eyes studying me. "You're not going to the hospital tonight, are you?" I shook my head. "Then why don't you come over to my place? I'll fix dinner." She was leaning against the file cabinet, large and blonde in her blue slacks, her turtleneck jersey showing off the shape of her breasts and the long curve of her athletic back.

"Well. . . . " I hesitated, then nodded. "That'd be great." I felt uneasy, but why not, for God's sake? I needed some warmth, some sex, and hell, Susan knew my situation. She had no illusions about our relationship now. I'd be at her place in a couple of

hours, I told her, after I took the sitter home and got the kids' supper. I'd take off as soon as Liz appeared.

Mrs. Pierce, the heavy, middle-aged sitter, talked about her swollen legs as I drove her home, her water retention, and the dreadful way Berkeley had gone downhill since all those Negroes moved in; I barely heard her. Laura was strapped into the baby seat behind, but Mikey had refused to come. He insisted that he wanted to watch *The Flintstones*. When I got back to the house, the Flintstones were chattering to each other in the living room, but Mikey was not there.

"Mikey," I shouted. "Mikey." Where the hell was he and where was Liz? Why couldn't she ever come when she said she was going to? Mikey appeared in the hall doorway after a moment and stood frowning at me. "What were you doing?" I yelled.

"Nothing." He looked down at the floor.

"What's the matter anyway?" But I didn't want to know; I was too rushed, too tired. I didn't have the patience to begin exploring some convoluted problem of my son's. I wanted to shower, change, and be off. "I'm in a hurry," I told him. "I have to go out. Turn off the television and get into your pajamas now. Okay?"

Mikey stared at me with suspicious eyes. I turned to the kitchen, maddened by his secretiveness, and jerked open the refrigerator door. Oh God, I was supposed to market, I remembered. I'd promised Liz. Never mind. There were frozen chicken pies in the freezer and.... I turned to the sink. Laura's bib lay crumpled on the drainboard, and the faucet was dripping rhythmically into a soaking pan.

"You left my shoe in the car, Daddy."

"What?" I turned. Laura was standing in the doorway in her pink undershirt, wearing one sandal. "You don't need it now. You're going to bed. I'll get it in the morning." I jerked out the frozen pies and shoved them in the oven. The hell with the cookie sheet. The bottom of the oven was so black and crusted now, who cared if the pies dripped on it? The phone rang beside me on the wall.

"Terry?" It was Liz. "Listen, I'm sorry. I've got to finish these costume sketches tonight. I'll be home by nine. Okay? Listen.

There was a message for you. Ralph Somebody-or-other called to say the mid-term grades have to be in for the freshmen tomorrow. Did you know that?"

"Tomorrow?" I turned back to the stove.

"Something about a directive from the dean. I should have written it down. I'm sorry."

"Don't worry," I told her. "Actually I've got most of those papers done."

I hung up the phone and moved to the window. I didn't have most of those papers done at all; I saw the sliding pyramid of them at the side of my desk, waiting to be read and graded. But I wasn't giving up my date with Susan, dammit. I'd leave her place early—five or six in the morning maybe. I wouldn't go to *Portfolio* tomorrow; I'd just stay here until I finished them.

"Daddy." Mikey was beside my elbow, his whisper was urgent. "There's a man outside the window. He came during *The Flintstones*."

I frowned at Mikey and took his hand. There was no man at the window. I got the flashlight from the hall table and held Mikey close, as I shone it down into the dim yard.

"It's that bush," Mikey said, pointing.

"There's nothing there, Mister Man, nothing to be afraid of." I waved the flashlight back and forth so that he could see the familiar yard. "Things look funny in the dark sometimes and . . . and when you're worried. . . ."

"It was the doctor," Mikey said. "I saw him, Daddy."

I knelt down. "What doctor, Mikey? Mummy's doctor, you mean?"

Mikey nodded. "He said it was my fault, Daddy. He said so."

"Look, Mikey," I put my arm around him. "You're not to blame for anything. See? Mummy's sick, but it's not because of you or me or Laura or Aunt Liz. Understand?" I pulled him close against me; the metal buckle on his cowboy belt pressed against my shirt. "I know what you feel. I worry too, Mikey. I keep thinking that it's my fault. But it isn't. Honestly, Mike. It isn't either one of us. Mummy has a sickness that's making her sad, but she's going to get over it. She's going to get well and come home." Mikey tipped his head back to study me. "Understand?" I asked again. Mikey nodded slowly, but it wasn't just a matter of understanding; I knew that.

100

As I rose and took his hand, I saw Laura standing on the couch in her undershirt. What did she think, I wondered. What inchoate guilt was she feeling?

"Susan, listen," I said into the phone. "I can't do it tonight. I can't come."

"Oh, hell, Terry. Why not?"

"I'm really sorry. It's just that . . . that. . . . I have to get the freshman grades in tomorrow and Liz hasn't gotten home yet and. . . ."

"But I bought two steaks."

"Listen," I started again. "Mikey's had a bad time tonight." I pressed his head against my thigh, as I went on. "He thought he saw a man at the window and. . . ."

"Oh." She paused a moment. "I get the picture, Terry. I'll put the steaks in the freezer. Okay?"

I sunk into the chair and pulled Mikey up into my lap. He twisted to peer in the oven window at the lighted interior. "You only put in two pies, Daddy. Aren't you going to have supper with me and Laura?"

"I'll put in another one in a minute," I told him and let my feet slide out so that they rested on my heels. "We'll have supper and read awhile. Okay?" Mikey nodded and rubbed his furry head back and forth against my chest.

"We can have Eskimo pies for dessert," Laura announced and pushed up against my knee.

"We can," I said. "Chicken pies first, then Eskimo pies after. We'll have pies and pies." I circled her waist with my free arm as Mikey settled against my chest. There was no rush now, I thought. We could just sit here quietly awhile, listening to the faucet water dripping, plink, plunk, plink into the soaking pan.

LIZ

I'd gone back to Kurt's apartment to pick up some clothes and when I heard Kurt's key in the lock, I emerged from the bedroom holding a pair of shoes.

"Well, well. The long lost princess." Kurt gave me an angry look as he stood, cradling the mail in the crook of his arm. "Are you coming home or just further denuding the place?"

"I can't come back now, Kurt. I've told you that," I said.

"Margo timed this pretty expertly, didn't she? *The Crucible*'s over and you have a month off before rehearsals of *A Doll's House* begin. Besides which, she is delighted to have you take a break in your affair with me."

"Look, Kurt," I pleaded. "Don't be sarcastic about my sister right now. Okay?"

"Why can't you hire a live-in sitter? There're plenty around."

"It isn't that simple. The kids are used to me, and besides, Terry can't afford one. You know that."

"But he'll accept your help for free for two full weeks, which effectively louses up our relationship."

"It's not his choice. We're in a crisis."

"Yes, I suppose it is a crisis," Kurt said. He put the mail on the table and moved over to me. "I'm sorry. I didn't mean to sound harsh." He put his arm around my shoulders and let his hand slide down to my breast. "Poor baby," he said. "I've missed you. Missed you a lot. How about if we go take a morning nap?"

I smiled and let the shoes drop on the couch. He pulled my hand and led me into the bedroom. I drank in his tobacco smell as he lifted my sweater over my head. Kurt moved to the closet; I pulled off my skirt, and reached behind me to unfasten my bra. When I turned to look back, Kurt was watching me, still fully dressed.

"On second thought, let's forget it," he said and sat down heavily on the end of the bed. "I've got work to do."

Need pulsed in me like a living thing. I pressed myself against him and stroked his neck. "Please," I said. "It won't take long."

"Next you'll tell me it won't take long for Margo to get herself discharged from that place."

"The doctor's optimistic," I whispered. "She could be home in another month."

"Another month." Kurt groaned, put his elbows on his knees, and stared down at the floor. "Christ, Liz. You're going to put our relationship on hold for a whole month?" He lifted his eyes a moment, then gazed down at the floor again. "Right now everything's messed up for me. Those New York sons of bitches won't cough up enough to cover the pictures for this issue. I can't do it without photographs, for God's sake. I . . . I've got to get that money. These issues are running me over a thousand each month

and. . . . Don't you see? I'm already overdrawn." He let his head drop. "Ah, Christ. I can't fail again."

"You won't," I said. "You won't." I kissed his ear. "I can lend you something." I waited, but Kurt did not raise his head. "Look. I'll stay tonight. Okay? Terry doesn't need to go to the hospital. I'll call his office now and tell him I'm staying here."

Kurt rose so quickly that I fell sideways on the unmade bed. "Forget it," he said and turned to the door. "Go back there, if that's what you want to do. I've got my troubles and obviously you have yours." He stood in the doorway a moment, looking in at me. "But just remember, Liz, this is your choice."

I clutched my arms around my breasts as I sat listening to his footsteps in the hall, then the metallic click as the apartment door closed behind him. I shivered and pulled the quilt around me. Who was this cruel bastard, I wondered, and why had I fallen in love with him anyway?

TERRY

Margo had been at Remington almost a week when Dr. Murray asked me whether I thought her father could visit her. "The doctor mentioned it yesterday," I told Liz one evening, "but I just haven't called Jack yet." Liz was folding towels on the kitchen table. She twisted to look back at the clock.

"It's eleven his time," she said. "Why don't you do it now? He's probably still up." I stared across at her. Her red shirt was pushed down into her faded dungarees, and a woven Mexican belt, pulled through the denim loops, showed off her trim waist. My eyes moved down to the neat curve of her behind. Her body had the same lithe kind of energy Margo's imparted, but there was a difference . . . a . . . I thought of Kurt and turned to the phone.

I had talked to Jack only once since Margo had been transferred to Remington. He had seemed sad, but now it occurred to me that a visit might reassure him. She was beginning to make progress, after all. I would suggest that he fly out next week and stay with us, I decided. "Jack," I said, when his voice answered. "I want to catch you up on the situation with Margo." He

grunted and I reported on Dr. Murray, the manic-depressive diagnosis, and Margo's current depression. He was silent throughout my explanation and I began to yearn for some reaction. "Dr. Murray suggested that you come out," I said. "You could stay with us and go visit her. He thinks it might help. So do I," I added, convinced that the plan was good.

"I can't," he said.

"But Jack," I began. "She's your daughter. You're paying all outdoors for this treatment and...."

"I can't," Jack repeated. "I'd do it if I could, but I can't. These primaries are crucial. We've got a real crisis in West Virginia. I tell you I just can't." His voice trembled and he paused. Were the primaries really the reason? Surely he could assign someone else to cover things for a couple of days while he visited his own child. All at once I felt disgusted. "Okay," I said. "I'll call you later."

"Jesus," I said to Liz. "I can't believe that."

"He's scared," she said, after I'd filled her in. "Don't you see?"

"I know, but he's her father. I mean my dad would do anything in this situation. He'd...."

"He isn't your dad, Terry," Liz broke in. "He's ours and he's a strange man."

"He sure as hell is," I said. "I never did understand him much. Now I don't think I understand him at all. I mean, I appreciate the fact that he's paying the bills. I really do. Christ, she'd probably be in a state hospital if it weren't for Jack. But my God, Liz...."

Liz flung the towel she was folding back into the basket and plunked down opposite me at the kitchen table. "You have to understand a few things, Terry," she said. "Daddy's been through his own terrible times. But he loves us; he really does, Margo and me. And...." She swung one foot in its red Turkish boot up on the empty chair between us. I glanced down at it and sighed. "I don't think he could bear to see Margo now. He loves her too much. Can you understand that?"

I nodded, but I didn't really.

DR. MURRAY

The patterns of manic-depressive psychosis can be bewildering at times, even to the professional. You have a patient desperately depressed one day, sunk in guilt and barely able to articulate her agony. Then the next day she's manic, full of talk and plans, eager to understand her illness, and very eager to convince you that she's well enough to be discharged. But Margo Sullivan was definitely not ready to leave. The manic phase that she had entered was as dangerous as the depressive one that had preceded it, more so perhaps, although, of course, she couldn't appreciate that.

MARGO

I sat hunched on the plastic-covered couch in the patients' lounge, writing in my journal, a gray blanket around my shoulders. The standing lamp beside the couch enclosed me in its orange glow, illuminating the journal and an open book of poetry in its circle of light. But beyond it the room was dim, the television screen dark. The jigsaw puzzles and the games—Parcheesi and Monopoly—were stacked on the shelf beyond the empty table, and the line of chairs by the door was in shadow.

 I loved these long sleepless nights, despite Dr. Murray's concern about them; they gave me time alone to think and read. I always slept easily for the first two hours, when all the patients went to bed. But at midnight I was wide awake once again and took a second dose of chloral. Under its influence, I slept another hour, but when I woke at one, the night nurse could not give me any further medication. Knowing I would not go back to sleep, I waited twenty minutes dutifully, then rose. I moved cautiously so that I would not disturb my roomates, gathered up my journal, my copy of Yeats, the blanket from my bed, my pen and pencils, and went down the corridor to the lounge. There I began to write, as I had done every night since my change had begun five days earlier.

 I peered down at the open book of poetry.

> Things fall apart; the centre cannot hold; . . .
> The darkness drops again; but now I know. . . .

I looked up. A strip of gray light had appeared between the two curtains at the long window. I shrugged back the blanket and rose. One cramped foot was asleep, making me limp as I moved across the floor. Out in the parking lot, I could see the lone shape of the gray hospital station wagon and the sagging chain between the metal posts at the entrance. "Who can distinguish darkness from the soul?"

I turned. Back on the couch, my open notebook was riding the gray wave of the blanket. I could see underlinings and arrows pointing up the margin. Paper clips held newspaper articles I had cut out. There were letters and a prayer. I sighed. It was too much, all that writing and thinking, too much.

The lighted nurse's station shone like a beacon in the dim hall. Behind the glass window, Mrs. Baxter, the night nurse, sat at the desk in her nylon uniform. A white sweater hung from the back of her chair and a wisp of steam was rising from a paper cup of coffee near her elbow. I stood peering in. The open chart in front of her looked luminous in the glow of the low gooseneck lamp.

"Hi," I said. "How's it going?"

"Okay." Mrs Baxter leaned back to stretch. "Quiet night." She nodded at an open package of Chiclets lying on the counter. "Want one?" I picked up a smooth white square and bit down; a sharp, sugary taste of peppermint flooded my mouth. The taste of sanity, I thought, and closed my eyes. How can I get it back again?

Lunch was over. A door was unlocked at the end of the hall. Three doctors in white medical coats entered—Dr. Murray and two others. I watched them move to the nurse's station, as I sat waiting. Would Dr. Murray take the new girl first, or would he begin with me? I pulled my notebook from the back pocket of my corduroy pants and opened it to my list. "Visit children Sunday? Home the following weekend? Does Daddy's absorption in his work explain my compulsiveness about my painting?"

"Margo." Dr. Murray nodded at me. I jammed my notebook back into my pocket, and followed him down the hall to the

consultation room. Surely I was his favorite patient, lively and refreshing, after all the depressing ones. We stood together at the frontiers of psychiatric understanding—he and I—the compassionate doctor and the bright, articulate patient. Together we would show the scientific world how the horrors of depression could be defeated and understood.

Peggy and Claire and I were having coffee in OT when the new girl joined us. She sat down at the battered table and listened as we talked of Peggy's dinner out with her husband the night before and of my possible discharge soon. Her wrists were freshly bandaged with white gauze, and she stretched one forearm out on the table and picked at the edge of one of her dressings. "Jeez," she said. "I just hope the scars don't show."

"They probably won't be much," Peggy said. "Look at mine." She turned her hands, with their red fingernails, palms up, exposing two neat marks on her wrists. "You just say you got them playing polo. That's what I tell anybody who asks. What the hell? It's nobody's business anyway." The girl stared, then picked at the gauze again.

Claire put one hand on the table and turned it over, revealing a long pink line. "You get used to it," she said, staring down at the scar. "I don't even think about mine anymore—much."

"I'm the only one here without any," I announced. "I tried poison instead. I thought it would be neater, but it wasn't." The others laughed. The window was open, and beyond the dark metal bars, the slender leaves of a pepper tree glittered in the sun. The drone of a plane drifted down from high above. "Strange society we are," I said and smiled. But it didn't seem particularly strange.

TERRY

Margo's mood changed abruptly her third week in the hospital. Dr. Murray had told me he expected an upswing soon in her manic-depressive pattern, and it came just two days after we talked. All at once she was full of plans. I went out there on a Wednesday night and was astonished at the difference. Her hair was washed and shiny, her face animated, and she was wearing a

bright blue blouse that Liz had sent. I was relieved, of course, and pleased, but oddly enough I was irritated too. I mean, we'd been through all that anguish, all that mess, and then, snap, Margo seemed to assume it was just over, gone.

"I've had this great idea, honey," she said. "You could come and give a seminar on the ward about Georgia O'Keeffe. She's a major figure in contemporary art now, and loads of people would be interested. You could bring your slides. I'm sure I could borrow a projector and a screen and...."

"Why don't you talk it over with Dr. Murray first," I broke in, imagining some of those dull, sad-eyed patients I'd met, staring at me as I chattered on about Modernism and representational art. Christ.

"Oh, he'll be pleased," Margo insisted. "The doctors love to have patients take the initiative. After all, we have loads of time."

I knew I must exercise patience, and yet Margo's bossy manner made patience peculiarly difficult. I confessed my jumbled feelings to Dr. Murray, who said that, in fact, they were pretty natural and he predicted correctly that Margo would forget the plan for the O'Keeffe lecture within a day or two. But there were other projects. And there was a night when she pulled me into an embrace in the waiting room, kissing me long and deeply. I was embarrassed; the door to the hall was wide open. I knew from Dr. Murray that sexiness was characteristic of the manic period. "It's the sex in the bathtub period," he said and laughed. I didn't smile. The warm supportive sex that Margo and I had once known seemed remote and I was too busy trying to keep on top of things at work and at home to brood over my own deprivations anymore. I felt like a work horse, just trying to keep on—one more day at the office, one more set of classes, one more evening reading to the kids, working until two, taking Mikey into my bed before dawn.

Within two weeks Margo was much calmer and more rational. She talked of coming home and Dr. Murray allowed her a trial weekend. All of us were tense—scared, really. She climbed the front steps and called to the children as she came into the hall. Laura came running and jumped into her arms, but Mikey stayed at the top of the stairs, watching and suspicious. Liz had made a celebration dinner—barbecued chicken, almond rice, and salad.

She and I were so nervous, we were falling over each other out there in the yard, getting pot holders, briquettes, lighter fluid. "Excuse me." "That's all right." "Excuse me." But Margo was surprisingly serene. She sat on the chaise longue with Laura in her lap, talking a little and smiling as she watched us. Gradually we relaxed, all but Mikey. Breakfast was easy. We took a drive and had lunch out, then it was time to take Margo back to the hospital again.

"How do you think it went?" I asked Liz that night.

"She was a lot better than we were, if you ask me." I agreed. Discharge was next. Dr. Murray warned that it was crucial for Margo to keep her weekly out-patient appointments with him, take it slowly, and see how things went.

She was to leave on a Friday afternoon. I was excited, but apprehensive, and I thought Margo was too. For some reason I remember my drive home the night before, although it was the same drive I had made dozens of times. I left the hospital about six. It was late March, a spring evening in California. I drove through the suburban town beyond the hospital, as I always did on my way to the freeway. Sprinklers were turning on the lawns, and some kids called out to each other as they bicycled past. In one driveway a car hood was raised, and two men were bent over, peering down at the engine. Lamps had been lighted here and there in picture windows, and I could see blue squares of television screens behind. Margo and I used to laugh about the boring sameness of such neighborhoods, but that night I leaned on the steering wheel at a stoplight and stared. It seemed such a luxury—men coming home to supper, women turning on lights and putting potatoes in the oven, children wheeling their bicycles into the garage. They weren't thinking about the risks of suicide, the length of this manic stage or that depressive one, the decision for discharge now instead of one more week of hospitalization. They were talking about replacing the ball bearings, rotating the tires, or buying some tomato plants on Saturday for the garden. Ordinary life—could we possess it again? That night it seemed precious and remote to me.

Chapter 8

MARGO

AFTER Terry drove me home from the hospital, I sat down at the kitchen table with Liz, and pulled Laura into my lap, grateful for her warm weight. My daughter, I thought, my normal little girl; we will be together now, the two women of the family. I glanced around the kitchen. My overnight visit two days earlier had erased the strangeness of my return, and I felt comfortable in that familiar space. Rectangles of sun lay on the linoleum floor, and the heart-shaped leaves of the philodendron plant on the window sill shone in the light. Mabel was dozing above us on the warm top of the refrigerator and, as I sat talking with my sister, it seemed to me that I could slip back into my old job easily and push the horror of my attempted poisoning far behind.

Mikey was off at his swimming lesson, and I rose when I heard him open the front door. Liz had told him I was coming home that afternoon, but I thought he'd be surprised that I was there in time for lunch. "Guess what? I'm home," I called out. "We're in the kitchen." Getting no answer, I went out into the hall. Mikey stood staring at my suitcase and the two cartons of books and art supplies that Terry had deposited beside the table before he took off for class.

"What's all this stuff?" Mikey asked and jerked his thumb at the pile. He was carrying his swim trunks rolled in a damp towel under his arm, and his striped jersey hung out over the top of his camper shorts.

"Those are my things from the hospital," I told him. "I'm home. I don't have to go back."

"Ever?" Mikey eyed me sternly.

"Well, just for appointments with Dr. Murray every week, but not to live there. You remember. I told you Sunday. I'm home now for good." I smiled.

Mikey stared at me. "I bet you won't stay," he said. "I bet you fifty cents you'll have to go back there again."

"Mikey!" I drew in my breath and looked down at the books. "Mikey, I'm well. Dr. Murray says that...." I stopped and put my arm around him. My job was not going to be so easy after all. "Come have lunch." I heard my voice tremble. "I'll make you a peanut butter and jelly sandwich. Okay?"

TERRY

I knew I should feel cautious about Margo's return. Dr. Murray had explained that we must be alert to danger symptoms like overtalking and sleeplessness, and I tried to watch. But joy kept bounding in like a big affectionate dog. Once again there were the smells of Margo's cooking in the kitchen, her flower arrangements on the table, her singing in the bathroom, and her warm body beside me in bed. Mikey seemed wary at first, but by the weekend I could hear him babbling away up in her studio, as he worked along beside his mother. I had thought Mikey and Laura might miss Liz, but both children seemed so caught up in the excitement of Margo's return that they appeared almost oblivious to the fact that their aunt had gone. I knew Margo was worried about Liz's affair. "If I just trusted Kurt more," she said one night. "I mean if I...." She stopped herself. It was possible that Kurt would become part of the family; in a way he already had.

I was concerned too, but all at once I was distracted by a stroke of good luck. I'd submitted teaching applications for summer school to half a dozen area colleges with not much hope, although my friend at San Francisco State had thought he could find me a part-time position at least. Two weeks before the summer term began, he called to tell me that Hopkins, the guy who usually did the art history courses, had had a heart attack,

and they wanted me to step in. I'd met Hopkins only once, an elegant white-haired little man who was widely respected. I conveyed my concern, asked about the prognosis, which was good apparently, but, as I talked, I could feel my excitement boiling up inside. Hopkins' trauma could prove a major opportunity for me.

I leapt up the stairs, without putting down my briefcase, and stood panting in the door of the bathroom. Margo was kneeling beside the tub, washing Laura's hair. "Guess what? I've got the job at San Francisco State. Professor Hopkins had a heart attack Sunday. It's mild. I mean, he'll be okay, but he can't teach this summer and they want me to do all three courses. Full-time teaching for the whole summer." Margo gave a shriek, then stood up in her long damp apron, and threw her wet arms around my neck.

"Poor guy," she said, stepping back. "You said they think he'll be okay?" I nodded. "Oh, but lucky, lucky us."

We sat in the kitchen later, talking about the possibility that the summer school job might lead to something permanent. My real ambition was the University of California at Berkeley, of course. I had published three articles in *Portfolio*, and there would be a long one on O'Keeffe in the September issue, but more important, I'd had a letter from an editor at Knopf who said he was interested in the book I'd written from my dissertation. If I got a Knopf contract, I would definitely be in the running at Berkeley, I thought. Meantime, San Francisco State was a wonderful boon. The salary was okay and the job would look good on my vita. Part of Margo's pleasure, I realized, was the fact that I would not be working for Kurt. She said she thought my break with him might encourage Liz to break with him too. I wasn't confident about that, but at least my move would give Margo a clear, untroubled sense about my work for the summer, and eliminate Kurt from our own lives for a while—or so I thought.

KURT

I was planning a fall issue on children's book illustrators, and it was after Terry left *Portfolio* that Liz told me that her mother, Yolanda, had been quite a well-known illustrator in the field. I

knew their father was a distinguished journalist, of course, but I hadn't realized that their mother had achieved considerable distinction in her own right. Liz was evasive about her parents, witholding bits of information, reprimanding me for my curiosity. But when she realized I was planning an issue on children's book illustrators, she told me about her mother. Yolanda had died fifteen years earlier, but she was still remembered as an original artist in the field, although her body of work was small. I got as much as I could out of Liz, but I wanted to talk with Margo. I decided to commission her to paint my portrait. A portrait would give me uninterrupted time alone with her, and besides, I liked the idea of having a painting of myself.

Margo seemed startled by my request, as though she'd like to turn it down, but, as I suspected, she was too professional to refuse a good job for personal reasons. She began by taking a series of photographs. A week later she called to arrange the first sitting. I went up into her studio and, as I peered at what she'd done, I reminded myself that the portrait wasn't the real point of this project. The face Margo had painted seemed curiously sad. The photographs showed the me I like—a bright, energetic, and yes, quite handsome man, bearded and attractive. But on the canvas, my eyes gazed downward, meditative, imprisoned almost.

"Is that the way you see me?" I laughed a little.

"It's probably different from the way you do," Margo said.

"Well, yes. I mean this guy looks kind of depressed, or at least contemplative."

"You have your contemplative moments, Kurt," she said and waved me to the chair where I was to sit. When I looked at the canvas forty minutes later, I liked it better. I moved close to Margo and leaned one elbow against the slanting wall just behind her. Margo glanced up at me with an uneasy look, but I didn't step back. "I'm doing the fall issue on children's book illustrators."

"I know," she said in a low voice.

"I plan to include your mother," I went on. "She had a rather brilliant career for a woman at that time." Margo nodded and continued to paint. "You and Liz certainly come by your creative talents naturally. I mean there's a real tradition of creativity in your family." I returned to the chair. I didn't want to overdo my

seductiveness. Margo nodded again, but did not speak. She seemed to be working on my shirt now, my shoulders. "Her death must have been a terrible shock." I watched Margo surreptitiously. She had begun a series of strokes at the top, moving her brush back and forth. "I don't mean to bring up a painful subject," I said. "But naturally her death is part of the whole picture I'm trying to reconstruct."

Margo jerked her head up. Her long braid swung back over her shoulder. She gave me a sharp look, but did not speak. "Reviewing her work, I realized how much of it was genuinely new and experimental in a period when an awful lot of art for children consisted of calico kitty cats and flowers." I pulled my pipe from my jacket pocket, then my lighter. "All right if I smoke up here?" Margo nodded. "Her work is remarkable, yet uneven, you know. There are periods when she was enormously productive and then long periods when she didn't seem to do much at all."

Margo stirred the paint on her palette and looked back at the canvas. I waited, wanting her to speak, but she did not. "When your father was in Europe during the war, she did some wonderful illustrations. Some of her best work. You must have been aware of it."

"I was eleven, Kurt. I was just trying to survive the sixth grade."

"Yes, of course." I smiled and tamped the tobacco down in the bowl of my pipe. "Do you think it's possible that she had a pattern of manic-depressive psychosis, such as you've experienced?" Margo put her palette down and squeezed the fingers of one hand.

"I don't know." Her voice was tense. "When I talk about that, I talk about it with my doctor." She locked her arms around her. "Besides I really don't think all that has much to do with Mom's work or with your article. Do you?"

"I'm not sure," I said. "I'm really not sure." I moved over to the easel and stood gazing at the painting. I leaned my elbow against the wall just above her once again and breathed in the odor of perspiration and cologne that she exuded—4711, Kölnisch Wasser, I decided. "I've thought about your mother's death a lot," I began. "It's a painful subject for you and Liz, of course. But if . . . if I could help you both see that. . . . "

Margo took a step back. "I have Dr. Murray, Kurt, and Liz has...." She pushed her braid back over her shoulder. "What are you intimating anyway? Thousands of people die in car accidents every year."

"And if it was a suicide?"

Margo stared at me. "We were never told that, not by Daddy, not by Aunt Libby or...." Margo twisted a button on her smock and glanced behind her at the attic stairs. "This is why you wanted me to paint you, isn't it?" she said. "You wanted to prod me about the possibility of her suicide." She paused and stared at me for a long minute. "You're a dangerous man, Kurt. I've just realized that." She turned, pulled her smock off, and hung it on a nail on the wall. "I won't need you to sit again. I'm going to work from the photographs now. I'll let you know when it's done and, as I told you in the beginning, I will need a second payment by the end of the month."

I was impressed by her show of professionalism, and irritated too. "You're as evasive as your sister," I said, "and the habit is at least as destructive for you as it is for her—a good deal more so probably."

"You may be trying to help me, Kurt," Margo said. "But I have a doctor. Yolanda was my mother; she's simply the subject of another article for you. I mean, there's such a thing as tact, consideration for your mistress, if not for your friend's wife."

"Good God, Margo," I exploded. "Of course. We're all friends. You don't need to make me seem satanic. I'm just pointing out that sometimes family secrets have to be confronted and examined in order to get a new measure of freedom. I mean, often when you can talk about them and confront them directly they're not so terrible—they become understandable, in fact." I bent over a metal wastebasket beside me and knocked out my pipe. When I straightened, Margo's face was flushed and tense.

"You talk a good Freudian line, Kurt, and I'm sure it's useful for some of your investigations. But not here. Not with my mother. I don't want that."

"All right," I said. "I understand." I paused in the front hall. "Has Liz told you about her Seattle possibility?" I knew perfectly well that she couldn't have, since the call had only come that morning, but I went on. "They've offered her Ranevskaya in *The*

Cherry Orchard. It's quite a coup. I don't know whether she's going to do it, but I hope so. Things like this don't come along every day."

I stood smiling down at Margo, confident that she had no inkling of the bitter fight I had had with her sister hours earlier about her threat of leaving me and going to Seattle for two months. I brushed Margo's cheek with a brotherly kiss as I said good-bye. I didn't want to cause Margo pain, and certainly not Liz, though God knew where that relationship was going. But an article for my journal, my *Portfolio*—that transcended the personal; it had to. Work has always come first with me and it always will.

LIZ

"I've decided to go to Seattle," I told Margo the next morning. "They've offered me the lead in *The Cherry Orchard*."

"I know," she said and smiled at me from the stove. "Kurt told me about it yesterday." Goddamn him, I thought. Couldn't he even let me report my own news? "It's wonderful, Liz. When will you leave? How long will you be gone?"

"About two months, I think. The pay's lousy and...." I paused. I wanted to tell Margo about Kurt and me, about our fight, and about my pain, my uncertainty. But I waited. "It's a great part, you know," I said, stalling. "I really like the director. I've seen some of his other work. They go into rehearsal Wednesday. So I'm going to fly up Sunday. That'll give me a couple of days to get settled."

"Oh, Liz, terrific," Margo said. She sat down opposite me, stretched her hand out and squeezed mine. "Terrific." I smiled back, anxious to begin on my problems with Kurt.

"What does Kurt think?" Margo demanded.

"A lot," I said and looked down at the table. "That I'm running away from an important relationship, that I'm abandoning past identities," I went on, imitating Kurt's language, "that I'm on an unrealistic quest for power and...." I stopped and stared at her, confused by my own evasiveness. Margo laughed, but I looked down. What was the matter? Why couldn't I tell my own sister about my pain?

"This is such wonderful news. What about Diane?" she asked, referring to a Seattle cousin of ours. "You could live with her awhile, couldn't you? Or does she have a roommate?"

"The roommate left last month, and Diane's delighted," I reported. "She says it's bound to work because we're both messy and love red. I'm supposed to bring two loaves of sourdough bread and lots of pictures of Mikey and Laura." We laughed. I chattered on, ignoring my need for a therapeutic talk, and yet I couldn't avoid the subject of Kurt completely.

"Look, Marg," I broke in finally, interrupting myself. "We both know that one reason you're so pleased is that you think I'm leaving Kurt. But I'm not. At least I haven't decided that. We haven't, I mean. I'm taking a break to think about the whole relationship. That's all. I may go back to him when I come home or I may not. I just don't know. See?"

"Sure. Of course." Margo smiled. "I love you, but I can't run your life—though I sure as hell try." She laughed and I joined in, but I felt tense.

"How's Kurt's portrait coming?" I asked.

"Okay. Not bad. I think I can finish it in another week maybe."

I looked at her sharply. "No more sittings?"

"No."

"Can you really do it from just the photographs?"

"I think so. I took a good set, and I've got the mornings now since Laura's started playschool, and . . . and. . . ." Margo gazed out the window and let out a sigh. "You know, it's queer about mornings," she said. "Sometimes I think of what the gang's doing back in OT right now. I can almost smell that bitter-tasting Sanka we used to make, and the reek of those leatherette boots. I can even hear the piano in the big room and those sappy tunes one of the guys from the men's ward used to play—'It's only a paper moon, sailing over a cardboard sky,'" she sang softly, " 'but it wouldn't be make-believe if you believed in me.' "

I stared. Margo was still gazing toward the window. "It's probably pretty natural to feel a little homesick for the hospital sometimes," I began. "I mean, it was cozy and safe there, and now you're back here with all these responsibilities."

"That's the way I want it," Margo said, turning back to me.

Her voice was harsh. "I never want to go back to that place again. Ever."

I sighed. "What did you and Kurt talk about yesterday?" I asked. It was a stupid question; Kurt and I had argued over his conversation with Margo part of the night.

"He asked me a lot of questions about Mom." Margo slung one arm over the back of the kitchen chair, as if to show me she was relaxed. "I know Kurt means a lot to you, Liz. But there were moments yesterday afternoon when I wanted to wheel around and punch him in the nose. Punch him or . . . or . . . "

"I know," I said and smiled slowly. "He has that effect sometimes; it's part of his attraction."

Margo gazed down at the surface of the wooden table as she traced an oval in the brown grain with her forefinger. She looked up at me all at once. "Liz, do you think Mom committed suicide?"

"I don't know." I sighed. "But I think it's stupid of Kurt to stir all that stuff up. What difference does it make? I mean, really. In the end, it's her death we have to cope with, her loss, not the way she died. We loved her, and she's gone. That's enough right there—we were only eleven and thirteen when it happened, for God's sake. We're still coping. Why add the other?"

"Because . . . because," Margo started, "it just might be true and if it is, we ought to know it, shouldn't we?"

"I don't think so," I said and felt my hands tremble, as I lifted my mug. "I don't think so at all. Kurt and I have argued about this. I mean, come on, Marg, he isn't the first to suggest it. Suicide—that she drove off the bridge, that the car wheels didn't just slip in the rain and the dark." I put down my coffee mug and pushed my chair back with a scraping noise. As I rose, I had the eerie feeling that I was delivering lines from a play. "Life is hard enough, Marg," I said. "My God, you, of all people, know that. Leave this alone. Sure, it could have been suicide. Lots of junk is more complicated than we'll ever know. She was depressed at times. Who isn't? But Marg, Marg." I reached out and clutched her wrist. "Don't start on this. Please. I mean what's the point? It can only bring pain." I stood there in my Mexican top, with my earrings hanging down, and gazed at my sister, pleading for something I knew she could not promise.

Margo stared at me for a long minute. "You mean you think it would drive me crazy again?"

"It could," I said and let her arm go. "Yes."
"Maybe you're right, Liz. Maybe I should stop thinking about it, if I can."

TERRY

I loved teaching at San Francisco State. They had a lot of adult students that summer who were motivated and exciting. I was working hard, three courses—six lectures a week, plus discussions—but I was happier than I'd been since I'd left Cambridge. And Margo was well. On Sundays we'd take the kids and drive up into hills for picnics. When I drove over a bump, Laura would shout, "Do it again, Daddy," and we'd all laugh. Driving home in the late afternoon with the sun getting low, Margo would sing, "Jacob's Ladder," "Spanish Johnny," and we'd chime in on the choruses, especially Mikey's favorite, "Casey Jones," I felt as though our luck in California had begun to turn at last.

I called *Portfolio* one morning. I didn't want to talk with Kurt, but I'd made some O'Keeffe slides that I needed to borrow back for a lecture. "He's not around," Susan reported. "He's in Seattle for a couple of weeks." I was thinking of how luxuriously free I was of the guilt and attraction Susan had once represented, when her announcement penetrated.

"Seattle?" I said. "For two weeks?"

"Yes. That on-again, off-again affair with your sister-in-law is on again, apparently." When I passed that information onto Margo, she felt sure that Kurt had gone up to end the affair. I wasn't so certain myself. Two weeks in Seattle was a long break for Kurt, obsessed with work as he always was. I thought it was more likely that he was just enjoying Liz, and that kind of enjoyment or exploitation could drag on for a long time.

MIKEY

I took swimming lessons every Monday and Wednesday morning all summer long. I got to be a Trout; that's for the middle boys. The big boys are Tunas mostly. All the Trouts can go out to the second rope and I got to jump from the big diving board twice. I said I liked it, but it was really scary.

LIZ

I told Margo to meet me at the airport because I wanted to be direct from the start. I felt I'd been away a long time and I didn't want to start out with the old sneaky stuff. Kurt's visit to Seattle was crucial for me; he was his warm, brilliant best. I knew I would go back to him, but I knew, too, that my decision would be hard on my sister.

"Hi," I yelled to her, as I got close to the crowd of people who were waiting for the arriving passengers. Margo looked tired, older somehow. Still I must have seemed haggard myself, after those weeks of long hours, my face pimply from the heavy make-up, and my hair a stiff blonde this time, which even I knew looked vulgar. Our shoulder strap pocketbooks banged against each other as we hugged. Eight weeks was a long separation.

"Oh, Liz," Margo said. "I'm so glad you're home."

"Listen, let's go get a cup of tea somewhere here," I suggested. "Or a drink even. I have loads to tell."

"Why not go home? The kids are waiting, and I've got your room all fixed. I bought this pretty little quilt for your bed and...."

"Margo, I want to talk to you alone first. Okay? I've got something to tell you and...." She drew back and stared at me.

"You're not coming home to Berkeley, are you?" she said. "Oh Liz, you're going back to Kurt again." I nodded. I felt mean upsetting her, but I'd made my decision.

MIKEY

Aunt Liz says that in Seattle boys stay in bed in the morning and sleep. They don't wake up early and go downstairs. So mostly now I stay in bed until Dad goes into the bathroom. But yesterday morning I got up while it was still dark. I went down to the kitchen to get the tractor for my refrigerator truck, and there was Mom in her bathrobe, sitting at the kitchen table, writing. There was a whole pile of pages beside her.

"What's that?" I pointed to the pages.

"Nothing," she said. "Just a little letter to Aunt Liz." It didn't look little to me. I shivered, because the kitchen floor was cold. "Don't worry, honey," Mom said. "It's all right."

MARGO

I made an impulsive decision; I felt as though the bad stuff was moving close again, and I knew I had to do something fast. The children and I were passing a pet shop, and we stopped at the window to look at the budgie. Below the bird, on his wooden perch, was this darling little poodle puppy, curled up asleep. The children were enchanted and I knew at once that he was the perfect dog for us. He was so bright and cunning, a bit high-strung maybe, but that was natural for a puppy, and he really wasn't expensive at all.

Terry was a little annoyed. He felt we should have talked it over first. Mikey named the puppy Mr. Green Jeans. Mr. Green Jeans did rip off the side of Terry's briefcase the first night and messed up some term papers, but they were still readable, and that briefcase was old anyway. He chewed about six socks and one of Mikey's new shoes that first week, but the back yard was the real problem. Terry fixed the fence so Mr. Green Jeans could play outside, but he was smart about digging holes underneath and getting out; he was clearly a bright little dog. I kept newspapers spread over the floors, but he went on our bed; I didn't tell Terry about that. I was sure he'd get better, and the children loved him. Mikey sat reading to him from *Babar*. Mikey needed to love Mr. Green Jeans, I told myself, and I needed Mikey to love me for buying him.

NANCY

I decided to repaper the family room, since the kids were back in school and I had the time. I went over to Margo's because I'd lent her my scraper and a sponge almost a year ago. She found them in the garage finally, with my help, and we went back up to the kitchen.

"Did you ever finish that job you started in the attic?" I asked as I leaned back against the sink. Margo had told me that she'd just finished this portrait of Kurt Somebody-or-other, a friend of theirs, but I was pretty sure she'd never finished scraping the paper off those walls. "I mean, you started that—when? Last October, wasn't it?"

"Well, I got a little sidetracked." She gave a nervous laugh. She was probably thinking of her six weeks in that hospital, but I wasn't going to ask her about that. "I'll get back to it in time," she said.

"Why not do it now?" I asked. "It's a job you really want to get done. I'll help. I'll bring my stepladder. We can start tomorrow morning." Margo hesitated.

"You're sweet to offer, Nancy," she began. "But I don't know. I . . . I mean, I . . . "

"You said you were going to take a break and get some house things done when you finished that picture of your friend. Now that it's done, why not do the repapering job?" Margo continued to protest. She was obviously worried about imposing, but I insisted. I was curious about that room she calls her studio, and I didn't really want to start on the family room anyway. I went back to the house and brought over an extra bucket and the stepladder, so we'd be all ready to begin as soon as the kids left for school in the morning. I told Margo I'd be there at 8:30 sharp.

Actually, it was mid-morning before we got started. I'm certainly not an artist, but I do know how to handle some basic tools, and I was surprised at how clumsy Margo seemed. No wonder she'd only made two big patches on the far wall the time she'd worked at it before. And the studio? Well, it wasn't all that much, really. There was an easel, of course, and some canvases and things. There was one picture of Terry that looked kind of nice, and one of a gray-haired woman holding a flower pot. That might have been her mother. I meant to ask. But she's dead and I didn't want to begin a lot of talk; after all, we had to work fast in the time we had while the kids were gone.

"You don't have to push so hard," I told her as we stood scraping. "Just relax and move it steadily." She did pretty well for awhile, then she began sort of chipping at it again in this really

tense way. She could've nicked the scraper, and besides it's bad for the wall. We made progress, though, and, when I heard Mikey bang the back door open down below, I realized it was noon.

"Mom, come quick," he yelled from downstairs. "Mr. Green Jeans is out! He's headed toward Panorama." I sighed. That dog was a terrible nuisance. I don't know what Margo was thinking of when she bought it. I mean, a dog has to be trained and walked, and you have to have some discipline. Margo backed down the ladder and put the sponge on the table.

"I'll be right back," she said to me. "I just have to...."

"Hurry," Mikey shouted. "There's traffic." I could hear him panting at the bottom of the ladder stairs. He's such a panicky child.

"You grab the leash," Margo told him. "I'll get the box of puppy bones." She was foolish to treat Mikey that way; she was just catering to his hysteria. They left and I went on scraping, but when they didn't reappear, I decided to go see what was up. I saw them a block ahead of me on Mosswood, Margo leaping down the sidewalk and Mikey rushing after. A heavy garbage truck rounded the corner at Panorama and turned into Mosswood fast. I heard a whine of brakes and saw it stop in the middle of the street with a shudder that shook the branches of the nearby eucalyptus trees. That high brake noise seemed to continue until I realized that either Mikey or Margo was screaming. Margo rushed forward. I was on the other side of Mosswood then and, when I stooped down, I saw the dog lying under the truck, like a white shag rug bunched up beside the thick black tire in front. Margo crawled under, dragged him back and lifted him. I saw blood trickle down one leg of her dungarees in a thin red stream, but the body was limp. The driver had gotten down from his cab and, when I joined them, Margo was telling him that it wasn't his fault, that the puppy kept getting out of the back yard and.... I wanted to stop her. After all, they might have gotten some money out of the city or.... But she put the body down on the parking strip and knelt beside Mikey. "It's all right," she kept saying. "It happened so fast, he couldn't have felt any pain, sweetheart."

Margo insisted on carrying the dog's body back to the house, although I told her she wouldn't be allowed to bury it in the

garden. It wasn't her property after all. Besides, I'm positive there's a city ordinance against burying dead animals in your yard. I called the Animal Rescue League myself, and they came right over. It was obvious by then that we weren't going to get any more scraping done in the attic that afternoon, so I gathered my tools and bucket and went home.

TERRY

Margo got through the afternoon of the accident calmly enough. The Rescue League took the dog's body, but she made a coffin from a cardboard box. The children colored it with crayons and collected flowers to put on top. When I got home, we had a little funeral and had gingerale and cookies afterwards. The children seemed to feel better and went to bed quite peacefully.

But after dinner, when we were alone, Margo began to cry. "I knew he'd dug another tunnel under the fence," she confessed. "I knew it, but I just didn't take time to go out and fix it. Nancy was here and. . . . Oh, God, I could have saved him, but I didn't. His death is all my fault." She wiped back some wetness with the heel of one hand. "I didn't love him enough to get him trained right," she sobbed. "I was the one who bought him, who brought him home, and I'm the one who killed him." Tears were trickling out between her fingers and when she lowered her hands, her face looked swollen. "Everything's crumpled," she said and for a moment I could see Mr. Green Jeans' body, the way she'd described it beside the truck wheels.

"It all looked so good and possible when I got home from the hospital in May: Mikey, Laura, you, and your new job. I was so pleased when Liz left for Seattle, but then there was Kurt's portrait. I never should have done that job. Never. And then when Liz went back to him and. . . ." She turned her wet face to me. "Take me back to the hospital, Terry, before I hurt someone else," she pleaded. "Take me back. Please."

I rose halfway to put my arms around her, but Margo shivered and pulled back. "Don't." She went to the window and stood there silent a moment, staring out. "I'm not going to act like this," she said and turned back to me. "Forget what I just said. I

didn't mean it. I'm going to be all right. I'm going to be fine." She sat down at the table and gripped both my hands in hers. "I'm not going to let you or the kids down again. I'm going to fight this thing, whatever it is. And I'm going to win. I'm not going back to that hospital. Understand?"

I nodded and watched her rise and stand with one forefinger pressed to her lips. "First of all, I'm going to push Nancy back. She gets me off balance. I'm not going to let her boss me around. Okay?" I nodded again and clenched my hands under the table. "Second, I'm going to make an extra appointment with Murray this week, and third . . . third, I'm going to get Kurt to pay up, and I'm going to find some more work fast. I need a commission for a brand new portrait right away. I'll call Larissa Crawford tomorrow and ask her about that friend she suggested last winter."

I went to the window and put my arms around her. "It'd be smart to see Murray," I said. Of her three objectives, that seemed the smartest and most possible.

Margo tipped her head back and looked at me seriously. "You're right," she whispered. "You understand everything."

I stroked her hair as she leaned her head against me and I looked out at the dark bay. She was fighting something big; clearly it had a strong grip on her once again. She shivered and I tightened my arms around her. We made love that night, and when I woke an hour later, she was sleeping, but I lay staring up at the shadows on the ceiling. Margo's fight had never seemed so clear to me before, or so heroic. Was it doomed? Suppose she went back to the hospital, suppose. . . . I thought of that barren waiting room with its plastic-covered couch, and of me alone in this bed once more.

Chapter 9

TERRY

It was queer the way it happened. The chairman's call came Monday morning, as I was standing at the kitchen window, worrying about Margo. I knew she hadn't slept well over the weekend. She had moved from her despair over the puppy into a sudden high and now she was talking about taking on two portrait commissions and teaching a drawing class at Mikey's school as well. She'd gone off to her regular appointment with Murray that morning though, and I hoped that would help. Then came the call.

"Terry?" The voice was familiar—Dr. Henderson, chairman of the Art History Department at Berkeley—Abe, his colleagues called him.

"Yes?" I felt heat rush into my body. What did he want? What had I done?

"I read your article on O'Keeffe in *Portfolio*, and I think it's a fine piece of work. Well written too." I breathed out. What was coming? "We're all impressed with you, Terry, and with the fact that you've got a top-flight commercial publisher for your book. That's excellent." He paused. I mumbled something and waited. "I called to suggest that you submit an application to the Personnel Committee this month. There's a tenure track position open, you know, and personally I think your chances are good."

"You do?" I stared at Mikey's crayoned drawing of a train taped to the refrigerator door as I pressed the receiver to my ear.

"You do?" I said again. I must have sounded like an idiot, but I was amazed. I knew they were considering other candidates, and one of them was impressive, much more qualified than I. Still my teaching evaluations were good and, of course, the contract with Knopf, which had come through at last, was a real victory.

I put down the phone and walked into the living room. If this happened, it could change our lives. I clapped my hands together with a hollow sound—Berkeley. Oh my God, to be a real part of that faculty—that Art History Department. I would say goodbye to part-time jobs like *Portfolio* forever. There would be money enough for a new car, a trip home, even our own house later. I strode out on the porch and stood gazing down. Oh God, if only it would happen. I leaned over the railing to wave as I saw our yellow Volkswagen turn into the street. My news was thumping under my shirt like a pulse. But Margo did not see me. Her face was stern. What was the matter? Had Murray delivered some reprimand about the sleeping problems or her painting plans? I'd wait and hear her news first, I decided, before I told her about Henderson.

"I'm home," she called out. "I'll have lunch ready in a minute, just as soon as I put the groceries away."

Should I tell her now or later? It would cheer her, certainly, but it would excite her too. Later, I thought, later. But would I be able to wait?

MARGO

My internal clock had speeded up over the weekend, and all at once time was beating inside. I didn't want to worry Terry, but that Monday morning I tried to describe my feelings to Dr. Murray.

"It's as if I have a deadline . . . as if I have to solve my problems now while I have the energy, before the grayness comes back again."

"How are you sleeping?" he broke in and held my metal-backed chart against his chest.

"Not marvelously. I mean, I'm going to work on it. But, well, I don't seem to be able to sleep after about four in the morning. I can't seem to stay in bed. Saturday night I got up about five and I

painted a little, and Sunday.... I've been thinking a lot about Liz and Kurt. It seems to me that they ought to just get married rather than...."

"So sleep's become a problem again?" He studied me and put down the chart. "We've seen this pattern before, Margo, you know. I realize it's very hard for you to sleep at this point or even to stay in bed. But you've got to try to doze at least. Just lying quietly in bed is better than getting up and doing things, because sleep is crucial right now." He paused and opened my chart, studied it a moment, then closed it again. "I'd like to give you some sleeping medication, but I don't think that's advisable now with the tranquilizer you're on."

"Sure," I said. "Don't worry. I'll make sure I sleep tonight."

"Loss of sleep is dangerous for you right now." He paused and I gazed at him, aware that he was about to make a pronouncement he found difficult. "Now here's my plan," he began. "We'll watch you closely all week. This is Monday, and I want to see you again on Wednesday morning. Then, when I see you on Friday, we'll make up our minds about whether you need to come back into the hospital for a while. Okay?"

I drew in my breath and gazed down at the rug. "You mean *you'll* make up our minds," I said. Dr. Murray did not answer. "Okay." I sat forward. "I have four days—four days to get sane again." I pushed my braid back and paused. "I think I can do it. I mean I'm not a novice at this any more. I know what I have to do. I've got to get sleep, rest, relax, take things as they come." I heard the clichés and stopped. "But you see, it isn't quite that easy...." I paused again. "I mean, as I told you, right now I feel this terrific pressure to find the reason behind all this, while there's still time, so that it won't come back again." Dr. Murray sat studying me with his steady gaze. "I've got problems to solve—Liz and Kurt, Mikey and Terry and ... and ... and Mom. But my first job is to define this thing that's making me crazy— driving me up and down. Don't you see that?"

"I can certainly understand the impulse, Margo," Dr. Murray said. "But you and I know this is a complex problem. The causes are not only psychological. They're chemical too. There is no one answer that either of us can simply isolate and point to. It's a combination of forces."

"Yes," I said, "but if I could... I mean what a victory, it would be if...."

"I'll see you on Wednesday at eleven," Dr. Murray said. "Try to get some sleep. I know it's hard, but try lying in bed, reading maybe. And...." He stood and sunk his hands into the pockets of his medical coat. "Call me if you need to. You have my home phone. You can call me there, if you want to."

I fitted the key into the ignition and looked out at the hospital parking lot. Four days—Monday, Tuesday, Wednesday, Thursday. Friday, Dr Murray would decide. The shadow of a pepper tree swayed beyond me on the asphalt pavement. I turned and gazed at the gray stone steps, leading up to the main building. I could not be institutionalized again.

Sleep was vital. A pulse was beating in my temple and my throat was dry. I would go straight home and make myself a mug of hot milk and crawl into bed for an hour. Terry was working in his study; he could make lunch for the kids and answer the phone. But if I went straight home, I wouldn't see the new gerbil babies that Laura wanted to show me at nursery school, and I wouldn't get the marketing done. No, another time, I told myself. Home, bed. Still I had practically promised Laura. Then I'd market fast. I could sleep while she took her nap; that was a better time.

TERRY

When Margo told me of Murray's plan, I knew things were serious. I was relieved when she announced at supper that Monday night that she was going to go straight to bed. The news of Henderson's call kept crowding into my mouth, but its implications might well keep Margo awake. It could wait until tomorrow, I decided, until this tense interval had passed. I had to work late and, when I finally climbed the stairs, I was startled to see that the light beside our bed was still on. I stood in the doorway, staring at two bureau drawers, bobbing like clumsy freighters on the blue sea of the bedspread. Margo was bending over them, a

roll of shelf paper in one hand, a pair of scissors in the other. She glanced up with a guilty look, aware of me all at once.

"I know I said I'd go to bed early," she began, "but I got sort of involved. I cleaned the closet, and then I got started on these drawers. Look." She held up a black Chinese jacket of embroidered silk. "Remember this? I'd forgotten all about it. It was way in the back." She slipped her arms into the sleeves and buttoned the jacket over her nightgown. "If I could just find some black pants to go with it, I could wear my long, gold earrings and. . . ." She caught up her loose hair with one hand and leaned over the dressing table, searching in her jewelry drawer. "Hey," she said. "Look at this." She plucked up an earring, held it against her ear, and turned back to me with an excited smile.

I stared; her face was flushed and her eyes looked dangerously bright. A terrible weariness flooded through me all at once; I sat down on the side of the bed and covered my face with my hands. "Oh God," I groaned. "God. I can't go through all this again."

"What's the matter?" Margo asked. I raised my head and saw her gazing at me, still holding the earring to her ear. "Don't worry," she said; her voice held concern. "I'm coming to bed right now. I'll just take off this jacket." As she began undoing the silk-covered buttons, I bowed my head into the darkness of my hands again. This was Monday. Would she sleep tonight? Could she? Would she be better in the morning? Or were we in for another hospitalization? I thought of the kids whining, the television sounds, the frozen dinners, the commute. Stop this thing now, I prayed. Please don't let it get worse.

MARGO

I meant to sleep, of course, but there was my journal and the thoughts I had to write down. I looked up from my writing and glanced out the living room window; a low band of pink lay just at the horizon. I looked down at my journal again. "I'm up early again, when I should be sleeping," the rapid writing read, "but I know I am getting closer to THE REASON." I turned to the open Bible on the table beside me and whispered the passage I had underlined.

"Save me, O God, for the waters are come into my soul. I sink in deep mire, where there is no standing." I thought of the pool of dirty clothes in the back hall, the drying clumps of paint on my palette, the children still in their pajamas, watching television, whining that there was nothing to do. I knew the rising of those waters—that grayness, that guilt. I could still see the red and yellow label—"Kills insects: aphids, red spider mites...." Had King David known such despair?

"Hide not thy face from thy servant, for I am in trouble." There was a soft thump at the end of the couch. I looked up. Mabel was kneading the far cushion. "You want your breakfast, don't you?" I spooned out cat food in the kitchen and turned to reach the coffee can. I was as lithe as a dancer, I thought, as I bent to pull the percolator forward; the old awkward me was gone. The pot gurgled as its familiar fragrance rose. I smiled—sane, on-going life. Today was Tuesday; today I really would sleep and tonight I would go to bed right after supper.

LIZ

When I stopped by Margo's late Tuesday afternoon, she was digging up some heavy clumps of lilies to transplant. She laughed when I sank into one of the faded canvas chairs and refused to help, then she wiped some perspiration from her forehead and flung herself down in the chair beside me.

"Did you get my letter?" She flapped her elbows and pulled her sticky shirt from her armpits. "Did you think about it? Have you talked with Kurt?"

I knew those questions were coming. I crossed my legs slowly and looked across the yard. Mikey was dragging the hose around the side of the house. His shorts were smeared with mud and he was barefoot. "Look, I know you want me to be decisive about Kurt," I began, "but right now I can't be. I'm not going to marry him this month, or this fall either. It might happen eventually, but not soon. Understand?"

"But Liz, if it's going to be later, why not make it sooner?" She smiled that queer, brilliant smile. I let my breath out softly and made the whole speech again. "Daddy would come," Margo

continued, oblivious. "I know he would, and he and Kurt would have things in common, you know. I mean, after all, with your husband-to-be and...."

"Margo, Kurt *isn't* my husband-to-be," I told her "and you've got to stop planning our wedding." I looked straight into her eyes. "You've got to stop. All right?"

"All right," she said. "But later, I...."

"I'm turning the spray on, Mummy," Mikey shouted. He was bending over a metal ring that he had attached to the end of the hose. I watched the water spurt up in a wide ring, wetting the grass around it and making mud of the bare brown area beside the back steps. Once I might have tried to spread out my tangle of feelings for Kurt before Margo—my times of awful need, my moments of revulsion—but not now.

"Liz, I've been thinking about Mom," Margo started. "I woke in the night with this vivid memory of Washington during the war. It was after Pearl Harbor, of course, after the bombing of Wake. Nineteen forty-three, maybe."

"Look, Mom. Look." Mikey had settled the ring on his head and was marching past us solemnly. "I'm a king," he announced. "A king." The little jets of water rose evenly above his head in a high iridescent circle, which had a definite majesty. I smiled and clapped. Margo smiled at him briefly, then turned back to me.

"It was right after we'd joined Daddy in Washington," she continued. "You were sleeping in my bed with me. You used to come in sometimes so we could talk. Remember? We'd huddle down in that big brass bed. There was a bay window and those buses outside, which stopped at the traffic light below and sat there roaring, waiting for it to change? Remember that?" I nodded. "We woke up—I did and you did right afterward. Mom was crying. It was a terrible sound. We clutched our knees to our chests and sat hunched there, shivering in our nightgowns, guilty to be listening, but unable to stop, and so scared. I remember Mom's voice. 'Oh Jack,' she cried. 'Not after twenty years. No. Please.' Don't you remember that, Liz? You must."

"I remember her crying," I said, and I did.

"Let me, Mikey," Laura whined and reached for the spray ring. "I want to be a princess."

"Give her a turn, Mikey," I urged. "Then she'll give it back. Okay?"

"Mom's voice came to me last night in my sleep," Margo continued. "I woke hearing it. I wrote it down, because I'm sure I remember the words. We heard Daddy cross the room in his bare feet. He was dressing and Mom went on crying. We heard his feet going down the stairs and the noise of Queenie's leash, hitting the back of the closet door as he pulled out his overcoat. We could hear his footsteps on the iron steps out front, then fading on the sidewalk. Don't you remember?"

"Some," I admitted. "Some. Okay, Mikey," I called out. "Your turn now."

"It's important, Liz," Margo said. "Kurt thinks she committed suicide."

"I know." I glanced at the children, but they couldn't be following our conversation. "Kurt doesn't know everything, Marg," I said in a low voice, then raised it. "Watch out, Mikey," I shouted as he aimed the spray at his sister. "Stop. That's enough." I hurried to the faucet at the end of the wall and twisted the handle tight.

"Please, Aunt Liz." I turned. The protest was automatic. Mikey had stooped down and was already stirring some mud in the puddle by the steps, and Laura was absorbed in taking off her sandals. We'd have to hose them off out here first, I thought, or they'd make a mess of the bathroom.

"If Mom was unhappy, desperately unhappy," Margo continued as I sat down again. "I mean, if she. . . . "

I turned to stare at my sister. "Look, Marg. What's important now is you, me, Mikey, Laura, Terry. Not Mom. You have to get well, and right now you've got to get these kids bathed and fed and. . . . I mean, life has to go on. Mom would have wanted that."

Margo looked at me hard. "I know," she said. "I know. But if I could just understand, if we could. . . . I mean it's so important, Liz."

"Of course it is. For me as well as you, but. . . . " I paused and glanced back at the kids.

"Turn it on again, Aunt Liz," Laura pleaded. "Just a little while. Please. I want to be a princess one more time."

Margo looked over at them finally. "Oh kids, kids." She groaned and pulled herself up from the chair. "Hey. You can have a crown of your own," she told Laura. Her focus had shifted with a dazzling suddenness. "I'm sure there's another one of those spray things in

the garage. We'll have the whole royal family," she laughed and hurried across the yard.

MARGO

I meant to take a nap that Wednesday. I knew Terry was worried about me, and Dr. Murray had told me again that morning that sleep was crucial. I lay stretched out on the bed, listening to the sound of the mourning doves under the eaves. I must sleep, I told myself, sleep. But, as I lay there with my eyes closed, ideas kept pounding through my mind—concepts that might illuminate my problems. I stared at the closet door, thinking of the *Bhagavad-Gita* and its similarity to the Bible. The Eastern concept had a geometric feel, I thought; I lifted my hand, meaning to write that down. Stop it, I ordered myself. Sleep. But the thought had perched beside me like a large black crow; if I didn't write it down, it would lift and flap out of the room. I swung my bare feet to the floor and crossed to the desk. I would write just for a minute, I told myself, and then lie down again.

My journal had become so full that I had to turn a dozen crowded pages to find a fresh one. The triangle was crucial; its strength had been recognized since ancient times. It was the yogi in the lotus position, and Christ with His arms outspread on the cross. I drew the shape on the page and gazed down. Buckminster Fuller, that architectural genius Terry lectured on, believed the triangle had unique qualities. If it could lock physical materials into stability, as Fuller said, then why wouldn't the same geometric form apply to human relationships? If people could work in triangles, they could move with greater sureness and direction. I drew another triangle and wrote the word "guru" at the base angle on the left and "student—me" on the right. I printed "God realization" at the apex and after it "soul."

I made two large dots at either edge of the page and labeled one "psychiatrist," the other "patient." Then I made parallel lines moving back and forth between them. In a purely horizontal relationship, there was no locking and the direction was not clearly defined. But with the triangle there was an apex toward which both people could travel. The guru and the student journey

upward together, toward God realization, but the psychiatrist and the patient proceed only toward the psychiatrist's definition of sanity, I thought. I drew another triangle hastily. "Mom"—"Daddy," I labeled the two base angles. "Me," I wrote at the top and drew a third triangle. "Me, Liz, Daddy." Wait. I made another triangle and started again.

The door opened. I looked up. A man in faded khakis was standing on the threshold. The sleeves of his blue shirt were rolled up and his face looked tired. It was Terry, I realized, and sucked in my breath. "Oh, honey, I'm so sorry. I meant to sleep. I really did."

TERRY

I had to leave Margo that afternoon to go back to the University for my office hours. I tried to call her several times, but the line was always busy. When I got home at five, I realized why. Margo was on the phone upstairs, describing what she called her Oedipus complex and how she thought it illuminated Liz's situation too. I strode into the kitchen and picked up the receiver of the wall phone. "It ties in nicely with that Ernest Jones article I was telling you about," I heard Kurt say. I ground my teeth. God damn Kurt. Couldn't he see that Margo needed quiet, not stimulation? "I'm home," I said into the receiver. "I've been trying to get hold of you, but the line's been busy almost an hour."

"Hi, darling," Margo answered. "Wonderful. I'll just finish with Kurt, then I'll be right down."

"Make it quick," I told her. "I'm tired of waiting." I clutched the curved edge of the sink as I stared down into the yard. The whole thing was impossible. Impossible. I swung around and stared at the refrigerator. Why did Margo seek out Kurt? On one level she disliked him as much as I did, and yet ... yet.... She was sick, I reminded myself and let out a long sigh. She was desperate for answers, and the fact was she might well have to be hospitalized again. This could go on for weeks, months maybe. I gazed out into the yard. Suppose Jack was unable to pay? Suppose she was moved to a state hospital, and the months rolled out into years? Liz would leave, marry, go back to New York maybe, and I would be left with two children to raise, educate, worry

over. I saw the stone posts on either side of the hospital driveway, then the familiar clutter of gas stations, the suburban streets, the traffic lights. Oh God, all that again maybe, and more.

Dad, I thought. I would call him tonight and tell him about Margo. He and Mother knew she'd been hospitalized earlier, but I'd simplified it, made it sound like something that was over and done. Dad. Just his listening would help.

"Terry." Nancy had appeared at the back door. "The kids are at our house," she said. "Why don't you leave them with me for supper? We're going to have a barbecue. Maybe you could take Margo out to dinner somewhere." I stared at this tanned, efficient neighbor in her white tennis shorts and striped blouse. Had I been all wrong about her for weeks, or was Margo so obviously sick that even Nancy could see her need?

When Margo got off the phone, we dressed and drove to a seafood place in Sausalito. We sat down at a table by the window, and I began telling her about some photographs I'd seen of some new O'Keeffe paintings. I described the vistas of desert and rock slowly, the pastels and shadows, hoping the subject would calm, even bore her. She broke off a piece of French bread, buttered it, and looked at me with a brilliant smile. "I've been saving up some important news," I started all at once. Surely it would be all right to tell her about Henderson's call now.

"So have I," she said. "I have some important news too. You see, I saw Peggy at the hospital this morning and we talked about suicide. She told me outright that she'd never really meant to kill herself; she just meant to get Rick's attention. I mean, you know, it's always a mixture between a real death wish and a cry for help anyway. Peggy's sure hers was a cry for help. But I think the death wish is in us all. The thanatos. I mean, Freud said that. . . ." I looked out the window at the dock where a log was bobbing up and down near one of the pilings. Stop, I wanted to shout at her. Stop. Come back. Can't you?

"We need to talk about Liz's wedding, honey," Margo started. "I never used to like Kurt, you know, but now I think they should just go ahead. I mean, it's going to happen anyway, and after all we have this big house for the reception, and the weather's lovely now. I told Kurt this afternoon, why not take advantage of the circumstances and just do it."

"Margo, they're not at that point," I broke in. "I'm not even sure Kurt's divorce is final."

"It is." Margo gave me a triumphant look. "I asked him that, and it is."

"Then let them work on those arrangements themselves. Okay? Don't try to plan their lives for them." Margo nodded, but I didn't trust that nod; too much was going on inside.

It was late when we got home. We made love, not passionately, but happily enough, and lay wrapped together afterwards, sweaty and complete. I was sure Margo had fallen asleep, but when I woke later, the clock read 2:30 and she was not beside me. I went downstairs barefoot, through the shadowy living room toward the kitchen, where a bright line of light showed around the door. Margo was sitting on the counter in her bathrobe. The contents of the tool drawer were spread out around her and she was sorting nails and screws into a line of paper cups.

"Do you know what time it is?" I demanded.

"Of course." She pointed to the kitchen clock. "I slept a long time and I'm going back to bed as soon as I finish this."

"You slept all of an hour," I told her and stared. Had I been making love to this woman earlier, kissing her, stroking her? What a fool I'd been to think my lovemaking could bring about a full night of sleep. "We didn't go to bed until one." I felt my irritation flame into anger, and I put my hands on my hips to hold it down. "Dr. Murray's told you not to get up when you can't sleep. You only make the problem worse." She stared at me in the raw brightness of the overhead light.

"I just have to finish this," she began.

"No," I said. "There's always one more project. Come on." I grabbed her arm. "You're coming back to bed."

Margo pulled away. "Not until I finish this," she said. "I'll be up in ten minutes."

I tightened my hand on her arm. "You're coming now," I told her.

Margo pulled out of my grip. "Don't you try to manhandle me," she warned. "I can take care of myself. I know how much sleep I'm missing and how much I'm making up."

"The trouble is you don't," I yelled. "You're sick and you refuse to face the fact." My shout seemed to make the yellow kitchen rock. We stared at each other.

"If you'd just trust me and leave me alone, I'd get well," Margo insisted. "But you keep smothering me with your fearful protectiveness." She wrapped her arms around her and glanced down at the cups of nails. "I'm just going to finish this one thing."

I glanced at the clock. "Come on. It's almost quarter to three." I raised my hand to grasp her arm again, but Margo grabbed the hammer from the spread of tools beside her.

"I'm warning you, if you touch me. . . ." She held the hammer upraised like some revolutionary spirit, brandishing a firebrand.

"Goddammit, Margo," I yelled. "You're sick! Can't you realize that?"

"That's what you keep saying," she shouted back. "You talk and fuss over me like a mother hen, you and Murray and Liz. You won't let me get well. Maybe you want to keep me sick. Maybe it gives you an excuse not to try for a real teaching job."

Fury spread through me like fire. "Listen here. Henderson called Monday to urge me to apply for that tenure position. Tenure!" I shouted. "He thinks I'm good enough, even if you don't, and he's the chairman of the Department." I waited, jaws clenched, shocked at the loud angry sound of my words. But Margo glanced down at the row of paper cups beside her and pushed a pile of brass hooks together. She hadn't heard me, I realized. She hadn't reacted in any way to my news. I felt my thumbs bite into my waist, as I sucked in my breath. "Christ, Margo. You don't even know that. . . . " I saw her hand close over one of the paper cups beside her. Her arm went back and I ducked as the nails rained on the linoleum floor. We gazed down at the bluish metal spikes, spread out near the legs of the wooden table and the bottom of the refrigerator. One nail had landed in Mabel's dish and lay half-submerged in the soured milk. We stared at each other, stunned. What had happened? What had we said? Margo slipped off the counter and knelt down and, seeing her, I knelt too. Together, we gathered the nails in silence, thinking of the bare feet in the morning, the questions. Had we passed through some crisis? What lay ahead?

LIZ

Terry asked me to go over to the house Thursday morning, since he had two lectures. When I pushed open the front door, a sweet spicy smell rushed toward me, and I stood a moment in the front hall, trying to figure out what it was. I moved into the living room and realized it came from a vase of white chrysanthemums on the table. There was another vase of white roses on the mantelpiece. The couch had been pushed back against the wall, and the fireplace was draped with greens. A long white tablecloth covered the dining room table and a package of paper napkins, stamped with silver wedding bells, lay half-open at one end. At the other was a stack of empty plates. I gripped the strap of my pocketbook. "Margo," I called. "Margo."

"Hi," she said. "I'm in here." I moved into the kitchen. Margo was at the table, still wearing her old chenille robe. A collection of drawings and colored pencils was spread out in front of her.

"Doesn't the house look pretty?" she demanded, looking back.

"Yes." I swallowed. "What's going on?"

"Oh, I was just trying out some arrangements, just in case you and Kurt do decide.... I bought some flowers early. You know that farmer's market in Oakland where you can go at dawn? But the thing is, I called Daddy and he can't come this weekend so. ... You know, you're right. We'll put it off a while longer. We can always enjoy the flowers."

I sat down opposite Margo. Her eyes were sunk into deep, gray caverns and her face had a bluish cast. She rose as though she sensed my appraising look and went to the stove. "Want some coffee? It's fresh." Her hand shook as she poured the dark liquid into my mug. "Oh, Liz, I have so many things to talk to you about. I've been thinking about Daddy and...."

Margo pulled the pile of drawings toward her. "I've had this new insight about him. See?" Food would be better for her than coffee, I thought, and put some bread in the toaster. I stared at her as she searched among her jumble of papers. A small blue vein was pulsing in her temple and her lips were chapped and gray. "See that," she said and placed a drawing in front of me. "That image came to me last night." I stared down at the sketch

of a large eagle-like bird. It was startling, for it did resemble my father—the brooding stance, the heavy folded wings, the wounded look. Margo had definitely caught something.

The phone rang and Margo glanced back at it. "If they'd only let me finish," she muttered. "If they'd just let me alone." It was Nancy, and I arranged for the kids to stay with her for the afternoon.

"Does that make any sense to you, Liz?" Margo asked, pointing down at the drawing again. "I mean, can you see what I mean?"

"Yes," I told her. "Some of your perceptions are important, Marg, brilliant even. But you've got to survive this assault of thinking, and we've got to figure out how."

"Assault?" Margo repeated and looked at me. "You're right," she said slowly. "It *is* an assault." She gazed around the room. "I've been trying to hide it, but the fact is I'm exhausted. I'm shaking. The room's spinning and . . . and I've got to sleep." She rose and turned to the window. "I can. I know I can, if I can just stop thinking. I'll make myself a hot water and honey drink right now and then I'll get into bed."

"I'll make it," I said and went to the stove. "You go lie down. The kids are at Nancy's for lunch and the afternoon, so you can rest awhile. Just dozing a little will help."

"Tomorrow's the verdict, Liz," Margo said, when I brought the drink into her room. "If I don't sleep, I'll be insane; Dr. Murray will hospitalize me."

"I know," I told her, "but tomorrow is twenty-four hours away."

"Liz." She lay back and I spread the quilt over her. "We had a happy childhood, didn't we? I was remembering the bathroom in Cambridge just now, those yellow ducks we played with in the tub, the painted bench with the ostriches. Remember? And the way Mom would kneel at the side, holding one of those big blue towels?" I nodded. "Some bad things happened later, but it was a happy childhood, don't you think?"

I nodded again. "Try to sleep now." I stood by the bed a moment, looking down. Margo covered her eyes with one arm, then lifted it and looked at me.

"I think I'll get a perm," I began softly and sat down on the end of the bed. "I'm sick of my hair looking the way it does and...." I talked on in a monotone, waiting until she closed her eyes, but just as I thought her breathing had grown even, Margo opened her eyes again and smiled at me.

"I don't know what I'd do if you weren't here, Liz," she whispered. "I really don't." I talked on until she fell asleep. Then I tiptoed downstairs.

TERRY

Liz was at the stove when I came into the kitchen late that afternoon. She put her finger to her lips in warning. "Margo's asleep," she said. "The kids are in the living room, watching television. I've got it turned down low."

"She's asleep?" I repeated. Liz nodded. "How long's it been?"

"Almost five hours. I went up a little while ago, and she's still sleeping. She started about noon." Liz smiled and pushed back a strand of hair.

"My God," I said. "This is a miracle." I put my briefcase down on the counter and stared at Liz. "Five hours. This could do it. You know that? It really could." I reached down and pulled a bottle of scotch from the cabinet beside the sink. "We need a drink to celebrate." I started to jerk out the ice tray, then dropped my arm, shocked by the noise I might have made. I gave Liz her drink without ice and sat down cautiously. We had no cause for celebration yet, I realized. The drink was strong, and I felt the whiskey warm my mouth and throat as I swallowed. Liz was stirring something red on the stove. Watery spaghetti sauce again, I thought. But who cared, if Margo was sleeping.

Liz lifted the spoon, and a spot of red spread out on the white enamel stove top as I felt her eyes rest on me. "Margo's fighting against big odds. This morning she was preparing my wedding reception. Did you know that?"

"Oh God," I muttered and shook my head. Had Margo told Liz of our fight last night, of my shouts, of the nails on the floor? "Murray told me yesterday he thought that the new tranquilizer is definitely helping," I started. Even if Margo had told Liz about

the fight, I was still the husband, dammit, the one who talked with the doctor. "With this sleep now, she really might not have to go back tomorrow."

"Look, Terry." Liz held the spoon upright, as another bloody drop fell. Her face was stern within its frame of orange curls, and her serious eyes were almost Margo's eyes. "If Murray decides she has to go back tomorrow, she has to go. That's it. It's not your fault or mine, and God knows it's not hers." Liz's voice trembled, and I glanced down at the table and saw its grained surface blur as the awful sadness of the thing rushed over me again—Margo fighting, fighting and. . . . I took another sip of my drink; the broken ovals of the wood grew still. I was worn out, but the only thing now was Margo, making her sleep, pulling her back from madness. She might have told Liz about the fight, I thought, though she would not have mentioned her dagger thrust: You want to keep me sick—it gives you an excuse not to try. . . . To think she had said that after Henderson's call, after all my careful delaying. Stop, I ordered myself. She's sick. Sick.

"If Murray decides that hospitalization is the best treatment for her now," Liz continued, "it's not a failure, but a fact, and we'll just have to accept it." I nodded again.

"We had a fight last night," I announced. "Did she tell you?" Liz shook her head.

"Don't kick yourself about that, Terry. I felt like screaming at her when I came in here this morning and found all that wedding stuff. She's impossible right now. Honestly." The touch of sympathy made tears crowd into my eyes, and I went to the window to look out.

"God, it's dry," I said, making my voice even. "There was another fire up in the hills last night. Did you know?"

"Margo called Daddy this morning," Liz reported.

"What about?"

"The wedding for Kurt and me."

"What did he say?"

"Margo only told me that he couldn't come, but he's probably figured out the situation. I think you ought to call him tomorrow, Terry, when we know."

"Okay," I said. "Sure."

My fingers tightened on my glass as I heard the sound of

Margo's bare feet on the stairs. The door opened and she stood in the doorway in her bathrobe. "Hi, gang." She smiled at me and then at Liz. "Wow. I really slept, didn't I?"

"Mummy." Mikey pushed up beside her and pulled at her arm. "Want to see *Leave It To Beaver* with Laura and me? It's just started." Margo smiled and hugged him against her side.

"I'd love to, sweetie. But first...." She turned toward me. "Honey, could you run down to Marvin's Art Supplies and get me a big charcoal drawing pad?"

I stared. "It's after five," I said. "Why don't you have a drink with us instead?"

"Marvin's is open until six," Margo said. "I know they are."

"I'll go get you one in the morning." I swallowed to push back the dread rising in my throat.

"I need it now," Margo said. "I'll go, if you're tired. I'll just put on some clothes."

I glanced at Liz, but she was staring down into the red sauce. "No, I'll get it," I told her and dug in my pocket for my keys.

When I brought the drawing pad into the living room, Margo was bent over the coffee table with her diagrams and colored pencils spread around her. She took the pad silently and went on working. Liz brought the spaghetti to the table, but Margo did not rise. "I'll be there in a minute," she called. "I just have to finish this one thing."

Liz tied on Laura's bib and sat down. The children attacked the jumble of slippery white strings on their plates silently. There were no giggles as they tried to wind the spaghetti on their forks. Laura tipped over her milk, but there were none of the usual shouts. I simply rose and got the sponge. I glanced over at Margo, when I came back to the table, but she did not raise her head. I stared for a moment at her shoulders in the blue robe; we had lost. Tomorrow she would go back to Remington.

MARGO

I snapped on the overhead light in my studio before dawn and stood gazing around me. The brown dragon was stretched across

the eaved wall, enlarged by the dark area Nancy and I had scraped the day that Mr. Green Jeans was killed. The dragon's curled tail was holding something, I realized, and moved closer to look. It was a woman, clutching her arms around her naked body. I picked up my large brush, squeezed out some black, and moved to the wall to fill in her form. I painted the dragon's coils a brilliant orange, flecked them with red and purple, and made his eyes yellow. I brought the coils up higher, so that the woman stood caught within them, then I stepped back, breathing hard. The woman was me, trapped in my sickness, fighting to escape.

I sank down in the armchair and peered out. I could see the gray cables of the bridge far off and the pink light, streaking the leathery surface of the water. A cloud was moving upward in the sky, its radiant underside unfolding right in front of me. It was a sign, I realized; it was an angel, and her name was Evelyn. I knelt on the bare floor and clasped my hands together. Today was Friday, the day I would see Dr. Murray again. But I had been given Evelyn, an angel, and she would help me, whatever Dr. Murray decided.

MIKEY

It was a holiday and me and Laura were out in the sandbox, because we didn't have to go to school. Mom came over to us; Dad was right behind her, holding her suitcase, so I knew. Mom's hair was all spread out like nighttime and her face was sort of red. "Goodbye, my darlings," she said. "Evelyn will protect you. Om shanti. Shanti." I just looked down at my cars. I didn't know what those dumb words were. She put her hands up like praying and said them again. I kept on looking at my red wrecker truck. I didn't see her go away.

MARGO

"Today has been declared an International Peace Day," I told Dr. Murray. I knew my time was over, but I went on. "It's because I, an ordinary housewife and mother, have been touched by the

divine; I have been given an angel to show the way." A nurse appeared and took my suitcase, and I followed her into the hall. I saw my sister standing beside the receptionist's desk, holding my white sweater. Then she was beside me and hugged me close. "Oh Liz," I cried out just for a moment. I was a saint, but I could allow myself this one cry. "Liz, I didn't mean to come back here. I didn't mean to, you know."

Chapter 10

MARGO

I RAISED my head and peered at the glass porthole in the door. The watching face was gone, but there were other watching holes in this room that I could not see. I had glimpsed eyes staring down at me from behind the ceiling light, which was covered by a metal grate, and I knew there might be eyes looking up at me from the drain in the middle of the floor. They were waiting for me to make a move that would reveal I was a sick woman, but I would not make that move. Evelyn had wrapped me in divinity; my body was enveloped in a halo of light.

When I had first sat down on the black floor, I had started to lean back against the brown padding that extended halfway up the wall. But a signal had come; the padding was electrified. It could shock, even kill. I pulled away from it at once and sat hunched together in my loose hospital johnny in the center of the room. An orderly urged me to lie down on the mattress in the corner, but I would not. I knew their tricks.

I straightened and looked around me. The sun had made a bright rectangle on the floor, which was striped by the shadows of the three vertical bars at the high window. I reached one hand into the light. The end of the rectangle lay across the top of the mattress. Did that mean the mattress was safe? I crawled toward it, touched the surface with the tail of my johnny and waited. No shock came. They had turned off the electricity; they were beginning to see that I was divine.

They would bring me clothes for the television interview. Surely they would remember that. But wait. Perhaps I would appear before their cameras as I was, simple and saint-like in my wrinkled white gown, luminous with truth. I thought of the lobby below, crowded with newsmen, the nurses making their way around the heavy television cameras, stepping over the thick black cords that snaked across the blue carpeting. Some of the doctors would be resistant, but I would be gentle in my new power. By now the news had spread from suburban grocery stores to city subway crowds to movie theatres and bars, by television and radio, teletype and plane, informing the world that Margo Sullivan, a California housewife, had been chosen to give a message of peace to the world. At the U.N., Dag Hammarskjold would direct the entire body to congregate and listen, for mine was the message he wanted them to hear. It was natural that I should be held in a mental hospital; that was the typical fate of saints. But the believers, the women with strollers, the men with briefcases or metal lunch boxes, knew that I had come and would speak.

Surprised at the prickly feel of my lips, I peeled off a piece of skin and held it to the light. The moving, changing body, I thought, continuously dying and renewing itself. "What I have to tell you is very simple," I said out loud. "It is clear, and yet so powerful that you will see it is the only direction we can take. The truth has been given to me." I held up my arms in a sign of benediction. Somewhere far off I could hear a phone ringing.

The flap of the porthole lifted. I turned and caught sight of a face in the circle. "May I have some water, Peter?" I asked. "Not now to bathe my feet," I added, speaking in the Biblical-sounding language that seemed to surround me, "but to bathe my throat, which is so parched and dry."

The door was unlocked, and a tanned young man in a white uniform came into the room. He smiled at me and held out a metal cup of water. "If you'd eat a little, you wouldn't be so dehydrated."

"The enemies, Peter. They, who fear us, have poisoned the food and brought in their spies."

"I'm going to bring your lunch up in a minute. You eat some of it today. All right?"

"Will *you* bring it, Peter?" My eyes filled with tears and for a moment I felt the urge to rub my cheek against the young man's white thigh. But I must not startle Peter; he was a new disciple. "You are very kind," I said. "Someday you will be a great doctor."

"Then I'd better get myself into college," the young man said. "My name is Sam. Remember? We've been over this one before." I smiled. I knew he was pretending to be with the enemy in order to fool the watching eyes behind the ceiling light; yet he was with me.

"The interview is at noon, Peter. When will they take me down?"

"Lunch'll be up in fifteen minutes," the orderly said. He reached for the cup, but I pulled it away, threw back my head, and poured the remaining liquid over my face, so that the water ran down my neck onto my limp white gown.

"The element of water," I whispered. "Earth. Air. Fire. But most of all, water." The morning was almost over; soon I would speak. "God give you grace." I bowed and brought my hands together in a gesture of prayer. "Tell them," I said to the orderly, as he turned to unlock the door, "that I will appear as I am."

TERRY

I should have gone to the library; I had some stuff to look up for my lecture the next morning. But I drove up into the hills above the campus instead, and sat at a turnout in the road, staring down. Margo was sicker than she'd ever been. Nothing we'd done had helped—not the months of therapy, not the tranquilizers at nine dollars a bottle, not the dinner out, not the patience, the love, the waiting. Liz had worked as hard as I had—harder— and we were much worse off. She was completely delusional now—talking of sainthood and angels, out of touch with everything. Recovery was remote, if it ever came.

A sparrow twitched its gray-brown feathers in a dusty pothole beyond the car, giving itself a bath. California—the great adventure. Margo was as good as dead, worse than dead maybe or. . . . I leaned my head against the steering wheel and covered my face with my hands. Margo, dead? I saw the kitchen in our Cambridge apart-

ment. We'd gotten interested in opera that first year, and we used to sing our plans for the day to each other in aria form. I remembered a long recitative I'd delivered about the necessity of emptying the garbage pail. I saw Margo's laughing face as she sat at the kitchen table. She had put her hands to her mouth; coffee had spurted from her nostrils. I raised my head and stared at the pothole again. What had happened? When had all that vanished? Why?

Ahead were weeks, maybe months of hospitalization, conferences with doctors, sitting in waiting rooms, all that loneliness and uncertainty. Liz couldn't stay with us forever. I didn't want her anyway, not if she went on with Kurt, that bastard, that.... I stared at the dirty windshield. Oh God, it wasn't Kurt. It was ... what? I didn't know.

"In sickness and in health." That's what everybody promised. But what kind of sickness and how much? I'd worked my ass off out here, trying to keep two jobs going. I'd distinguished myself in graduate school, and Knopf had accepted my book, for Christ's sake. I clenched the steering wheel with both hands. Back at Harvard, my tutor had told me that I would probably have a brilliant career. But now.... I thought of Margo locked in some room in that hospital; I let go of the wheel and shut my eyes again.

In the darkness, I heard a record Laura had been playing. I saw her sitting on the floor beside the record player, sucking her thumb. "Here comes Lassie round the bend/ Greatest dog you'll ever see...." She'd been playing that damn record over and over for days, all week, maybe. I saw the curled wet hand, covering her mouth, the dull stare. It wasn't just Mikey anymore. Laura, too, was full of guilty fear.

I heard the distant sound of the bell in the Campanile tower striking noon. I straightened and glanced at my watch. Liz would give the kids lunch, but I had to pick up Mrs. Pierce at two. Keep on, I told myself. Get the stuff done at the library, then go get Mrs. Fussy. Just keep on.

MARGO

I poked my finger into the mound of yellow squash on my tray and peered at it. Down in the bowels of the hospital, where the

meals were prepared, the believers put in signs. The slices of boiled meat in the top triangle of the tray made a clear "G" for God. The warm oval of squash was a "P" for peace.

I pushed back the tray and stared at the metal drain in the floor. I was a spider, hanging in a web, peering down through it into other webs of life. There were the webs of nurses' lives trembling nearby, and those of orderlies like Peter's, doctors' webs, and the countless webs of people beyond the hospital, driving along freeways, sitting in classrooms, lying in hospital wards, waiting to die. Webs crossed webs, tangling and extending within the moving mystery that none could see completely. Yet I, the spider-saint, could see far more than most. I sucked the squash from my finger and drew a wet cross on the metal grate. "Om shanti," I whispered, and bent forward to kiss the drain.

MIKEY

I'm not going to school this morning or any other morning either. They can't make me. I'm going to stay up here in my room. The only one who can come in here is Mabel—not even Daddy can come in here now.

DR. MURRAY

Some patients affect you more strongly than others. Their pain can keep you awake at night, despite years in the profession. Margo Sullivan has known the worst of both extremes—the suicidal despair and now this hallucinatory fever. I had to put her in isolation; that's always a tough decision. Within ten years, more effective drugs may exist. But now.... She's getting tranquilizers, of course, but in a case like this the effects can be slow. Ray Herbert's stopping by tomorrow to take a look. I can use a second opinion. He may well recommend electroshock or increased tranquilizers. If only I could help that young woman. She has a seriousness, a kind of passion. There are the children, and there is her art. I don't know anything about visual expression, really, but what I've seen of her work is moving to me. I'll be damn glad to

have Ray Herbert's ideas on this tomorrow. She's as sick as anyone I've ever treated. When you get to this point, you realize the enormous limits to our understanding—mysteries we have not even begun to penetrate.

MARGO

I could not remember how I had gotten the pencil. Perhaps I had stolen it, or perhaps Peter had brought it to me. The eyes below the drain must have seen it, but they had not taken it away. In the dim light from the ceiling fixture, I worked rapidly at my drawing on the wall. I had covered the space with the outline of a large tree, whose branches formed a wide triangle. Labels came to me with a startling precision, quotes from the Bible, Melville, and *King Lear*: "The valley of the shadow," "Call me Ishmael," "Let me not be mad. . . . Keep me in temper. I would not be mad." It was a drawing of voices and relationships. The trunk spread out into branches, making a huge tree of life. I stepped back and surveyed the wall. It was marvelously clear. Reporters would bring in their television cameras tomorrow, and the world would see. I lay down on my mattress. A field of meadow grass rose up around me and I slept.

When I woke, I rolled on my side to look up at the wall. My diagram was gone. The room smelled of detergent and the wall was damp. They had destroyed my work, cleaned it off completely. But I would reconstruct it. I felt under the mattress; the pencil was not there. I hurried to the porthole in the door. "A pencil," I shouted. "Something to write with. Please." I thought of the quotes from *King Lear,* from *Moby Dick;* I could still replace them. The vision was not gone. "A pencil," I called again. "A pencil, please."

"Shsssh," a woman's voice whispered close to the door. "Stop that. You'll wake the others."

"I need a pencil. A pen," I said. "Anything that will write." But there was no answer. After awhile I turned back to the room.

There must be some way. I tried to draw with my fingernail, but the scratches were faint, and I tore my nail. I glanced at the corner of the room; there was one other way. I stooped down and

dipped my finger into my excrement. "You have forced me to do this," I muttered, looking up at the metal-covered light in the ceiling. "I *must* recreate this drawing so that others can see."

TERRY

It seems incredible that my confrontation with Kurt should have happened in the midst of the confusion and horror of that first week when Margo was hospitalized again, and yet it was a kind of release. I was working part-time for *Portfolio* again, editing at home mostly, so I hadn't been to the office in awhile. I walked straight into Kurt's cubicle. He looked up from his desk, surprised. "You ran the article on Yolanda without ever letting Margo read it," I said.

"Margo's in the hospital." Kurt pulled some folders toward him. "As I understand it, she's very sick; she couldn't possibly read it now."

"Then why did you run it this month? You could perfectly well have held it for the January issue," I said.

"We were ready. I planned it to coincide with that children's book convention in L.A. You know that."

"Christ, Kurt," I said, and banged my briefcase down on the low table beside the desk. "That conference is four hundred miles away. Those people have never even heard of *Portfolio*, much less subscribed. Why the hell are you doing this now? You know Margo is desperately sick."

"I can't postpone the L.A. convention because of Margo's breakdown. I'm running a business. I have to sell *Portfolio*." Kurt picked up his pipe from the large glass ashtray beside him, then put it down again. "I'm trying my goddamn best to make this thing sell, Terry. Can't you see that? I'm not lucky enough to have a wealthy father-in-law."

"You son of a bitch," I muttered. "I can't believe how stupid I've been, working for you. You may be under financial pressure, but you've insinuated that a distinguished illustrator was not only a manic-depressive and desperate because her husband had been unfaithful, but you've virtually announced that her death in a car accident was a suicide."

"Well, that's pretty much what we all know. Right?" Kurt leaned forward to pull some matches from his pocket.

"What we know and what we don't know is not the point. You used it in an article, which you printed without Margo's permission. That puts you on shaky legal ground."

"You just said yourself that Margo's very sick. She couldn't have given me permission. I have her sister's anyway."

"But Margo was the one who gave you the interview, not Liz."

Kurt gazed at me a moment. "How do you know what Liz's given me?"

I jerked my briefcase from the table. "I'm leaving," I told him. "And this time I won't be back." I realized I was being a little melodramatic as I banged the flimsy door behind me, but it felt good.

MIKEY

Laura and me play records in her room. Aunt Liz wanted us to go to the Bensons'. But we wouldn't; we stayed inside. If Chuck Benson comes over here, I'm going to tell him to get out. This is my house and he can't come in.

TERRY

I went into the kitchen to get a beer about eleven one night and found Liz ironing. Margo never ironed; she just folded stuff and put it in the drawers. The difference made me tired. I opened the can, took a swallow, then sat staring down at the triangular opening in the top.

"I take it the consultation with that other doctor didn't prove very helpful," Liz said. "What does Murray suggest now?"

I sighed and put one foot up on the empty chair. I didn't really want to talk with Liz, not after what had happened at *Portfolio* the day before, but.... I raised my eyes and studied her. What the hell did she see in Kurt anyway?

"Murray says there's electroshock," I began. My voice sounded weary. "Electro-convulsive treatments. They might help. But he wants to try a couple of other things first." I paused and watched

Liz spray water from a plastic bottle onto a shirt sleeve, then pick up the iron, and nose it down the length of the damp blue cloth. "He thinks we should get Jack to fly out."

"Daddy?" Liz tipped the iron up on its end, and I gazed at its flat triangular face. "He thinks Daddy could help?"

She pressed the collar, buttoned the shirt around a hanger, and hung it on the doorknob. I watched her spread another shirt arm out on the board and begin pushing the iron along its length. Maybe the process was soothing, I thought, as I breathed in the moist clean-smelling air; maybe it would soothe me too. "He thinks it's worth a try," I said. "I told him I thought Jack's feelings had shifted since last spring, and that he might well come. Of course, it's a bad time for him now with only three weeks to go before the election." I took another swallow of beer. "He's called a lot, you know, but...."

"Oh, he'd come," Liz said. "Campaign or no, he'd come."

"Why're you so sure? He wouldn't come last spring."

"It's different now. I think he's accepted Margo's sickness and.... I don't know. I just think he'd come." She paused. "It's what Margo's really wanted, you know. But would it help?" She raised her eyes to gaze out of the dark window. "Would it help to pull her out of this chaos, this...I mean, would it work or would it just disturb her more?"

"You're not sure?"

"It's just that I don't think a visit from Daddy would prove any more magic than anything else. Margo was terribly concerned about the family during that awful week before she left. She was trying furiously to figure things out about Daddy and Mom, and what happened.... There were diagrams. Remember? And all that journal writing and.... I mean, would it be wise for her to see Daddy right now? Suppose it made things worse?"

"Murray's got to be aware of all that," I said. "I think he's betting that it's less dangerous to risk upsetting her more at this point than to let her remain in her present condition."

Liz turned the shirt and sprayed the back. "Margo's going to ask him about Mom's death, you know," she said without looking at me.

"Maybe she deserves an answer," I told her. "Maybe you both do." I was on dangerous ground, but I continued. "I mean, Kurt's

got his version, but Jack's version would be a hell of a lot more authentic."

"If he'd give it," Liz said. She lifted the iron and looked across at me. "I know what you think about the article. I know what you did, and . . . and. . . . " Her voice shook and she put the iron down. "The thing is, Terry, I'm not sure where I am myself with Kurt right now. See?"

"Sure," I said and went to the window. I wanted to say something more, something brotherly and understanding. Instead I asked, "Did Mikey eat any better tonight?"

"A little. He had two hot dogs for supper, and Laura did pretty well. Tonight was better than last night. We read together a long time."

"If Mikey'd just go back to school," I said. "Of course, Mrs. Lawton says we shouldn't force it." I sighed. "Sometimes the kids seem the worst casualties of all."

"Listen, Terry." Liz's voice was stern. "Mikey's stronger than you think he is. So's Laura—we all are, maybe. They're bright kids. They know their mother's sick, but they know she's going to get well, or they hope she will." She stopped and when she began again, her voice had a tone of longing. "It's just . . . it's just. . . ." She looked past me out the window again. "I don't know," she said slowly. "Maybe a visit from Daddy could break through some layer and clear things for Margo. If she could begin to lift, I think we'd all get better, begin to emerge somehow. Know what I mean?"

I nodded. I felt as though I did.

MARGO

I could not remember when my days in the violent ward ended, but I knew I had been living in some dark paneled rooms at the top of a big building for a long time. I couldn't remember the names of the patients around me or the nurses, who seemed to keep changing. Maybe I was in an admissions ward, or maybe I was in another hospital. I didn't know when I had last seen Dr. Murray, and I felt that if I were to see Terry again, someone would have to lead me down a long staircase and through a hall

of closed doors. Every few hours a nurse came with a tray of pills, and after the pill she would give me bitter-tasting water from a paper cup.

In the late afternoon, I sat by the blue television screen, watching people dance. They moved with an eerie aloofness from each other, twisting their hips, turning, moving their hands. Their eyes did not rest on their partners, but seemed to stare into some emptiness beyond. I sat watching, wondering if I would sit in this place, staring at these dancers forever, as my gray, formless days went on and on.

DR. MURRAY

The increased dosage of tranquilizers brought Margo out of her delusional state, and she was moved to a closely supervised ward. At first she was a little disoriented, but within a few days she was fully rational again. I explained to her that it was natural that she should feel tired and depressed. She had survived a period which had been a shock to her whole system, but she would feel better soon, I reassured her. Much better.

"You think I'm better now," she said, "because I wear clothes and talk about things you can understand." I studied her tired face with its deep-set eyes, as she continued. "You think I'm better because I line up in the hall with the others for meals and make leatherette boots in OT. But I was closer to health back there in that solitary confinement cell." I waited. A yearning for the euphoria and energy of the manic stage is a familiar symptom in depressed patients. It often occurs when the delusional fever recedes. "I know I was crazy, but I was alive," she insisted. "Now I'm dead, dull, an automaton. I have no ideas, no visions, no passion about anything. All that is gone." She raised her long hands, then let them drop into her lap. "You and your medicines, your drugs." Her voice was bitter. "You've taken it from me—all my pulsing sense of life."

"That's true in a sense," I admitted. "You've been through an extraordinary high, and now, partly due to the tranquilizers, you're down again." I paused. "But you're on your way up, you know."

"Even if I am," she said, "I'll have to go down later." She stared at her hands. "That's what I'm condemned to, don't you see—crazy ups and suicidal downs. How would you like to live like this?"

"I wouldn't." I sighed. "But Margo, we understand the way this disease of yours works better now. We have diagnostic tools. We're much better off than we were when you were first admitted last spring."

"That's not the way I feel," Margo said and bowed her head into her hands. "Terry should dump me in a state hospital and save all this money." Her muffled voice continued. "It's hopeless; it's just going to go on and on."

"I know that's the way it looks now," I said. "But you'll feel differently soon." I paused. I had planned to wait another day before announcing her father's visit, but I decided to do it then. "Your father's coming to visit you," I began. "He'll be here this weekend."

"Daddy?" Margo looked up. "Why?"

"Well, he wants to see you and...."

"Oh God. You told him to come, didn't you? You told Terry to call him."

I nodded and kept my eyes on her. "Is his visit such bad news?"

"No, of course not," Margo said. "But it's expensive, dammit, and it won't do any good. Why distress Daddy too? I mean, why spread this mess of mine out over everybody's life?"

"He loves you; he wants to see you. Isn't that natural?"

"Oh, I don't know," she sighed. "Maybe. But it won't do any good."

"Well, we'll talk about it some more tomorrow." I closed her chart and we moved to the door. For an instant I saw myself walking down the corridor in my long white medical coat, stopping to unlock the ward door with a key from my metal ring, and stepping out into the bright parking lot. But this patient would remain inside, locked within a disease we had not conquered, despite my euphemisms about "diagnostic tools." Perhaps the father's visit would help, I thought. It might hurt or perhaps it wouldn't do anything at all.

TERRY

I drove Jack straight to the hospital from the airport. We saw Murray in his office first. Jack listened intently as the doctor described the nature of manic-depressive psychosis and sat scowling at the rug as Murray went on to report on Margo's delusional period. The doctor explained that, although she was depressed, she was lucid, and, he was fairly certain that within a few days she would be feeling much better. He assured Jack that he could talk normally to his daughter, not evading topics she asked about, or making them bland. However, she might be rather unresponsive, he warned. After Murray finished his explanation, Jack attacked him with a series of probing questions, the experienced journalist conducting an interview. He wanted to know the length of these cycles, and how Dr. Murray could predict them. Murray admitted that he could not predict the cycles exactly, but after his months of working with Margo, he had a fairly accurate overall picture, and he felt sure Margo was on the verge of a new upswing. When Jack asked him about the control of the disease, he was cautious. Each patient had to learn his or her unique warning signs and management techniques, he said, and that took time. But when the patient recognized his situation as a disease and began to work with it, significant progress could be achieved. Jack asked a question about heredity, which Murray answered in the same cautious way. Jack nodded and sat back. He had the information he'd come for, apparently.

I felt tense as we sat side by side on the plastic-covered couch in the visitors' lounge waiting for Margo. Please don't let some weirdo with empty, staring eyes appear, I prayed. Don't let a scream rise up or the smell of excrement flood out. But nothing happened. Margo came in, wearing a shapeless brown skirt and a wrinkled blouse. Her hair was pushed back, unbraided and dirty-looking, and her face was gray.

"Daddy. You came," she said. It wasn't an exclamation of delight, just surprise, although I knew Dr. Murray had told her of the plan. He clapped her shoulder, then patted her knee when she sat down in the chair beside him.

"I wanted to see my girl," he said, but the phrase sounded

clumsy. I thought they should have some time alone, so I left them. I was standing at the big window at the end of the hall, when Jack appeared at my elbow. He hadn't been with her more than eight minutes, maybe less.

"She left," he said in a low voice. "Said she wasn't worth visiting." He stood beside me, staring out at the trees. "I told her I'd be back tomorrow." I heard a jingle of change, as he dug one hand into his pants pocket. "Might go better a second time. Could have been tough for her—seeing me after almost a year. We'll give it another shot in the morning."

Poor guy. His shoulders sagged as we crossed the parking lot together, and he stopped a moment to light a cigarette. I knew he must be hungry so I swung off the Bayshore and stopped at a little diner near San Carlos. Liz wasn't going to be home until eight, and I couldn't see trying to get a meal with the babysitter around. The place was dim, but clean enough. We balanced our hamburgers on our paper plates and moved down the aisle to an empty table. Jack planted both elbows on the damp table surface and stared down, eating silently. I held up the pepper shaker, but he shook his head. I took another bite and kept quiet. There was no point trying to talk if he didn't want to.

"This Kurt Wolfe... this friend of Liz's," he began finally. I drew my breath in. I knew from Liz that Kurt had called Jack in New York to ask him about his first marriage. I clenched my fist under the table and waited.

Jack paused. "He seems to have done a lot of investigating of the family."

"Too much," I said. "Too damn much."

"He's the editor of that journal you write for, isn't he?"

"I quit," I told him and covered a burned spot on the vinyl surface of the table with my thumb. "I'm going to find something else part-time."

Jack gave me a harsh look, then took another bite of his hamburger. "This article the guy published about Yolanda," he said after a moment. "What do you think of it?"

I studied my tense thumb pressing the table before I met his eyes. "I think it's lousy," I said. "Trashy. Sick. That's why I quit."

Jack reached for the catsup and shook some blobs of red on the remains of his hamburger, then looked back at me. "I agree," he

said. "It's a tasteless piece of journalism. The man's bad news. He may be bright, but he's untrustworthy. I know the type." He paused again and frowned. "There's Liz," he went on. "She's no dope. She's going to discover all that soon enough and leave him. She won't stay with him much longer. That's my guess."

"Well," I said, and sighed. "I hope you're right, but...." I thought of Liz talking to Kurt, the long phone cord snaked down over her shoulder, as she set the kitchen table. I wasn't so sure myself.

"You did right to cut out of that situation," Jack broke in. "That was a good move." He mopped his chin with a paper napkin and studied me. "I want you to do something for me," he said.

"What?" I stared at him.

"Don't start mucking around with some part-time job at this point, will you? Take a loan from me, for Christ's sake. Now." His eyes were stern, but I didn't look away.

"It is a bad time to start something new," I said. "Actually, Jack, I have some important news. Two weeks ago or whenever it was that it happened, it seemed major. But then everything else closed in and...." I paused. "The chairman of the Department wants me to apply for a tenure track position. I mean, there're a lot of applicants and, even if I got it, there's no guarantee they'd keep me on, of course, but...."

"You're talking about the Art History Department at Berkeley?"

"Yes. There's no certainty, but...."

"That's fine. Excellent, after only a year. You've done well, Terry. I meant to say something to you earlier about that book contract. You've done very well." He nodded at me, not smiling, then looked down at his plate again. "Now you'll take that loan," he asked. "All right?"

"Okay, Jack. Thanks."

"Good. That detail's taken care of. Now we'll see what happens tomorrow."

MARGO

I woke early that morning in the ward and remembered all at once that my father had come to see me the day before, and that he would be back in a few hours. The facts startled me. I sat up, swung my feet over the side of my bed, and peered around at my sleeping roommates. I would take a shower, I decided, wash my hair and braid it right.

I waited at the window, and when I saw Daddy start up the steps to the main building, I pushed back my braid and went down to the visitors' lounge. "I'm so glad you came back," I said and kissed the rough skin of his cheek. "I'm sorry I was so gloomy yesterday." He stared at me a moment, then patted my shoulder and coughed. I sat down on the couch, and he took the tan chair opposite, the one with a tear on the arm.

"Well," he said, and slapped his coat pockets with both hands to locate his package of cigarettes. "I'm glad you're feeling better. You look better too."

I watched him light up and snap the burnt match into the ashtray on the table between us. All at once I knew what I needed to ask. "Daddy," I began, "I've got some questions for you about Mom. I should have asked them years ago. She committed suicide, didn't she? She was depressed and she killed herself, didn't she? She didn't have to run off the bridge like that. There were railings, there were...."

"Marg, it happened fifteen years ago," Daddy began. "Are you sure you really want to turn back to that now?" He sighed and blew out a long stream of blue smoke.

"I've got to, Daddy," I said. "I don't understand why. But I've got to."

"That Kurt Wolfe or whatever his name is—that goddamned article of his...." My father raised his head and our eyes met. "No. It's not just that, is it?" He said slowly. "You have to know." I nodded. Daddy rose and walked to the window. "Well," he said, and stood there a moment with his back to me. "I never wanted to talk about your Mom's death to anyone, especially you kids. I couldn't." He turned to look at me. "I just couldn't."

"It had to do with Katherine, didn't it," I said. "I mean it wasn't just the kind of down time she'd known before?"

"Yes," Daddy said. "You're right." He glanced toward the door of the waiting room, as if he suspected someone might be lingering there to eavesdrop, then he looked straight at me. "She knew about my affair. I told her I wanted to marry Katherine, and I said if she didn't give me a divorce, I'd leave her anyway." He turned to the window, then looked back at me again. "Yes, it was suicide. There was no ice. That railing would have held if it had been just a slip or a roll." He stared down at the driveway a moment, then at me again. "You're right, Marg. Your mother ended her own life, and if someone is responsible, it's your father."

Daddy sat down in the armchair with a heavy movement and stared at the linoleum tiles on the floor. "She had been depressed for a month or more. She knew. . . . I never could deceive her. And yet the thing is, I didn't know whether I really wanted a divorce." He looked up at me, dropped his head to gaze at the floor, then looked at me again. "Oh, Christ, sweetheart. The fact is I didn't know for sure what the hell I wanted the night I talked to her. I've gone over it a million times; I was in a swamp of uncertainty." My father flicked a long ash into the round glass ash tray and rose again.

"If Mom had lived," I said, "if she had fought back instead and. . . . " I paused. Daddy was at the window; I wasn't sure he'd heard me.

"The fact of the matter is, we were both sick," he announced. "I spread out my anguish in front of her, my indecision—Oh, Christ." My father stared at me, then looked out of the window again. "Well, now you've got it," he said, turning back to me finally. "Your parents were very sick. Your father more than your mother, probably, and he drove your mother to suicide. That's the story, as I see it—as I've lived with it now for fifteen years." He stopped and glanced around him. The room was quiet. A full minute seemed to pass, maybe two. "Do you want me to leave, Marg? I can get out of your life now, if that would help. I could just leave and not come back."

I hurried over to the window. "No, Daddy, of course not." I put my hand on his arm. "I'm grateful to you—tremendously grateful to you for telling me this at last."

"You are?" His eyes stared into mine, dark and full of sadness.

"Come back and sit down." I pulled his arm. "You're helping me, Daddy. There were a lot of problems in the marriage, weren't there?" I said, when we were seated again. "I mean, there were frustrations on both sides."

"Well, yes. Sure. You know the life I led. Always traveling. Abroad for long periods. We had months of separation and...."

"You were in danger sometimes," I put in.

"Yes, that and...."

"Was she a manic-depressive, do you think?"

"I suppose psychiatry would call her that today. We didn't have that term. We just talked of her ups and downs. God knows I was an erratic bastard to live with myself, obsessed with my work, and...."

"When did you meet Katherine? When did the affair begin?"

"Back in London during the war. We were all focused on Europe, on Hitler, the raids. People do strange things in war. We thought we would get over it when we settled into our peacetime lives again, but...."

"And now that you're remarried, are you happy?"

"Happy?" My father looked at me with a sad smile. "What's that word mean, do you suppose?" He sighed, then straightened. "I'll tell you this, Marg. I married a fine woman. She's not your mother, but she has fine qualities. I wasn't easy to be around after that accident, not for a couple of years, five maybe." He put a large hand to his face and smoothed back some wetness. "I've been through a pile of stuff, sweetheart, believe me," he said, and leaned back so that the plastic made a squeaking noise. "A hell of a lot of it is stuff no psychiatrist could ever explain. But what I think is, we've got to take what's given, finally—stop anguishing over the might-haves, just be grateful and go on. You're asking me about the what-ifs with your Mom, and I tell you I've spent years doing nothing but that: what if I had gotten psychiatric help for her, what if I had never mentioned Katherine, what if I had never met Katherine at all? I tell you I'm a goddammed expert on that stuff and it hasn't done any good. I'm married to a kind, loyal woman, who's put up with one hell of a lot and, God help me, I'm going to try to make her life a little better now after all I've asked."

He stopped and pulled another cigarette from the package on the table. I watched him light it and exhale. "I'm going to try to

appreciate what I've got," he said, "which is no goddamn easy job either, I'll tell you. I'm alive, I'm married, and I've got exciting work I can still do." He paused again and looked at me. "Does that make sense or am I just talking a bunch of baloney?"

"No, Daddy," I said and heard my voice shake. "You're making a lot of sense." I squeezed my hands together. "Do you think this manic-depressive thing is hereditary?"

"I asked Murray that yesterday, and he says there's some evidence that it is. But the point is, Marg, you have a much better chance of living with this condition than your mother did. I mean, that's the way it looks to me—you can live a pretty normal life, despite this thing. Your mother didn't have the help you're getting here." He glanced toward the door. "Much more is known now. Attitudes have changed drastically about all this and...."

"I tried to commit suicide too, Daddy," I told him. "I made a botch of it."

"I know, I know," my father said. "And I refused to come see you. Terry called me, but I didn't come. One more outrageous act and yet.... Oh, Christ, I've been a damn coward, Marg, and that's a fact. But you've got to believe I loved you girls all the same."

"I believe that," I said.

"Margo." A voice spoke from the doorway. I turned. The head nurse looked curiously unfamiliar, standing there in her shiny white uniform. "It's almost time for lunch." My father coughed and went back to the window.

"Fine," I said. "I'll be right there." The nurse left and I went to stand beside my father. "You've helped me, Daddy," I told him. "I think you've made me better somehow."

My father took my hands in both of his. "You have...." His eyes were wet and he paused. "You've helped me too," he began. "I feel now as if...." He dropped my hands and clapped my upper arm.

I stood waiting for him to finish, but he turned to the window instead. "You know, Daddy," I said. "What you've told me today might help us all somehow. Not just me." He glanced back, then looked out of the window again. I moved closer and gazed down into the parking lot below. "But I guess we won't know that for a long time, will we?" I added. "If ever."

Chapter 11

DR. MURRAY

THE textbooks refer to "crises" in this disease—the moment when the situation seems to clarify for the patient, or shifts in some way so that it seems livable. The visit from Margo's father seemed to be a kind of crisis point for her, though these things are often ambiguous. You think the patient has reached a new understanding one day and the next day, you're not so sure. Margo was markedly better after that visit, however, and her upward trend, which I had known was coming, continued.

"Do you think your father's visit helped?" I asked her a week later, when she was back on the open ward.

"I guess so," Margo said. "Maybe not so much anything he said, as the fact that he came at all." She flicked back her braid and sat studying me. "The big male actor in this drama is not Daddy, you know." She gave a little laugh. "It's you." She paused. "But when I try to remember one particular session here, I merge half a dozen talks. It's like a spiral. You say things and I think, boy, I'd better remember that one. But I don't quite, and yet I know it'll come round again."

I talked to Margo a lot in those weeks about managing her illness, about finding a sane place somewhere between the extremes of the manic and the depressive states, where she could work and live. "It's a balancing act," I told her. "We don't want to take away all the energy you feel in the manic or even all the perceptions of your despair. What we want is a balance—some

kind of livable stance between the two extremes, where you can take something from each, but not be overwhelmed by either."

"I often feel as though I'm walking a high wire," Margo said. "There are scary spaces on either side of me, and I don't dare look down. I think I need a balancing pole," she said, and we laughed.

I compared the situation of the manic-depressive patient with the diabetic's, since, for both, survival depends on careful management. But I had talked of management in September—watching the talking, making sure she slept, and, when the acute phase of the disease gripped her, all those cautions had collapsed. I wasn't complacent, and yet perhaps, if we moved with care, she would recover and live a fairly normal life. I had talked to both Margo and Terry about beginning a program of couples therapy. It was a treatment I had had success with before in manic-depressive cases, and it seemed to me that the Sullivans were good candidates. Obviously they had trouble being direct with each other in crises, but I thought with help they could improve. There was a lot of love there, it seemed to me, and respect too.

"This talk regime you're suggesting is pretty time-consuming," Terry said. "I mean, I'm so damn busy right now. But if you think, if you really think.... Hell, what am I saying? Of course I'll do it. When do we begin?" I wanted to get them started before Margo's discharge, so we began that week. Meantime Margo was busy with other plans.

She had begun sketching patients—sad, in-turned faces, manic, over-eager ones, and the other patients wanted her to do more. She came up with an idea for a mural in the lounge. They would all work on it, she proposed, painting in the figures, the backgrounds; it would be a group project. I gave my permission and they rounded up two ladders and worked all week. I heard someone's portable radio blaring music, news, and music again while four of them—all excused from OT—worked on the wall. They mixed paint and talked, and I think they had fun. The mural was quite impressive, different from what I had imagined, lighter and more spacious. There was a circle of figures and a door beyond them, which represented health maybe or life outside the hospital. The whole thing was bright and yet soothing to look at—a distinct improvement over the scarred tan surface that had domi-

nated the room before. It wouldn't have happened without Margo, Peggy pointed out, and teased me about postponing her discharge. I would miss her too, I realized, as that date approached.

LAURA

My Mummy's home again and we do things. She says I'm getting to be a big girl. Tomorrow we're going to get barrettes for my hair.

MARGO

I was discharged in time for Thanksgiving and I remember shopping for groceries, cranberries, stuffing, and the turkey, of course. Laura was sitting in the seat in the front of the shopping cart, looking surprisingly grown-up with her blonde hair held back by two red barrettes.

"If we get a big turkey, Mummy, me and Mikey can make sandwiches after," she announced. I smiled. My friendship with my daughter seemed like a surprising gift I had been handed upon my return from the hospital.

"Sandwiches definitely," I said, "and soup too. Now these are what we need." I picked up a package of cranberries. "And then celery." Beside the produce scale, a tanned young man in white shirt sleeves was whistling, as he sprayed the banked heads of lettuce with a small black hose. He glanced at me and back at the lettuce. Did he know where I had been, I wondered. Could he tell that two months ago I had been locked in a violent ward?

"Sugar Pops," Laura insisted. "We need Sugar Pops, Mummy."

Relative normality, I thought, as we stood in the check-out line. I smoothed Laura's hair and pressed the barrettes in more firmly. If I can look and act like others, then maybe I will be normal too. If I can make another month go on like this one and then another and another, with marketing, chauffeuring, bringing up the laundry, and working at my painting, then maybe even I will begin to believe that I am sane.

TERRY

Margo seemed quiet and steady when she came home late in November, but I was tense, suspicious lest I be disappointed once again, lest Mikey or Laura be. Laura seemed to accept her fairly easily that first week of her return, but Mikey held back, watching, waiting to see if she would stay. Liz was with us for Thanksgiving—just the five of us for dinner—and it was an easy, happy time. Still, I kept looking up, listening for that manic rush of words, reaching out in bed at night to make sure she was still beside me.

Then something happened early in December that changed my world. I got another call from Henderson, the chairman of the Art History Department, saying they would like to interview me. I'd been hoping for that call, and all at once I was rigid with tension.

"I want it too much," I told Margo as we sat outside on the porch that night. "I could mess it all up just out of wanting it so badly."

"You won't," Margo said and reached over to stroke my arm. "You're going to be fine."

There was a round of interviews, and then my lecture on O'Keeffe. I was sweaty but excited, astonished at how friendly the chairman and the others seemed. "We were very impressed with your lecture. Your presentation of the backgrounds of Modernism and, of course, now that you have that book contract...." I nodded. The book, which was my doctoral thesis, seemed remote, almost all of it work that I had done back in Cambridge. There was something eerie to me about this possible triumph, as though these academics were looking at someone I had been, not someone I was now. I had often taught mechanically during the long, terrible months of Margo's hospitalizations, preoccupied with one crisis or another. And yet something was going for me, apparently, for there had been good months too—a long spring term, during which I had instigated a lively new lecture series and an honors group. Then, in the fall, the horror had closed in again and I had just pushed on. It seemed miraculous, finally, that my dogged days of mere persistence had led to

this astonishing reward, for even if I didn't make it, I had the chairman's interest and that of some of my colleagues. I went home to wait. If I made it and was awarded tenure later, a major tension in our lives would be lifted. As a full-time faculty member of the University of California, I would have a real salary, a professional identity, and I would be a permanent part of an exciting academic community that I respected deeply. A week went by and then another. A friend told me they were interviewing four other candidates.

"One's from Yale—a big Ruskin man," he reported.

"Don't go on," I interrupted. "It'll either happen or it won't."

"Terry." It was the chairman's voice on the phone. "We'd like to have you, if you'll come."

"Oh, Lord," I breathed. We talked a moment and I ended, saying I'd let him know soon. I hugged Margo in the kitchen and went off to buy champagne, while she called Liz. Even Mikey seemed pleased.

"We'll stay in California, won't we, Daddy?" he asked me that night, when I sat down on his bed to read.

"Yes, old pal. Sure." I peered at him. "Did you think we'd move?"

"I don't want to leave Argillo," he said, referring to his elementary school, "now that Eric and me are friends." I patted Mikey's head. Two months ago he had refused to go to school for a full week, and now a new boy down the street, a thoughtful dark-faced boy named Eric, was Mikey's best friend. I opened *The Wind In The Willows*. "Where were we?" I asked him. For a moment the print blurred, then I put my arm around my son. "Here we are," I said. "Wayfarers All."

MIKEY

I came home from school Friday and dropped my lunchbox in the hall. It has *The Flintstones* on the cover and *The Flintstones* on the thermos too, but I don't take a thermos. None of the second grade boys do. We get chocolate milk or O.J. sometimes. O.J. That's what we call it. Me and Eric like boxes of raisins too. I was going to shout to Mom to get me more raisins, when I

smelled this yucky smell. "Pee yew," I said, coming up the attic ladder. "What are you doing anyway?"

"Painting my studio," she called out. "Come see."

I stood at the top of the steps and looked around. That big red dinosaur with its tail around that woman was gone, all gone, and the old wallpaper too. Mom was standing there in her dungarees, holding this roller thing on a wire that was soaked with white paint and Laura was on the floor, painting a brown bag. I looked around. The walls were all white and the room felt funny—clean and quiet, sort of.

"Wow," I said. "Did you do all this?"

"I did a lot," Laura said. She was wearing some blue overalls that used to be mine. They had white streaks on them, but I knew she hadn't done much.

Mom put the roller down on some newspapers and smiled. "Do you like it?" she asked.

I nodded. "You should've done this a long time ago," I told her.

"She couldn't. She didn't have the paint," Laura said.

"Well, at least it's done now," Mom said.

"What pictures are you going to do up here?" I asked.

"Maybe some of the family," Mom said. "I'm not sure. What about you?"

"I'm going to finish my train story." I looked down at the newspapers spread on the floor. "If you stay home, that is."

"I'm going to stay, Mikey," Mom said and sat down in the rocking chair. I leaned against the bookcase. Laura was still on her hands and knees, pretending to make some kind of picture, but I knew she was listening. "I'm well now," Mom said "and I'm going to stay home. But if I start getting sick again, we know what to do now, you see?"

"What?" I looked down at the floor. I didn't want to talk about all that stuff—who made her sick and why. I didn't want to start all that. It made me mad.

"Well, I'll go right back and see Dr. Murray. He can help me, if I go to him in time."

"Dr. Murray's nice," Laura put in.

I didn't even bother to look at her; she'd never seen Mom's doctor and neither had I. I waited, then I sighed. "I got mad at

you, going to the hospital all the time," I said. "It was boring."

"I know," Mom said. "I was sad to leave you both and Daddy. I wanted to come home."

"Aunt Liz made us eat pea soup," Laura put in.

I looked out the window. Sometimes Laura is so dumb. "If Aunt Liz goes away," I asked Mom, "who's going to take care of us when you get sick?"

Mom took one of my hands in hers. "I don't know, Mikey. It would be hard if Liz was gone."

"Mrs. Pierce can't come," Laura put in. "She has a grandbaby."

I waited; I wanted Mom to say more, but I didn't too. "We would try to find somebody good, that you and Laura liked," she went on. "But right now what I'm going to do is get as strong as I can, so that I won't go away again, so that Dr. Murray can help me before I get so sick that he has to put me in the hospital. See?"

"Me and Mikey will get strong if we take our vitamins," Laura offered. "Like on *The Flintstones*." She got up and pulled herself up into Mom's lap.

I sighed and put the toe of my boot into this knot hole on the floor. "I wish you didn't have that sickness," I said. "It's boring."

Mom pressed her mouth against the top of Laura's head, the way she does. Then she pulled me close. "You're right, Mikey," she said. "It is boring."

LIZ

I went over to Margo's two days before Christmas. I needed to see her alone before all the excitement began. I wanted to report on some big decisions I'd made. I could have gone earlier, but I'd felt cautious then. I wanted to watch Margo those first weeks and be sure. I'd gotten back from Seattle two days before and I drove out to Berkeley, filled with all I had to say. But I hadn't figured on my quirky father.

We hugged and I sat down at the kitchen table. "Do you know what's just happened?" Margo turned from the stove to confront me. "Do you know what our damn father has just done?" I eyed her quickly. Daddy and Katherine were to arrive that afternoon.

Margo's face was flushed and she clenched the back of the kitchen chair with both hands.

"No. What?" I drew in my breath.

"He's not coming tonight. He called twenty minutes ago and said he had to finish some last-minute story on Central America or something. The bureau has to have it by midnight and.... They're flying in tomorrow instead." She yanked the chair back and sat down. "Dammit, Liz. I've arranged a whole dinner party around him for tonight. I mean I...." Her voice broke and she squeezed her hands together. "I asked the Hendersons. You know, the Department head, who's been so nice to Terry. He's told me several times that he admires Daddy's work and I thought.... Oh God. It's just so humiliating. I mean what the hell am I supposed to do? They accepted two weeks ago and I told them Daddy would be here. They're coming tonight. I've just finished the boeuf bordelaise and I made a meringue pie yesterday and... and...."

"It could be a nice cozy evening, just the four of you. He's fond of Terry and...."

"Oh sure. I know. But Liz, how can Daddy do this to me? It's so arrogant, so.... I don't know." She clenched her hands into fists and sat looking down at them.

"It's not new, Marg. He's always done this."

"But it's so thoughtless, so selfish. I told him I'd invited them. What does he mean putting some stupid career thing of his ahead of me?"

"He always has," I said.

"I know, but...." Margo got up. She clutched her arms around her as she stood with her back to the stove. "What's new is me," she said. "I'm not going to put up with it, Liz. He knows I don't give dinner parties. My God, we haven't had anybody to dinner since I got home from the hospital. This is the chairman of Terry's department; he knows that."

"Oh, Marg, it's nothing new," I told her again.

"I know," Margo said. "But this time it feels different. I'm furious at him. I don't even feel sad. I just want to grab him by the lapels and shake him."

"You can't, Marg. It's Christmas. There's Mikey and Laura and, you know. It's just one more frustration you have to live

with. Hey, is there any coffee? I've got some stuff to report too."

"I'm sorry. Of course there is." She brought the warmed pot to the table and pulled two mugs from the cabinet. "Listen, how was Seattle? Did you get the part?" She poured out the coffee and sat down opposite.

"Yes. But it's not just the part. They've asked me to join the company. They asked me last summer, but...."

"Liz, that's terrific. I mean, isn't it?"

I sighed and poured in some milk. "In a way it is—in a negative sort of way."

"What do you mean?"

"I've left Kurt, Marg. For good. I'm not going back."

Margo brought her hands to her mouth in a prayer-like gesture of gratitude. "Oh, thank God," she said.

Her reaction filled me with anger. "You act as though we were rid of some scourge. Kurt was my lover, my...."

"I know, I know. But awful things happened. That article. That way he used Mom's depression and you and...."

"Oh, Marg, it wasn't that black and white. He was only trying to...."

"He exploited Mom's private life, her death, to sensationalize his magazine."

"Marg, stop it. He didn't." I felt the blood rush into my face and I paused. "You don't understand him. He's obsessed with that magazine. It comes before everything else for him." I stirred my coffee and put down the spoon. "You think you know people's motives, Marg, their reasons, their...." I raked my thighs under the table and felt the bite of my fingernails through my skirt.

Margo drew in her breath with a gasp and reached out to clutch my hand. "You're right. Oh, Liz, I'm sorry. You loved him. Hell, I was very attracted to him myself. I kept calling him to talk during that terrible week. Remember? And . . . I don't know. He's a strange man. I'm just relieved that you've left him at last." Margo sat back and studied me. "What made you finally decide?"

"I've been wondering that myself," I said and looked around the kitchen. The sun was streaming in across the African violets on the window sill, and Mabel sat folded together, dozing on top

of the refrigerator. I sighed and looked back at Margo. "I think I finally decided when you decided to get well."

"What do you mean?"

"Well, I started feeling differently about Kurt then, I think, clearer, and...." I paused and put both elbows on the table. "Marg, you know how your sickness blanketed us all? There were times when I thought it was what we'd been given—the thing we would live with from here on in our different ways: Terry, the kids, and me too."

"I thought that for a long time myself," Margo said.

"But then something happened. Maybe it was Daddy's visit or.... I don't know. But somewhere in there you seemed to turn and see the mess of your sickness. You seemed to push it back and lift. And that's sort of what happened to me. There was a day soon after you were on the open ward again, when I stared back at my long affair with Kurt and it looked sick and gray. I realized I'd been lost in delusion too, only mine was less visible. I'd been enveloped by a man I knew was bad for me and well . . . finally I just lifted too and got out."

"That's amazing," Margo said. "You had the courage to make a decision. My lifting doesn't seem like a decision to me."

"Maybe not," I agreed, "but we both came to see something differently."

"Was it Daddy telling about Mom's suicide, do you think?"

"Oh, it was more than that. I mean in a way we both knew that on some level all along. Right?"

"Right," Margo said and paused. "It's mysterious, Liz. I wish I understood it better. I still think that if I did, I'd have a better chance of fending the dark time off, if it comes again."

"Maybe you have to take comfort in the fact that nobody understands it very well, not even Murray. You just try to keep learning, I guess, like the rest of us, trying to steer around the bad stuff, trying to understand."

"I guess," Margo said, and lifted her hands as if she was going to expand on that, then dropped them to her lap, and smiled. "Are you going to fly up to Seattle right after Christmas?" she asked. I nodded and she sat forward, her face serious again. "God, I'm going to miss you, Liz. I don't know what I'll do without you."

"You'll be fine. We both will be. We've survived a pile of junk and we've both gotten stronger. Who knows? Maybe you'll tell Daddy how mad you are about tonight. Might be a therapeutic exercise after all." I laughed.

"No," Margo answered. "That'd be too hard. Besides, as you said, it's Christmas. We're supposed to be a warm, cozy family now. Right?"

TERRY

I was pissed off at Jack myself. I mean, what the hell? Henderson was chairman of the Department and he'd been unusually kind to me. But actually it turned out to be a good evening, important maybe—just the four of us. Mrs. Henderson confessed to Margo that their daughter was a manic-depressive; they knew a lot about it; they even knew Dr. Murray. The four of us talked a long time and when they left I felt we had two new friends, almost parental, and that would never have happened if Jack and Katherine had been there.

The plane was late and when they finally appeared, Jack was in a rush to get to the baggage claim. The airport was a mess. I was to deliver Katherine to her daughter's in San Francisco, where she was spending Christmas Eve. She and her daughter were to come to Berkeley the next day for Christmas dinner. I was to bring Jack home. But it wasn't just Jack that I brought; I brought Toby too—a little golden retriever puppy with light blond fur and deep affectionate eyes. He was a superior dog, Jack announced; he even had papers. Fine, I thought, but what about Mabel? Besides we'd already had an experience with a puppy.

"He's newspaper trained now," Jack said. "But give him just a week or two and he'll be completely housebroken." The roar of a motorcycle muffled his words as a familiar figure pulled up just beyond me, her head wrapped in a long blue scarf. She shouted something to a bearded man pressed close behind her on the big leather seat. I saw him smile and close his denim arms more tightly around her waist. When the traffic started again, I watched the motorcycle pull ahead, weaving into another lane, then out of sight.

MARGO

We fixed up a bed for Toby in the kitchen after the kids went upstairs. He seemed quite docile, even sleepy. But I woke about three in the morning at the sound of someone going downstairs. I heard the creak of the kitchen door and knew Daddy had gone to check. I lay awake; this was my chance to confront my father or should I just sink back into sleep? I rose finally and pulled on my bathrobe. The puppy was lapping some water from a bowl by the sink and Daddy was sitting at the kitchen table, staring down into a glass of scotch. He looked up at me and frowned.

"He's fine," he said and nodded at the puppy. "I just couldn't sleep. This Cuban thing is serious. Eisenhower's been drilling anti-Castro troops in Guatemala for months now. I'm not convinced that Kennedy understands how bad this really is. I just hope to God he doesn't continue Eisenhower's stupidities."

I stared. I hadn't gotten out of bed at 3:30 on Christmas morning to discuss Cuba or Castro. I yanked back the opposite chair and sat down. "You know, Daddy." I swallowed. "It would have been nice if you'd consulted us about Toby first. I mean he's going to take a lot of work and training and...."

"Huh?" My father peered across at me. "I thought you liked him." He looked down into his glass again.

The puppy trotted toward me, then plopped on his bottom and began to scratch his ear; clearly he had fleas. "I do," I said. "I do. It's not the puppy, Daddy, it's... I just can't understand how you can be so thoughtless about promises you've made. That dinner party last night was a big deal for me. I mean, it was Terry's reputation and...." I was exaggerating. My voice shook and I rushed on, hot with the sense that I had my father's attention. "Sometimes you're just so oblivious to everything but your own work. You drive your big brilliant career over the rest of us like a steam roller." I stopped, startled at the accuracy of my image. "You've done it for years," I went on. "But I'm not taking it forever. Hear?" I waited, but my father did not speak. He lifted the bottle of Dewar's White Label beside him and sloshed in more scotch. "You make me so mad." I rose and felt the cold linoleum under my bare feet. "You think bringing a cute little

puppy forgives everything—your neglect, your...." I shivered and glanced at the dark window above the sink. My father had paid almost six months of hospital bills and had insisted on making a loan to Terry as well. He had visited me in the intensive ward, when I was despairing, and... and.... I clutched my arms around me. Was I being fair? Maybe not, but I had to say this stuff now. I might never feel this hot courage again. The puppy pushed at my ankles with his wet nose, and I stooped down and gathered him. "I just don't understand why you can't...." My voice broke again. A wet spot fell into the soft brown fur on the puppy's back and then another. Damn. I held the puppy's warm body close, fondling his ears as I struggled to hold onto my righteous rage.

"I'm sorry, Marg," my father said. "I don't know what to say."

I put the puppy down and straightened again. "Maybe you can't change," I said. "But I can stop being the awed, dutiful daughter of the great man. I can...."

"Look," Daddy broke in. "I told you at the hospital that I'd get out of your life, if that would make it better. I can get out and stay out, if you want me to."

"Oh, dammit," I began. "That's not what I want. That's too easy. I want some change, some respect—a little consideration. I know you've been generous about the finances, the bills, the loan. I know all that. But Daddy, Daddy, I want... I want...." I glanced around the kitchen, feeling my face burn. "Can't you see what I want? Don't you know?" I squeezed my hands together. The door squeaked; I turned.

"What's going on in here?" Terry demanded. "It's almost four in the morning." He looked from me to my father and back at me again. "Tomorrow's Christmas. Remember? We've all got a lot to do." I shivered again. Terry moved close to me and put one arm around my shoulders. "We can talk in the morning. Okay? Right now, let's get to bed." I stared. All at once that other time in the kitchen, when Terry had ordered me upstairs, flooded in. I could see the nails spread out on the floor, glittering and sharp.

"I just told Margo that I'd leave, if that's what she wants." Daddy pushed his chair back and stood. "I can take a taxi to Katherine's daughter's place tonight. No need to have me here for Christmas if you don't want me. I can take the dog too."

"Daddy, don't. *Don't*." Even as I heard my shouted words, I knew we were both playing parts. "We want you here. I didn't mean to say all that. What I meant was...."

"I don't know what you two have been talking about," Terry broke in, "but this isn't the time for heavy psychiatric explorations. We've got to get some sleep before the kids get up. Here we go, Toby," he said, scooping up the dog. "You're going to sleep now, and we are too." He knelt and settled the puppy on the bed of old blankets and covered his back. "Now that's better."

I stared at my father, then at my husband in the bluish light from the overhead fixture. Daddy stood slump-shouldered by the table. His brown robe was open at the neck, revealing the gray curls on his freckled chest. Stooping down in front of the puppy, Terry's thighs looked strong and nimble in his blue pajama pants. I glanced at his hands with their long, blue veins and remembered that I had loved his hands first. He straightened and switched off the light.

"Don't leave, Daddy," I whispered, though I knew the danger of his going was past. "We really want you here, you know."

"I'm not going anywhere." My father gave my arm a friendly cuff. "Terry's right. Let's all get to bed."

NANCY

I went down to the kitchen before dawn. I was cooking an eighteen-pound turkey, and I wanted to get it started well ahead. I can't stand having to run back and baste in the midst of all the present-opening and everything. The window in Margo's kitchen was lit up; I stood at the sink and peered out. I could see Margo, standing in her bathrobe talking, and then, when I bent forward a little, I could make out this gray-haired man at the table. It must have been her father, and she wasn't saying anything affectionate or Christmassy to him either. I know that. He had a bottle of liquor in front of him and Margo was just giving it to him, talking away, shouting maybe. I wish I'd been able to hear.

The thing is, I hadn't really seen much of Margo after she got home from the hospital that second time, which I understood, of course, although I thought if anyone deserved to hear the details

about her time in that violent ward, or whatever it was, it was me. After all, I took care of those children afternoon after afternoon, when either Terry or Liz was busy. Oh, they were both good about returning the favors, and my children are crazy about Terry, especially after he took them all to Chinatown. But I thought Margo would tell me a little about what had happened to her at least. She hasn't, though; she's sort of pulled back. I mean, I know she's still a close friend and all. But, well, I suppose this is just one more stage in her getting over her nervous breakdown or whatever you're supposed to call it nowadays.

I've asked them all over for carols Christmas afternoon. I've made real eggnog and they're all going to come, including Margo's father, his wife, and her daughter.

A dumb thing happened, though, as I was standing there watching. I knocked this spoon into the disposal with my sleeve. I was looking out and didn't notice and when I turned on the switch—Lord, what a racket. I glanced over at Margo, scared she'd heard and would know I'd been spying. Of course, she didn't. Nobody did. I pulled out the spoon, but it was done for.

TERRY

Jack was still there in the morning, of course, a little red in the eyes, saggy at first. But he brightened with coffee and the mound of scrambled eggs that Margo brought in. I watched him, and I really watched her. I'd given her a sleeping pill at ten after four, when we got back in bed. She'd slept, and I thought she was handling the morning situation well, though I continued to observe. The puppy was a huge success with the children, of course. His presence pretty much blanketed the excitement of any of the other presents. I'd gotten fond of the dog. He seemed sweet, although I kept comparing him to Mr. Green Jeans, as I knew Margo was doing, too.

Liz arrived, and Katherine with her round-faced daughter, and there were more presents. Then Liz and Margo got busy in the kitchen. The long lace-covered table looked festive, but I felt clumsy carving the turkey, spilling the stuffing out. I glanced over at Jack, expecting criticism, but he was busy telling Liz about

Cuba's internal politics. I looked down at the end of the table and saw Margo smile. What did that smile mean, I wondered? Had her confrontation with her father last night begun to turn her manic? I had heard only part of it, as I crossed the dark living room, but I could guess what she had said. Or was she pleased that she had had the courage to stand up to him? I didn't know.

I cut up Laura's meat, then Mikey's and looked down at Margo again. This time it seemed to me that she glowed. She didn't look excited or angry; she looked like a happy woman. I put the carving knife beside the platter and sat down. Just possibly, Margo had experienced something clarifying last night. Perhaps she had moved upward, out of the cycle of sickness, toward some new strength. In just three more days we would be talking it all over in Dr. Murray's office; that realization felt reassuring.

MARGO

"Grandaddy won't like that picture, Mom," Mikey warned, peering at the face I was sketching on my long pad. "Yuk. I don't either. He looks like Chief Komoi in *Rin Tin Tin*."

"You might be right, honey." I stepped back from the easel to consider. "I'm just trying out some ways of doing him. See?" I glanced down at Mikey, who stood at my elbow, his shirt hanging out, his chin smudged gray from the charcoal pencil he'd been using.

"Aunt Liz's not going to like it either," Mikey announced. My stern colleague, I thought, my old studio companion.

"Have you finished your new train story?" I asked.

"No. I'm sick of it. I'm going out to play with Toby." He pulled one sock up and turned back. "When's Laura coming home from Dodie's?"

"Soon," I said. "Call me when she gets here and we'll have gingerale and animal crackers. Okay?"

His feet sounded on the attic ladder, then on the stairs below. I sighed, glad to be alone in my white studio again. The quiet lapped around me as I turned back to my canvas. Maybe Mikey was right; Daddy's face did look brooding, almost sinister. I flipped back the sheet of the sketch pad and began again. I lifted

the head, keeping the eyes serious, then I put his broad hand across his chin. The pose gave the picture a new immediacy, as though he were considering something he was about to say.

I sketched in the heavy brows, the furrows in the forehead, a mole on his cheek, and stepped back. I was beginning to catch something, maybe. I turned and stooped down in front of the stacked canvases in the dusty area at the bottom of the eaved wall. Leaning them against my knees, I tipped one forward, then another, until I reached the portrait of my mother. I pulled it out and blew dust from the top. I propped it up on the paint table, so that it was almost even with the sketch of Daddy on the easel. My mother knelt, holding the flower pot, as though she might rise in a moment and transplant its contents to the herb garden. All at once, I saw what was wrong with her expression. She looked too passive. She needed more chin, more cheekbone, a look of determination in her eyes, as if these herbs just damn well better grow. I worked fast, relieved by the change, then glanced back at the sketch of my father. They were not looking at each other, yet they would be companion paintings—companions to me, at least. They would stay up here in my studio, maybe, to remind me—of what? Of growth and love and danger too, perhaps.

On Wednesday, I would begin a new commission and would put this sketch for a portrait of Daddy away. Once more I would be painting for someone else. Yet I would finish this painting someday, for it had proved an absorbing project after the high excitement of Christmas. It had helped to fill the sudden emptiness that had followed Liz's departure. I clutched my arms around me and moved to the window.

Tomorrow Terry and I would see Dr. Murray again. Would he think I was doing well, getting stronger? Yes, maybe. But I was not complacent. The dark waters could rise again, the grayness and the mess. Or I could begin talking furiously, be unable to sleep or stop my pounding thoughts. I looked out toward the bay; I was still clutching my balancing pole.

Down below me, I could see Toby pawing at an old hole in the fence. I jerked up the window. "Mikey," I yelled. "Mikey." But he did not hear me. He was spinning the front wheel on his upside-down bicycle, unaware of the puppy working busily

behind him. I hurried down the attic ladder, down the stairs, and out into the yard. There was always something, I thought—a hole in the fence, a telephone ringing, a set of sheets on the clothes line about to be drenched in the fragrant rain—always something pulling one past the scary unknowables, pulling one on.